Van Gogh
Self Portraits

Van Gogh
Self Portraits

WITH
ACCOMPANYING LETTERS
FROM VINCENT TO
HIS BROTHER THEO

by Pascal Bonafoux

Translated by Daniel Simon

THE WELLFLEET PRESS

WELLFLEET

There certainly is an affinity between a person and his work,
but it is not easy to define what this affinity is, and
on that question many judge quite wrongly.

Vincent to Théo, The Hague,
April 1882, Letter 187

Either inside or outside the family, they will always judge me
or talk about me from different points of view, and
you will always hear the most divergent opinions about me.
And I blame no one for it, because relatively few people
know why an artist acts as he does.

Vincent to Théo, Brussels,
2 April 1881, Letter 142

Published by
WELLFLEET PRESS
110 Enterprise Avenue
Secaucus, New Jersey 07094

Copyright © Éditions Denoël, Paris

English translation copyright © 1989 William S. Konecky Associates

ISBN: 1-55521-471-1

Printed and bound in Hong Kong

Table of Contents

The text of *The Complete Letters of Vincent van Gogh* (2nd edition, New York Graphic Society, 1978) is the only reference work for the present edition. The classifications and paginations indicated in the margins are from this edition. The letter following the reference indicates the language in which van Gogh wrote: *F* for French, *D* for Dutch, *E* for English. Letters preceding some classifications designate the identity of van Gogh's correspondent when someone other than Théo: *R* for Van Rappard, *B* for Émile Bernard, *W* for Wilhelmina, Vincent's sister.

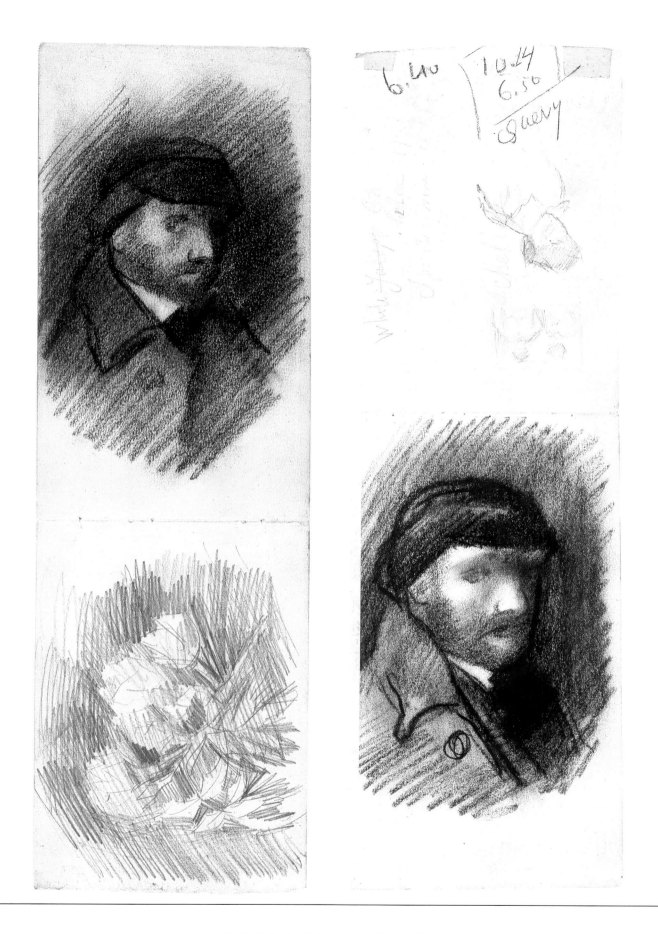

1. *Self-Portrait* (recto and verso),
Anvers, 1885, black pencil on paper, 19.7 × 10.9 cm,
Amsterdam, Rijksmuseum Vincent van Gogh.

Vincent Who?

There is a portrait of Millet by Millet himself which I love, nothing but a head with a kind of shepherd's cap, but the look through half-closed eyes, the intense look of a painter—how beautiful it is—also that piercing gleam like in a cock's eye, if I may call it so. [248 D, November 1882]

It is a similar look that I am set to decode. That of Vincent van Gogh.

Sunday, 27 July 1890, he put a bullet in his chest. On 29 July, at one o'clock in the morning, he died. And his fame is killing him still. Fierce, spurned and unhappy, alone, scorned and exiled, ill, alcoholic and crazy, the man has supplanted the painter. A Genius. A myth. And the curse has concealed from us the painting.

Gauguin used to recount the following anecdote: "I had the idea of painting a portrait of him at work on the still life he loved so—the sunflowers. After I'd finished, he said to me: 'It's me, all right, but me having gone crazy.' That evening we went out to a café. He ordered a light absinthe. All of a sudden he tossed the glass and its contents in my face."

The response of van Gogh to the portrait, and especially his objection, "me, *but* me having gone crazy," foreshadowed the terror, the violent scenes, the times when van Gogh was "beside himself."

Gauguin would continue: "The next morning, very calmly, he says to me, 'My dear Gauguin, I have a vague recollection that I offended you yesterday evening.' "

A vague recollection . . .

The van Gogh file is chock full of stories, remarks, analyses. But here I wish to capture van Gogh the painter, van Gogh according to himself: the ardent passion, the intransigence, and yet someone different as well from the painter he desired to be. Day in and day out, year in and year out, Vincent wrote. His letters told of his determination weakened by afflictions, failures, and disappointments, his faith strained. Vincent wanted only to paint.

These pages, in which the portraits Vincent painted of himself are interwoven with fragments from his letters, do not comprise a biography. I mistrust the anecdotal—tales of youth, sugary sweet or crisis ridden, that become the engine of an inexorable trap that ends with Vincent dead at the age of thirty-seven, having said nothing all the while about the painting.

Such a book would be telling the story of van Gogh so as not to have to look steadily at him. Thus the debate to ascertain the true nature of his illness is a vain one. Schizophrenia, epilepsy, alcoholism, paranoia—they explain nothing. His canvases are not the mere symptom of what destroyed him. Perhaps it is time to look at these canvases so often unsigned as one would look at those that were anonymous,

to begin to disabuse ourselves of the mythology of the *artiste maudit* (the cursed artist, so conveniently situated in the conventional repertory along with the graybeard, the nursemaid, or the confidant, clearly defined types for the stage or novel). Van Gogh, however, is not so easily typecast, and painting itself is always enigmatic.

These pages comprise an essay—what the dictionary defines as a "literary work in prose, in a free style, treating a subject but not exhaustively." There are indeed no words to describe Vincent van Gogh, because his achievement in color and in silence has to do with seeing, not with speaking. I recall the words of Artaud: "Van Gogh painted himself in a large number of canvases, and as filled with light as these paintings are, I cannot rid myself of the painful suspicion that this light is a falsification of the real and indispensable luminousness which, in order for these canvases to carve into him as they do, he had to deprive himself of." And this, again from Artaud: "If you plunge into old books on alchemy, it isn't long before you feel at home. But with van Gogh it is just the opposite. The deeper you plunge, the less familiar things are, the less like what one knows." I can only confirm this assertion.

And the only thing that counted was the dogged quest that is painting. The rest, whatever that rest may be—the humiliations and unhappiness, the gin and the absinthe, or the whores—were but obstacles, or refuges, along the road towards painting. Just anecdotes.

When van Gogh painted his self-portrait, he was expressing neither his unhappiness, nor his disease, nor his madness. Rather, he was painting despite these things. To paint meant the mastering of that which had otherwise undermined him; the painting of self-portraits meant having the will, the fury, to subdue for a time the terrible forces that were destroying him. To paint oneself was to exorcise that which separated him from painting. Van Gogh's portraits of himself are portraits of him lucid. As such, each portrait is an epiphany.

And to paint was a tragic endeavor. This was because it was an act of desperation. The despair of van Gogh, with that keen and sorrowful awareness, represented a struggle. Not to paint, to be unable to paint, was to be utterly and irremediably lost.

Van Gogh painted as he prayed and as he preached. He prayed and preached in spite of being a sinner. He painted in spite of the reverses he had suffered in life. The Holy Writ and color both involved an anguished and frantic pursuit of one and the same light, one and the same salvation. He was a painter as he had wanted to be a pastor. Van Gogh entered painting. Without reserve he became both missionary and martyr. And his portraits are the legion of the saved having risen after the resurrection, which his faith invented.

Van Gogh's first self-portrait was not painted until after his arrival

in Paris at the end of February 1886. He had made but one preliminary drawing, in charcoal, one year before. He painted no more of them after departing from the Saint-Rémy-de-Provence asylum in mid-May 1890. One of his first self-portraits shows him wearing a dark felt hat and holding brushes and palette—a portrait of a painter, as is one of the final portraits, painted in September 1889. He wears a blue smock; his thumb grips the palette and presses against it a clutch of brushes. Portraits of a painter. Van Gogh was a painter only during the period when he was in exile, a period totaling less than five years.

He painted more than thirty self-portraits. They show him drawn, haggard, and bearded; or with his thick red hair close-shaven; wearing a hat of felt, or of straw; with a scarf, or a smock; and the look on his face doesn't change. The implacable and severe intensity remains the same. He scrutinized himself, spied on himself, stared at himself as he must have stared at his paintings. These are portraits of distress and defiance painted in such a way that the two qualities merge into one. The resulting expression concerned van Gogh alone. And it concerned only what was essential. He became what he painted. His work was his whole life, rather than his life being his work.

In these self-portraits lay the essential part of van Gogh. The sole commentary that might accompany them was that which was carried in these letters, whose voice spoke of both the necessity and the danger. What I am trying to illuminate by presenting the self-portraits and the letters here is how a man, Vincent van Gogh, born in Groot-Zundert on 30 March 1853, was metamorphosed into the very stuff of painting. It was an act of will, an act of conscience and of necessity. It was a purely painterly matter, and that from which van Gogh suffered was without cure.

CHAPTER 2

Fame's Perversities

And I think a certain popularity the least desirable thing of all. [R16 D, September–October 1882]

The self-portraits van Gogh painted more than a century ago are his crowning glory. To scrutinize them, seeking to unmask their hush and mystery, is somehow to violate van Gogh's memory.

In January of 1890 there appeared an article by an Albert Aurier in *Le Mercure de France* entitled "Les Isolés" ("Those Alone"). The article consisted of unmitigated praise for van Gogh's paintings, six of which were then hanging in the Eighth Exhibition of the Twenty in Brussels.

On April 29, 1890, van Gogh requested: "Please ask M. Aurier not to write any more articles on my painting, insist upon this, that to begin with he is mistaken about me, since I am too overwhelmed with grief to be able to face publicity." [629 F, 29 April 1890] In a postscript to a letter written to his mother and sister soon after, he adds: "As soon as I heard that my work was having some success, and read the article in question, I feared at once that I would be disheartened by it; this is how things nearly always go in a painter's life: Success is about the worst thing that can happen." [629a D, May 1890] One must understand such words as these if one is to understand van Gogh at all. The expression of the self-portraits was intended as a private communication to himself. Van Gogh's concern was not what others saw, whether in the form of present fame or posthumous glory. "This afternoon I had a select public—four or five hooligans and a dozen street Arabs, who were especially interested in seeing the colors come out of the tubes. Well, that same public—it meant fame, or rather I mean to laugh at ambition and fame, as I do at these street Arabs, and at the loafers on the banks of the Rhône and in the rue des Pont d'Arles." [539 F, September 1888]

The disdain, rather the scorn, with which van Gogh viewed fame was by no means a way of forbidding others from looking at his work, but was an plea, a command, that they see it with his eyes. What was most important was not how the paints came out of the tubes.

To stand face to face with van Gogh it is necessary to see him, forgetting what you already know about him, more than once. "In general, and more especially with artists, I pay as much attention to the man who does the work as to the work itself. If the man is not there, I am now and then forced to draw conclusions from the work alone (we cannot know all artists personally), or if the work is not there, to form an opinion from the man." [R6 D, 23 November 1881] "It has always seemed to me that when an artist shows his work to the public, he has the right to keep the inner struggle of his own private life to himself (which is directly and inevitably connected with the

peculiar difficulties involved in producing a work of art)." [181 D, March–April 1882] The "instructions" on how to read a work of art contained in these words pointed out the essential fact. The vicissitudes of a man's life do not in the least explain his work. To assume otherwise would be to embark on an endless and futile misinterpretation. Conversely, the work itself—its risks, demands, and challenges—does indeed determine the nature of the life. Van Gogh's life was but the quest of painting.

And the quest was a pitched battle. "I for one am quite decided to go on being armed with nothing but my brush and my pen." [571 F, 17 January 1889] The strokes of his brush and pen did not follow his life, but determined it. "So I have a horror of success; I am afraid of 'the morning after the night before' of an Impressionist success, even these difficult days will later seem to us 'the good old times.' " [524 F, August 1888] It is the aim of these pages to recover these "good times"—those of creation. "And already I can see myself in the future when I shall have had some success, regretting my solitude and my wretchedness here." [605 F, 10 September 1889] No other time counts.

Van Gogh while painting neither challenged, stalemated, negated, nor destroyed time. Rather he painted, then and there, humbly. Van Gogh envisioned no future for his work. "And yet it is a certain pleasure to paint a picture, and yet at this very moment there are some twenty painters here, all having more debts than money, etc., all leading lives approximately comparable to the lives of street dogs, who are going to be of perhaps more importance than the whole of the official exhibition as far as the future style of painting is concerned." [W4 D, June–July 1888] And although for years his life had been the one most like that of a stray dog, yet he is less than sure that he is to be counted among the twenty painters whose future importance remains so promising. He did not go in for that kind of illusion. To Théo he wrote: "If I, for my part, have some confidence in my own work, it is also because it costs me too much effort to believe that nothing will be gained by it or that it is done in vain." [366 D, April–May 1884] But then he adds: "You must by no means suppose that I have great illusions about the appreciation of my work; I think one must be satisfied if one succeeds in convincing a few people of the seriousness of one's intentions and is understood by them without flattery." [366 D, April–May 1884] Van Gogh is intransigent on the subject: "As to general sympathy, years ago I read something about it in Renan, which I have always remembered, and shall continue to believe, namely, that he who wants to accomplish something really good or useful must neither count on nor want the approval or appreciation of the general public but, on the contrary, can expect that only a very few hearts will sympathize with him and take part in it." [400 D, April 1885] Having resigned himself

to the shadows of obscurity, van Gogh was able to paint with nothing at stake but painting itself—without having to prove anything to anyone. His self-portraits concerned him *and him only*. Painting laid the foundation of his solitude. When we look at the paintings today, we admire the mysteriousness with which they embody that solitude. But what then is the law by which such painting exists when it was painted for no one? Why did van Gogh paint? What hopes had he for his exclusive, implacable, and fatal work? He, the painter, remained wild, an outcast, and he painted and painted and did not cease to paint. He swore: ". . . it is my bound duty to look for opportunities to hunt up chances to sell my work," and announced, ". . . if they take no notice of them, all right—I am prepared for that, too." [R44 D, April–May 1884]

To what kind of painting was it that van Gogh consecrated himself, that damned him to defeat, sapped his strength, broke his spirit, and unwaveringly isolated him? "Well, I hope to keep courage after all, whatever may happen, and I hope that perhaps a certain frenzy and rage for work may carry me through, as a ship is sometimes thrown over a cliff or sandbank by a wave, and can make use of a storm to save herself from wrecking. But such maneuvers do not always succeed, and it would be desirable to avoid the spot by tacking a little. After all, if I fail, what does my loss mean? I don't care so much after all. But one generally tries to make one's life bear fruit, instead of letting it wither, and at times one feels that after all one also has a life of one's own, which is not indifferent to the way it is treated." [303 D, July 1883] And these words, written in July of 1883, "to make one's life bear fruit," are the sole justification for the years of hunger, of loneliness and fear—*to make one's life bear fruit*. . . . Did he remember them seven years later at Auvers, when he placed against his heart the barrel of a gun?

Vincent painted the way an anchorite prays. You must pass by the desert. As the hermit is alone with God, so van Gogh was alone with his painting, and the completion of each canvas represented an act of faith. His life as a painter was one of pure fervor. And there remains but one question, and it has no answer (and perhaps there is no point in asking it): What did van Gogh expect in return from painting? Might it be supposed to save some part of him? I know of only one phrase, humble and despairing in tone, mystical or absurd in meaning, that even approaches a response: "Were we paving the way to enrich the lives of the painters that will follow in our footsteps, that in itself would provide some comfort."

The Creative Power

I feel such creative power in myself that I know for sure that the time will arrive when, so to speak, I shall regularly make something good every day. [229 D, Summer 1882]

At the time he wrote the words quoted above, during the summer of 1882, van Gogh had made the decision to be a painter but six months earlier. August 1881: "[Mauve] thinks I should start painting now." [149 D, August 1881] The choice does not represent his own impulse but that of another, and this is still the case on 12 October: "Before long I hope to be able to pay another visit to Mauve to discuss with him the question of whether I should start painting or not. Once started, I shall carry it through. But I want to talk it over with some people before starting." [R1, 12 October 1881] By "some people" he is referring to Mauve and De Bock. Finally, by the end of the year, the decision is made and van Gogh can voice his enthusiasm: "For, Théo, with painting my real career begins. Don't you think I am right to consider it so?" [165 D, December 1881]

Van Gogh is twenty-eight. He has everything to learn. Since being dismissed by M. Boussod, since having to leave the Goupil and Cie Gallery for which he had worked in The Hague, in London, and in Paris, van Gogh's life has been one of mishaps, failures, and miscalculations. Painting and drawing have been his constant companion, however. He has delivered sermons at Isleworth and has visited Hampton Court. He has studied for his examination at the School of Theology in Amsterdam and has visited the Rijksmuseum. In Etten, where he awaits convocation at the Flemish School of Evangelism, then under the direction of Pasteur Bokma, he draws. In Pâturages, in the Borinage region, in Wasmes and Cuesmes, where he preaches and offers help to the neediest, he is a poor man among poor folk and still manages to draw. From Cuesmes he travels by foot as far as Carrières, in the Pas-de-Calais region, where lives a painter, Jules Breton, whom van Gogh admires. It is as though he were making a pilgrimage. On 26 December 1878, Vincent writes to his brother: "As for me, I am sure you realize that here in the Borinage there are no pictures; generally speaking, they do not even know what a picture is. So of course, I have not seen anything in the way of art since I left Brussels." [127 D, 26 December 1878]

Van Gogh had left Brussels in October. In March 1879, he told Théo: ". . . and when you tell me something about painters, remember that I am still capable of understanding it, though I have not seen any pictures in a long time." [128 D, March 1879] Finally, in July of 1880, he confesses: "When I was in other surroundings, in the surroundings of pictures and works of art, you know how I had a violent passion

for them, reaching the highest pitch of enthusiasm. And I am not sorry about it, for even now, *far from that land, I am often homesick for the land of pictures.*" [Emphasis by van Gogh; 133 F, July 1880] This was van Gogh's earliest exile: to have been driven from the "land of pictures" for twenty months.

In order to become a painter one day, it was necessary first to unlearn. "I must try to forget some things I taught myself, and learn to look at things in quite a different way." [173 D, January 1882] In November 1880, alone and isolated, he raged: ". . . How can one learn to draw if nobody shows one how? With all the best intentions in the world, one cannot succeed." [138 D, 1 November 1880] "There are laws of proportion, of light and shadow, of perspective, which one *must know* in order to be able to draw well; without that knowledge, it always remains a fruitless struggle, and one never creates anything." [Emphasis by van Gogh; 138 D, November 1880]

But then one may reassure oneself. "What one learns from personal experience is not learned so quickly, but it is imprinted more deeply on the mind." [232 D, September–December 1882] The same question, forming itself in a variety of shapes and sizes, haunted him for months: How to work? It sometimes presented itself as a quandary: "There are two ways of thinking about painting, how not to do it and how to do it: *how to do it*—with much drawing and little color; *how not to do it*—with much color and little drawing." [184 D, October 1882] At other times it appeared as a bafflement: "The one thing that is increasingly difficult to decide on is the best working method." [253 D, November–December 1882] And sometimes it took the form of a discovery: ". . . I have observed that one feels more definitely what kind of studies one has to make while composing. I am working with great animation these days and am relatively untired because I am so interested in it." [293 D, June–July 1883] Or a conviction: "Now about the work, I do not doubt it has its faults, but neither do I doubt that I am not entirely wrong, and that I shall succeed, though it be after a long period of seeking." [314 D, June–July 1883]

In January 1886, in Brussels, van Gogh had a final go at the École des Beaux-Arts. "I have now been painting at the academy for a few days, and I must say that I like it pretty well. Especially because there are all kinds of painters there, and I see them work in the most varied ways, something I have never experienced before—I mean seeing others work." [446 D, January 1886] It was at Anvers that van Gogh would draw his first self-portrait, sketching on both sides of the same sheet of paper. Thus, not until he went as a painter among painters could he paint himself. At Anvers he also served as model to the others, beginning with the painter Horace Mann Levens (in an almost

fantastical parallel to the first portraits of Rembrandt painted by his studio companion Lievens).

Van Gogh's first self-portraits were not those of an apprentice. "And *my* aim in *my* life is to make pictures and drawings, as many and as well as I can; then, at the end of my life, I hope to pass away, looking back with love and tender regret, and thinking, 'Oh, the pictures I might have made!' But this does not exclude making what is possible, mind you. Do you object to this, either for me or for yourself?" [338 D, November 1883]

In his room at Auvers, he would murmur: "Encore raté" ("Still defeated"). Was he speaking of suicide? Of painting? Did he remember the letter of application he had written in mid-June, 1876, to a Protestant minister? Van Gogh, who at that time had desired to be an evangelist, wrote: "But the reason which would rather give for introducing myself to you is my innate love for the Church and everything connected with it. It may have slumbered now and then, but is always roused again. Also, if I may say so, though with a feeling of great insufficiency and shortcoming, 'The Love of God and man.' " [69a D, June 1876] When five years later his profession became that of a painter, he might have rewritten the same letter (to whom?). It would have sufficed to revise one word, changing *Church* to *Painting*. There are no portraits of van Gogh as a novice. He painted himself only as an ordained painter, and by means of the self-portraits that he painted, he was consecrated.

*The fact that I have a definite belief about art
makes me sure of what I want in my own work,
and I shall try to reach it even at the risk of my own life.*

Vincent to Théo, Neunen,
August–September 1885, Letter 423

2. *Self-Portrait of the Artist at His Easel*,
Paris, early 1886, oil on canvas, 45.5 × 37.5 cm,
Amsterdam, Rijksmuseum Vincent van Gogh.

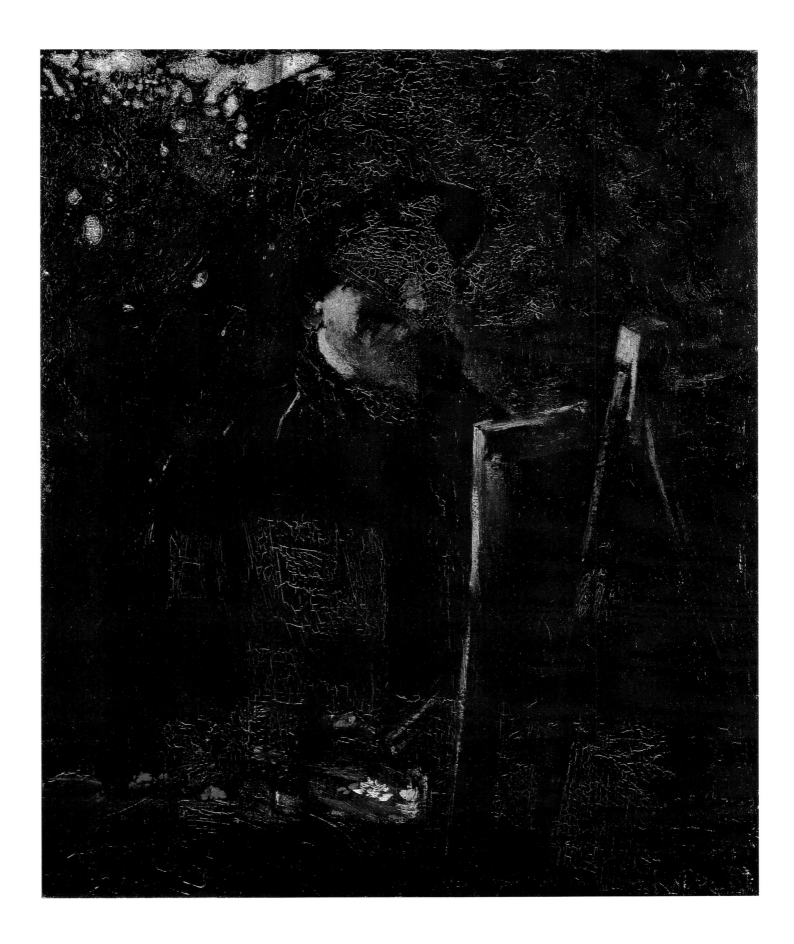

*Fortunately for me, I do not hanker after victory any more, and
all that I seek in painting is a way to make life bearable.*

Vincent to Théo, Arles,
August 1888, Letter 529

3. *Self-Portrait*,
Paris, early 1886, oil on canvas, 41 × 32.5 cm,
Amsterdam, Rijksmuseum Vincent van Gogh.

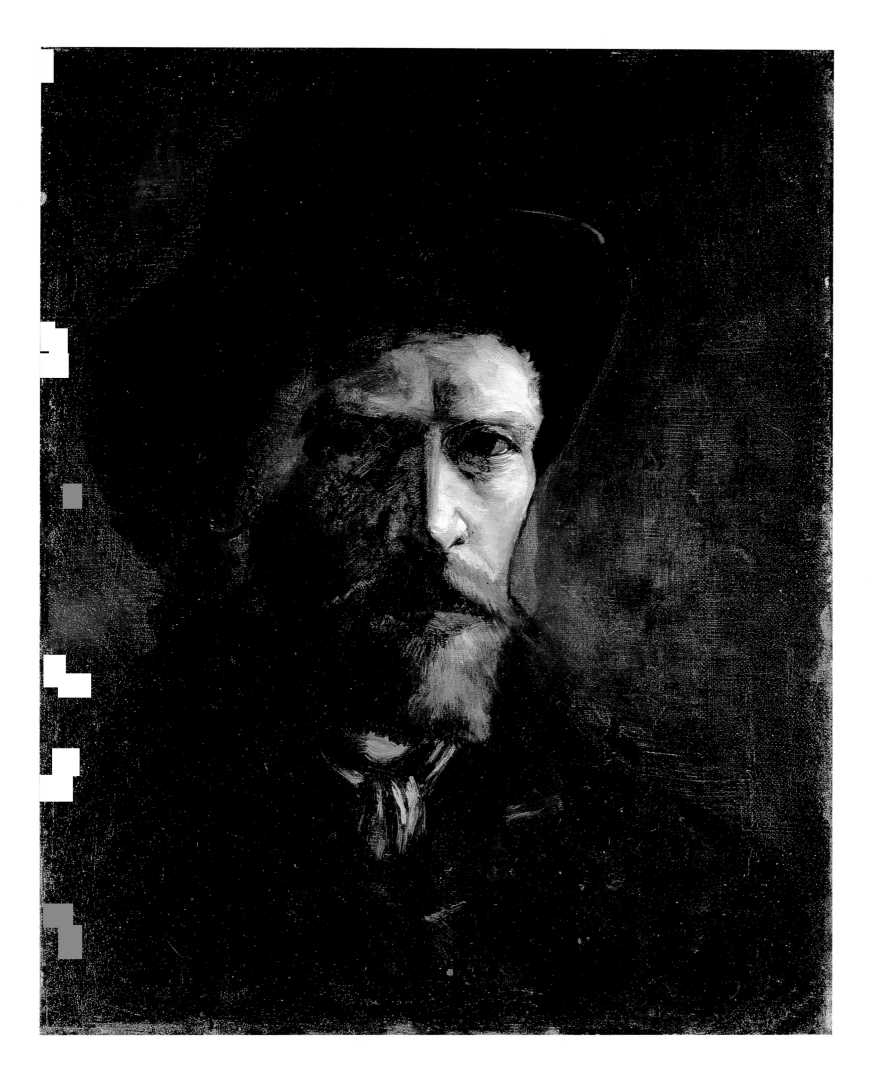

And my own future is a cup that will not pass from me
unless I drink it. So Fiat voluntas.

Vincent to Théo, The Hague,
July–August 1883, Letter 313

4. *Self-Portrait*,
Paris, 1886–early 1887, oil on canvas, signed and dated in the upper left, 61 × 50 cm,
Amsterdam, Rijksmuseum Vincent van Gogh.

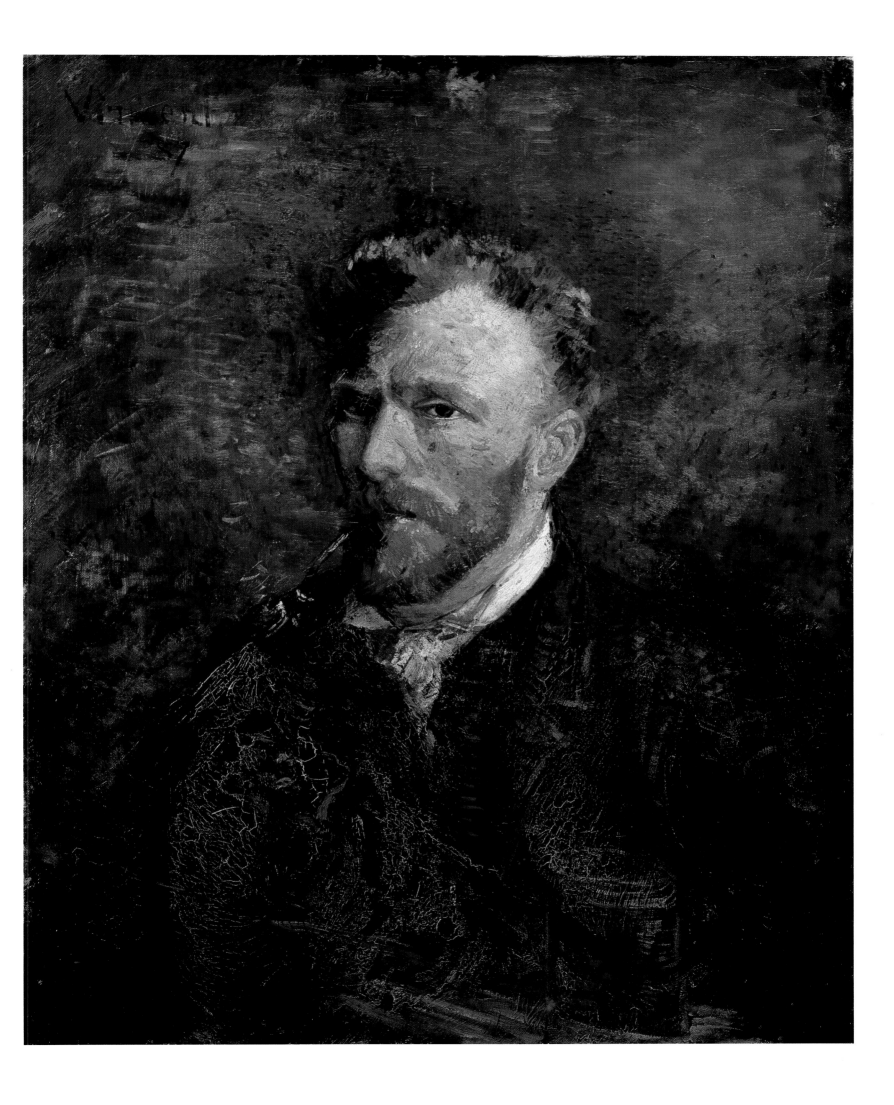

The battle is but short, and sincerity is worthwhile.
If many are sincere and firm, the whole period
becomes good—at least, energetic.

Vincent to Théo, The Hague,
February 1883, Letter 266

5. *Self-Portrait,*
Paris, early 1886, oil on canvas, 27 × 19 cm,
Amsterdam, Rijksmuseum Vincent van Gogh.

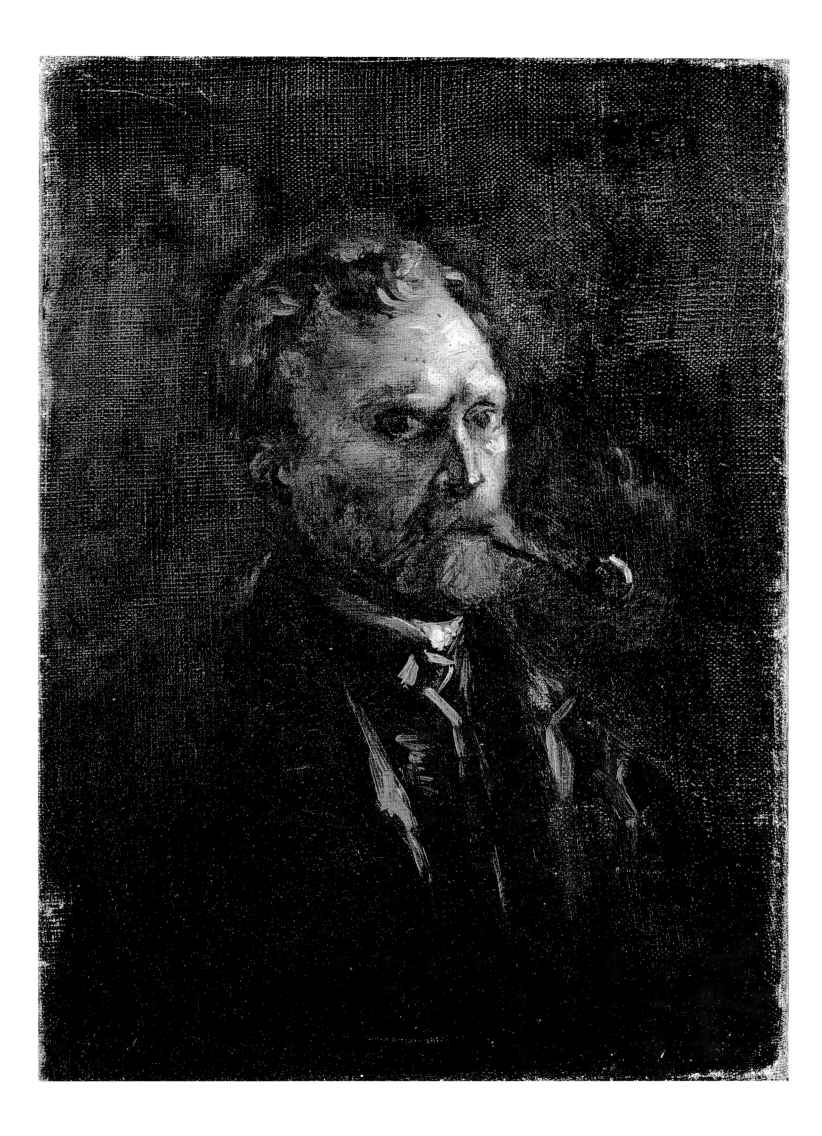

I am a man of thirty with wrinkles on my forehead
and lines on my face as though I were forty,
and my hands are deeply furrowed.

Vincent to Théo, The Hague,
1 June 1882, Letter 204

6. *Self-Portrait*,
Paris, early 1886, oil on canvas, signed in the upper left, 46 × 38 cm,
Amsterdam, Rijksmuseum Vincent van Gogh.

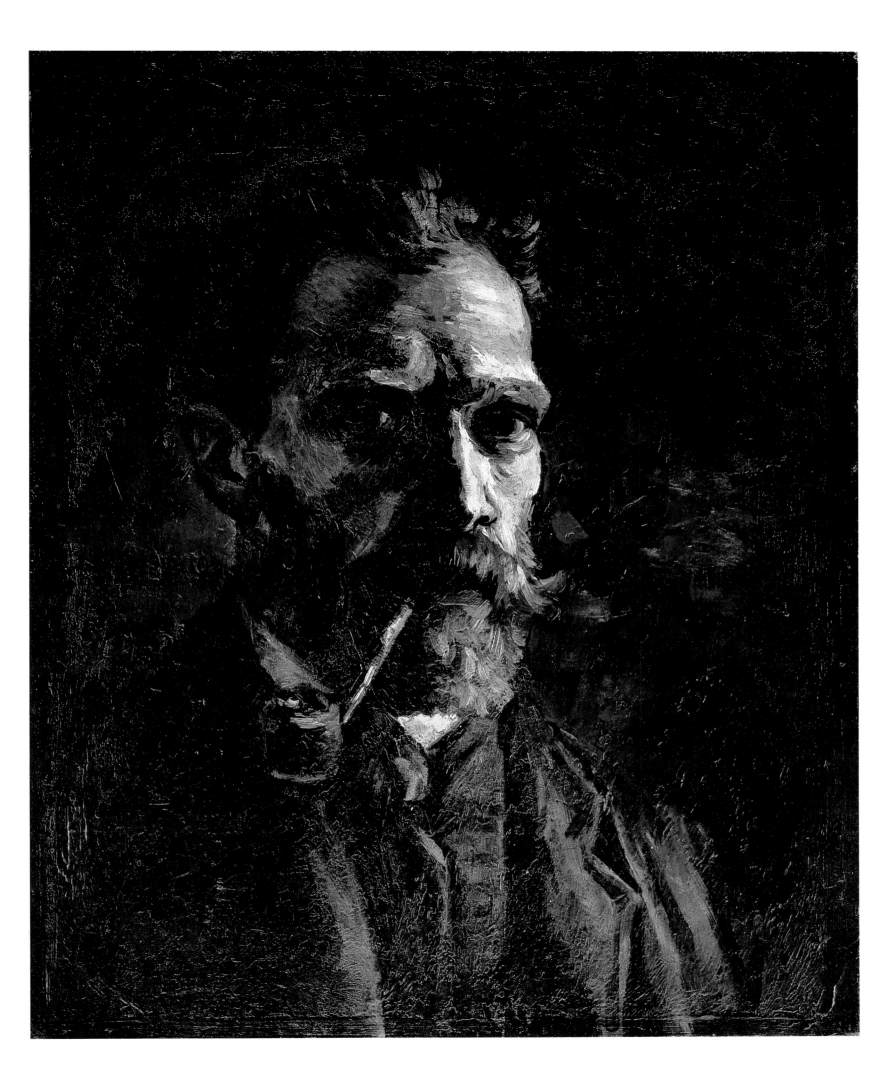

Demands

Don't regret that your life is rather easy; mine is too. I think that life is pretty long and that the time will come soon enough when "another shall gird thee, and carry thee whither thou wouldst not." [23 D, 6 March 1875]

On 6 March 1875, van Gogh, at the age of twenty-two, wrote that admonition to Théo. Eleven years later, in exile, he would exist only as a painter. Was he led "whither he wouldest not"? The painter was vested with a mission, and painting itself became a kind of asceticism. The eleven years of mysticism, failure, blundering, and miscalculation had only increased the vigor with which he practiced his vocation once he finally existed exclusively as a painter.

In May of 1875 he transcribed the following passage from Renan: "To act well in this world one must sacrifice all personal desires. The people who become the missionaries of a religious thought have no other fatherland than this thought. Man is not on this earth merely to be happy, nor even to be simply honest. He is there to realize great things for humanity, to attain nobility and to surmount the vulgarity of nearly every individual." [26 D, 8 May 1875]

For a long time I was surprised that van Gogh had painted no portraits of himself while still a young man. Even when isolated and unable to afford a model, he had not been willing to paint himself. No sketches, no drawings, no rough drafts—nothing with his own face as the subject. Why had he denied himself his most docile, available, and affordable model? He needed but a mirror. Rembrandt at twenty had engraved the image of his own face at every opportunity. Whether with distressed, haggard, merry, or stern expression, Rembrandt's face served as trusted early model. Van Gogh's early attempts to paint himself, by comparison, were wholly absent. At the age of twenty, Rembrandt knew how to be entirely a painter. Painting was already his only embodiment. It went otherwise for van Gogh at that age. He had to deaden the parts of himself that were not devoted exclusively to painting before he would be able to paint himself. Dead to himself, he then existed only in paint. The transformation lasted eleven years. Eleven years of awesome lucidity.

From 31 December 1876: "That is God's will that we should part with what is dearest on earth—we ourselves change in many respects, we are not what we once were, we shall not remain what we are now." [83 D, 31 December 1876]

And 3 April 1878: "One must never feel secure when one is without difficulties or some care or trouble, and one must not take things too easy. Even in the most refined circles and the best surroundings and circumstances, one must keep something of the original character of a

Robinson Crusoe or anchorite, for otherwise one has no root in oneself, and one must never let the fire in one's soul die, but keep it burning." [121 D, 3 April 1878]

Van Gogh, with his interest in mysticism, tended always toward the light. "You do not know how I am drawn to the Bible; I read it daily, but I should like to know it by heart and to view life in the light of that phrase, 'Thy word is a light unto my path and a lamp unto my feet' [Psalm 119:105; 98 D, 16 March 1877] The light he seeks in his reading and rereading of the Bible is the light his canvases will raise. It is indeed to light that van Gogh has irrevocably bound and consecrated himself. The light he seeks, through prayer, meditation, and preaching, is the same as that which *emanates* from his canvases. (And it is the same light as that which Rembrandt saw in his daily Bible reading and which he envisioned for his paintings and his engravings as a light that gushes forth.) Van Gogh's ambition was the same, and the consequences of making such demands upon oneself were also the same. On 3 April 1878, he wrote: "For who are those that show some sign of higher life? They are the ones who merit the words *'Laboureurs, votre vie est triste, laboureurs, vous souffrez dans la vie, laboureurs, vous êtes bien-heureux'* [Laborers, your life is dreary, laborers, you suffer during life, laborers, you are blessed']; they are the ones who bear the signs of *'toute une vie de lutte et de travail soutenu sans fléchir jamais'* ['a whole life of struggle and constant work without ever faltering']. It is good to try to become like this." [121 D, 3 April 1878]

Van Gogh was determined, but still the change came slowly. July 1880: "But you will ask, 'What is your definite aim?' That aim becomes more definite, will stand out slowly and surely, as the rough draft becomes a sketch, and the sketch becomes a picture—little by little, by working seriously on it, by pondering over the idea, vague at first, over the thought that was fleeting and passing, till it gets fixed." [133 F, July 1880]

December 1881: "Just think how I have been struggling along for years in a kind of false position. And now—now comes a dawn of real light." [164 D, December 1881] Once the light was found or, rather, revealed through painting, there remained nothing but for him to consecrate his whole strength to his quest. Théo was his witness: ". . . You see that I do my best to work, and that some power to draw—and I think to paint also—is in me, and will eventually show itself." [198 D, May 1882]

And eventually he learned what painting demanded of him in return. November 1882: "And then to swallow this despair and melancholy, to be patient with oneself as one is—not in order to sit down and rest, but to struggle on notwithstanding thousands of shortcom-

ings and faults and the uncertainty of conquering them—all these things are the reason why a painter is unhappy too. The struggle with oneself, the trying to improve oneself, the renewal of one's energy—all this is complicated by material difficulties." [248 D, November 1882] There would be no further question of his veering off course. "I cannot do this nearly as well as I have set myself to do it, and for that very reason I must not relax on this point. If I exact this, I demand no more of myself than many others do." [250 D, December 1882] As humble himself as were the others he spoke of, van Gogh persevered obstinately despite doubts which tormented him.

The anguish of van Gogh: "I had written you early this morning, but after I had mailed my letter, it suddenly seemed as if all my troubles crowded together to overwhelm me, and it became too much for me because I could no longer look clearly into the future. I can't put it any other way, and I can't understand why I shouldn't succeed in my work. I have put all my heart into it, and, for a moment at least, that seemed to me a mistake. But boy, you know it yourself—what things in practical life must one devote one's strength and thought and energy to? One must take a chance and say, 'I will do a certain thing and carry it through.' Well, then it may turn out wrong, and one may hit an impenetrable barrier when people do not care for it; but one needn't care after all, need one? I don't think one has to worry over it; but sometimes it becomes too hard, and one feels miserable against one's will. [302 D, July 1883]

During that summer of 1883, van Gogh judged that which he had accomplished against that which remained to be done, with pitiless clarity and humility but without fear or anger: "So I go on like an ignoramus who knows only this one thing: '*In a few years I must finish a certain work*.' I need not rush myself too much—there is no good in that, but I must work on in complete calmness and serenity, as regularly and fixedly as possible, as concisely and pointedly as possible. The world concerns me only insofar as I feel a certain indebtedness and duty toward it because I have walked this earth for thirty years and, out of gratitude, want to leave some souvenir in the shape of drawings or pictures—not made to please a certain taste in art, but to express a sincere human feeling. So this work is my aim, and when one concentrates on that one idea, everything one does is simplified in that it is not chaotic, but all done with one object in mind. Now my work is going slowly—that much more reason not to lose time." [309 D, July 1883] Van Gogh goes on to discuss Guillaume Régamey, an obscure painter who died at the age of thirty-eight after having consecrated, van Gogh states, all the strength of his last six or seven years to his drawings, despite physical ailments. "He is one of many, a very good one among the very good. I am not mentioning him in

order to compare myself with him—I can't be put on the same level with him—but I mention him as a special example of a certain self-possession and energy clinging to one inspiring idea, of the fact that difficult circumstances showed him the way to accomplish good work in complete serenity. This is the way I regard myself—as having to accomplish something with heart and love in it within the next few years, doing this with energy. If I live longer, 'tant mieux,' but don't count on it. *Something must be done* in those few years—this thought dominates all my plans for my work."

And again in the same letter he writes: ". . . My body will keep a certain number of years, between six and ten, for instance. . . . This is the period I can firmly count on; for the rest, it would be speculating too much at random to dare say something definite about myself; my future work will depend on these next ten years; but will there still be something more for me to do, yes or no?"

All has been said. At the time of writing the above words van Gogh was thirty. All his cards are on the table.

"When I do better work later on, I certainly shall not work *differently* than now. I mean it will be the same apple, only riper; I shall not change my mind about what I have thought from the beginning. And that's the reason why I say for my part, If I am no good now, I won't be any good later on either; but if later on, then now, too. For corn is corn, though city people may take it for grass at first, and also vice versa." [393 D, January 1885]

Van Gogh's last canvases. The corn in the plain at Auvers. Their torrid light. And still I wonder at the question he asked in July, 1883: "But will there still be something more for me to do, yes or no?"On 27 July 1890, Van Gogh put a bullet in his chest. Everything was done.

The Profession of Painter

Painting is a profession in which one can earn a living just as well as a blacksmith or a physician. At all events an artist is the exact opposite of a man of independent means. [184 D, March 1882]

That assertion was dated March 1882. Van Gogh had not yet turned thirty and had been painting for only a few months. He was content to wait for mastery to come. The next sale of his canvases would signify first and foremost the recognition of such mastery. What remained was for him to paint and then paint some more.

"Practice makes perfect: One becomes a painter by painting. If one wants to become a painter, if one delights in it, if one feels what you feel, one can do it; but it is accompanied by troubles, cares, disappointments, times of melancholy, of helplessness and all that, that's what I think of it." [333 D, October 1883]

In April 1884, van Gogh learned the cost of being a painter. He learned once and for all what painting was. What painting was, and what it would remain, exclusively and implacably, was the imposition of a duty. "However hateful painting may be, and however cumbersome in the times we are living in, if anyone who has chosen this handicraft pursues it zealously, he is a man of duty, sound and faithful. Society makes our existence wretchedly difficult at times, hence our impotence and the imperfection of our work." [B21 F, December 1889]

Despite all, despite both the world and painting itself, van Gogh persevered. Once he was a painter, he could be nothing else—and whatever permitted him to paint was good. Including the asylum. On 21 April 1889, he wrote: "At the end of the month I should like to go to the hospital in Saint Rémy, or another institution of this kind. . . . I should be afraid of losing the power to work, which is coming back to me now, by forcing myself and by having all the other responsibilities of a studio on my shoulders besides. And temporarily I wish to remain shut up as much for my own peace of mind as for other people's." [585 F, 21 April 1889]

Several days later, he elaborated: ". . . It is really for the best if I go into an asylum immediately. Things may come out right perhaps in the long run. Anyway, my very poor excuse is that painting narrows your ideas about other things; perhaps you cannot be doing your work and think of other things at the same time. It's hard enough, come to think of it, for the job is pretty thankless and its usefulness is certainly questionable." [586 F, April 1889]

On 9 June 1889, he explained yet more clearly: "Besides, I should not have the courage to begin again outside. I went once, still accompanied, to the village; the mere sight of people and things had such an effect on me that I thought I was going to faint and I felt very ill. Face to face with nature, it is the feeling for work that supports me." [594 F, 9 June 1889]

Nature and work comforted him. But the feeling of resignation exhausted him. "I no longer see any possibility of having courage or hope, but after all, it wasn't just yesterday that we found this job of ours wasn't a cheerful one." [601 F, July–September 1889] And yet even the feeling of resignation was tolerable by comparison with his fear of having sacrificed all for nothing; it was remorse that brought him madness and then killed him.

June 1888: "And the days when I bring home a study I say to myself—'If it was like this every day, we might be able to get on'; but the days when you come back empty-handed, and eat and sleep and spend money all the same, you don't think much of yourself, and you feel like a fool and a shirker and a good-for-nothing." [498 F, June 1888]

May 1889: "But the money painting costs crushes me with a feeling of debt and worthlessness, and it would be a good thing if it were possible that this should stop." [589 F, 2 May 1889] In December 1889, he asked still: "Tell yourself, 'I will not paint any more,' but then what is one to do? Oh, we must invent a more expeditious method of painting, less expensive than oil, and yet lasting." [615 F, December 1889] Renunciation of painting? The beginning of something new?

Eight months later, in a field of Auvers-sur-Oise, van Gogh shot a bullet into his chest. Painting had taken everything, leaving him nothing but remorse—that of having been unable to repay the actual costs not being the worst. Had his work fulfilled the expectations he had of it? "I am always filled with remorse, terribly so, when I think of my work that is so little in harmony with what I should have liked to do." [593 F, May–June 1889] Were the last self-portraits that van Gogh painted also expressions of a gnawing remorse? These portraits that did not perfectly satisfy the requirements of the kind of painting he required of himself—were they but the anatomy of his failure? Questions without answers. "I always think that poetry is more *terrible* than painting, though painting is a dirtier and a much more worrying job. And then the painter never says anything; he holds his tongue, and I like that, too." [Emphasis by van Gogh; 539 F] And from van Gogh too there came but silence. The date—March 1883—was omitted when he wrote: "Of course, my moods change, but the average is serenity. I have a firm *faith* in art, a firm confidence in its being a powerful stream that carries a man to a harbor, though he himself must do his bit too; at all events, I think it such a great blessing when a man has found his work that I cannot count myself among the unfortunate. I mean, I may be in certain relatively great difficulties, and there may be gloomy days in my life, but I shouldn't like to be counted among the unfortunate, nor would it be correct if I were." [274 D, March 1883]

But years later, van Gogh would yet rage: "Unfortunately I have a handicraft which I do not know well enough to express myself as I should like." [581 F, 24 March 1889]

CHAPTER 6

Commitment

We are alive—if we do not work "comme plusieurs nègres," we shall die of want, and we shall cut a most ridiculous figure. However, we happen to abhor this mightily—because of that same thing which I call surprising youthfulness—and in addition, a seriousness that is damned serious. (Van Gogh wrote the last two words in English.) [336 D, November 1883]

The words quoted above were written in November 1883. Van Gogh now knew. The sacrifice had begun. He did not shirk, but rather stepped forward into the fray.

August 1883: "I don't leave things undone from laziness, but rather to be able to work more, putting aside everything that does not belong directly to the work." [312 D, August 1883]

November 1885: "I don't know what I shall do and how I shall fare, but I hope not to forget the lessons that I am thus learning these days: *in one stroke*—but with absolutely complete exertion of one's whole spirit and attention." [431 D, November 1885]

In Arles, the jaws of the trap that painting comprised were closed. Van Gogh no longer decided anything. April 1888: ". . . You should not imagine that I am doing exactly what I like, and not doing what I should prefer to leave undone. Work has got me in its grip now, and I think forever." [W3 D, April 1888]

Van Gogh renounced everything, including life itself; and such renunciation was merely what was necessary. "But with my disposition, going on a spree and working are not at all compatible, and in the present circumstances one must content oneself with painting pictures. It is not really living at all, but what is one to do?" [480 F, May 1888] Several days later he adds: "One does not rebel against things, nor is one resigned to them; one's ill because of them, and one does not get better, and it's hard to be precise about the cure. I do not know who it was who called this condition 'being struck by death and immortality.'" [489 F, May 1888]

As van Gogh's life changed, so did it change the nature of his painting. At the end of June 1888, van Gogh wrote to Émile Bernard to compliment his having taken up Bible reading: ". . . the artistic neurosis. . . . For the study of Christ inevitably calls it forth, especially in my case, where it is complicated by the staining black of innumerable pipes." He describes Christ *"as a greater artist than all other artists . . .* because he made . . . *living men* immortals. This is serious, especially because it is the truth." [Emphasis by van Gogh; B8 F, June 1888] Van Gogh in Arles did not resume preaching. He never ceased prayer, and doubtless the paintings of this period are themselves first of all prayers. Moreover, speaking of the Bible, of the gospel according to Luke, and of the epistles of Paul, van Gogh was speaking of painting. He wrote:

34

"These considerations . . . make us see the art of creating life, the art of being immortal and alive at the same time. They are connected with painting." [B8 F, June 1888]

The portraits painted in Arles, the last ones, are those of a man whom painting has permitted to be *immortal and alive* because painting is an apostolate. A few weeks before his death, he wrote: "For me life might well continue being isolated. Those whom I have been most attached to—I never descried them otherwise than through a looking glass, by a dark reason. And yet there is a reason for there occasionally being more harmony in my work now. Painting is a world to itself." [641 D, 14 June 1890] And he belonged solely to that world. Beyond the mirror. To enter he had had to pass through martyrdom. (Was he thinking of van Gogh when, in 1896, Gauguin painted *Self-portrait near Golgotha*?) Did being a painter mean being sacrificed? Was the Borinage the region of Gethsemane, van Gogh's Mount of Olives, where he might have said again: "Father, if thou be willing, remove this cup from me: nevertheless not my will, but thine, be done." [Luke 22:42]

Toward the end of August 1883, van Gogh had written: "Yes, for me, the drama of storm in nature, the drama of sorrow in life, is the most impressive. A Paradou is beautiful, but Gethsemane is even more beautiful." [319 D, August 1883] Five years later, Paradou, between Arles and Saint-Rémy, between Arles where he severed his ear and Saint-Rémy where he was committed, would be his Gethsemane.

Until in the end I shall stand with a clear eye and a free neck.
When? If I persevere until the end—in the end.

Vincent to Van Rappard, Etten,
23 November 1881, Letter R6

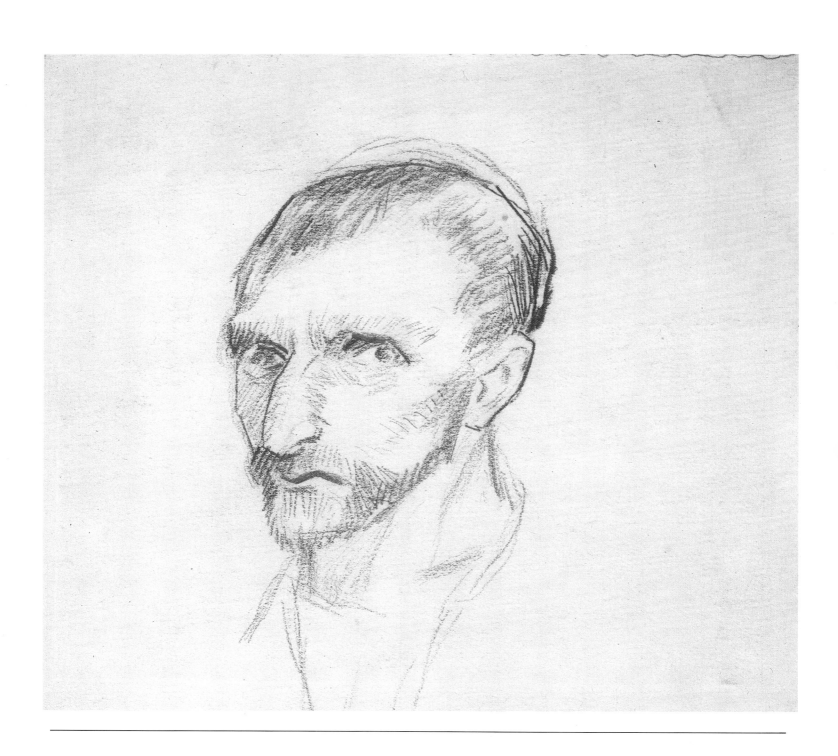

7. *Self-Portrait*,
Paris, Summer 1887?, pencil on paper, 19.3 × 21 cm,
Amsterdam, Rijksmuseum Vincent van Gogh.

8. *Self-Portrait*,
Paris, early 1886, oil on canvas, 39.5 × 29.5 cm,
The Hague, The Haags Gemeentemuseum Collection.

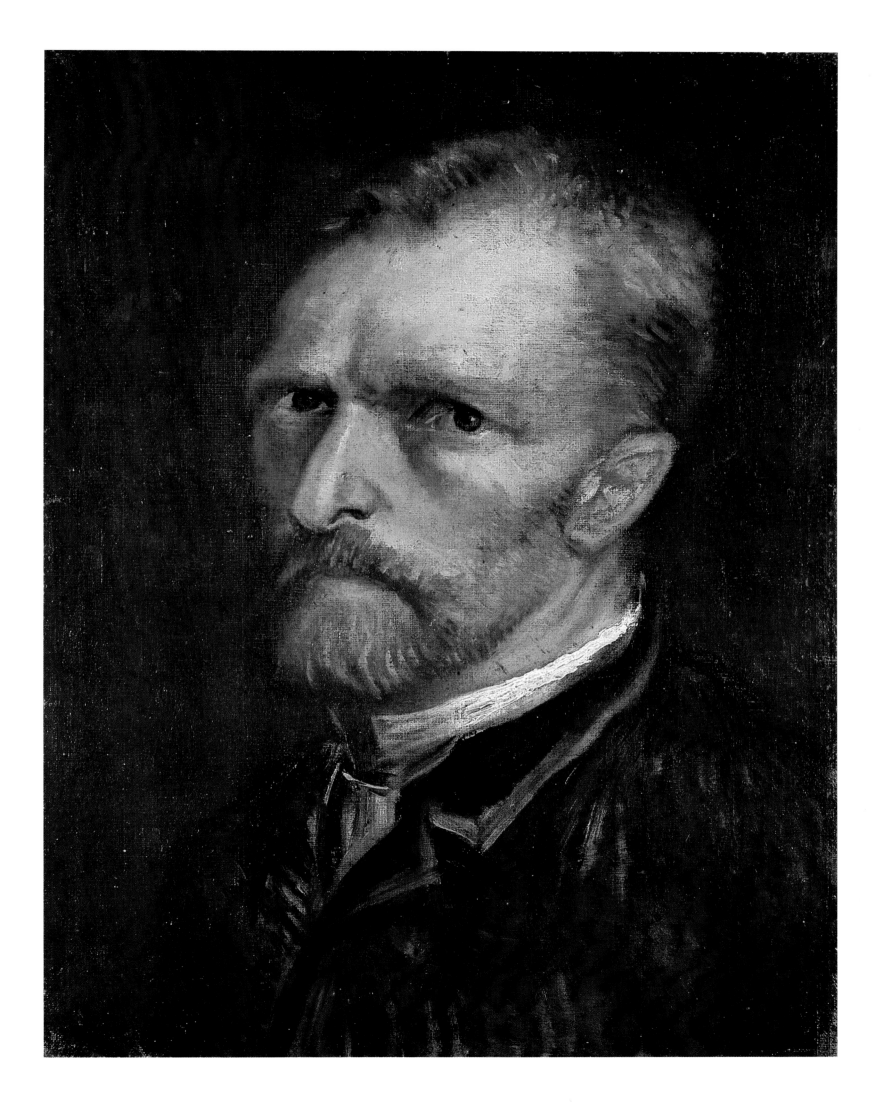

But in art, for which one needs time,
it would not be so bad to live more than one life.

Vincent to Théo, Arles,
July 1888, Letter 511

9. *Self-Portrait*,
Paris, summer 1887, oil on cardboard, 42 × 32.7 cm,
Chicago, Art Institute.

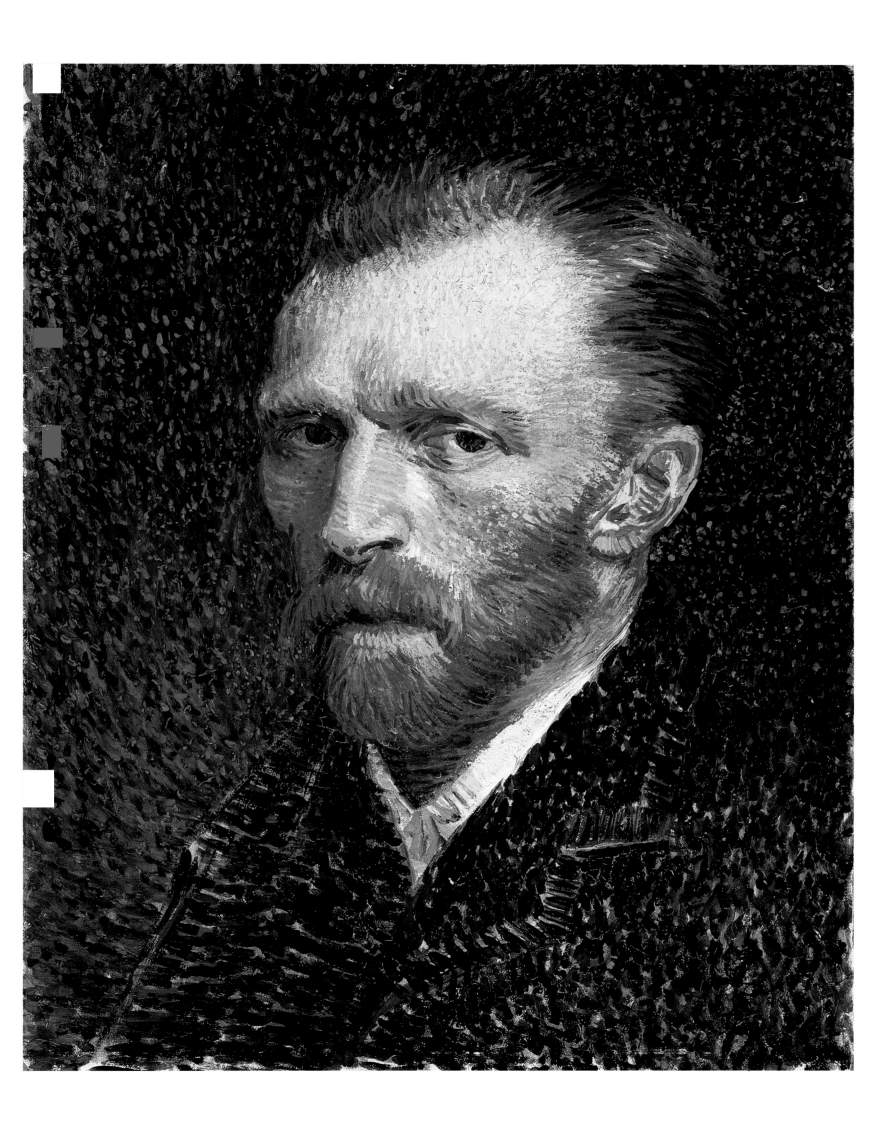

But this painter who is to come—I can't imagine him living in little cafés, working away with a lot of false teeth, and going to the Zouaves' brothels, as I do.

Vincent to Théo, Arles,
5 May 1888, Letter 482

10. *Self-Portrait,*
Paris, summer 1887, oil on cardboard, 19 × 14 cm,
Amsterdam, Rijksmuseum Vincent van Gogh.

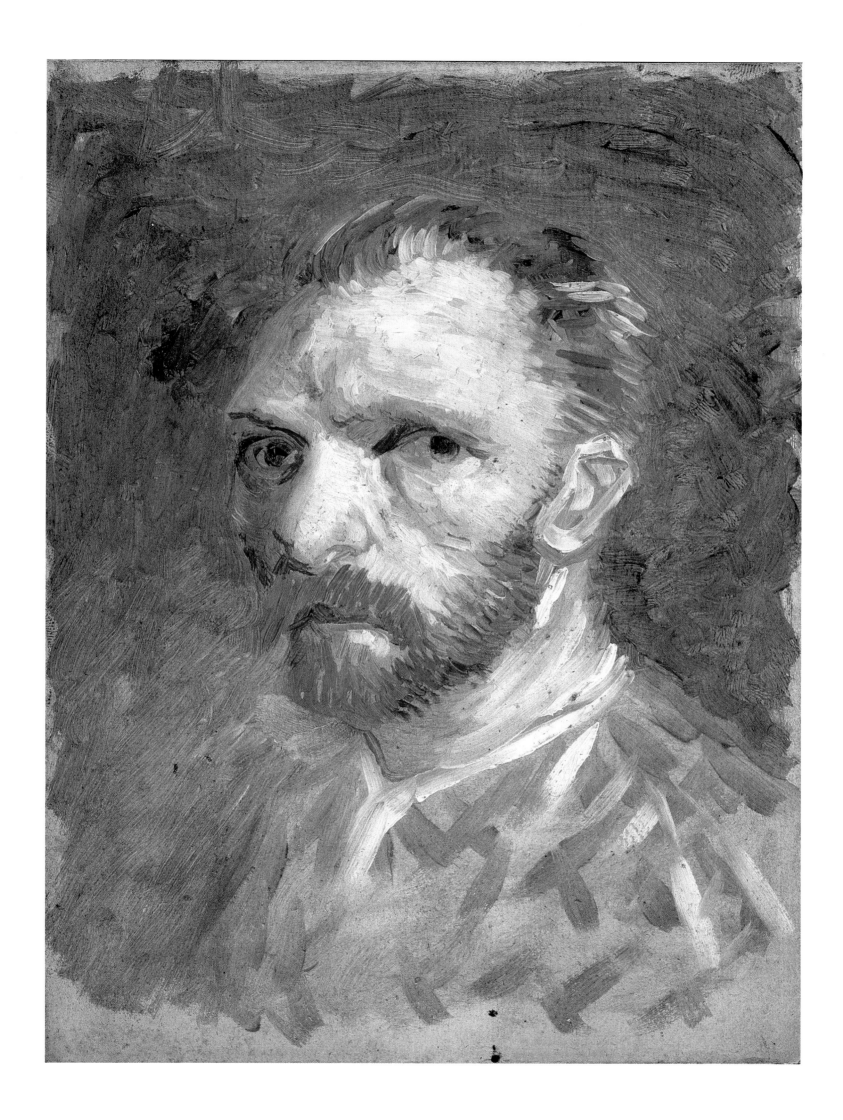

*Painting a picture is as difficult as finding
a large or a small diamond. Now, however, whereas everybody
recognizes the value of a Louis d'or or a pure pearl,
those who cherish pictures and believe in them
are unfortunately rare. But they exist nonetheless.*

Vincent to Émile Bernard, Arles,
late September 1888, Letter B18

11. *Self-Portrait*,
Paris, summer 1887, oil on canvas, 41 × 33 cm,
Amsterdam, Rijksmuseum Vincent van Gogh.

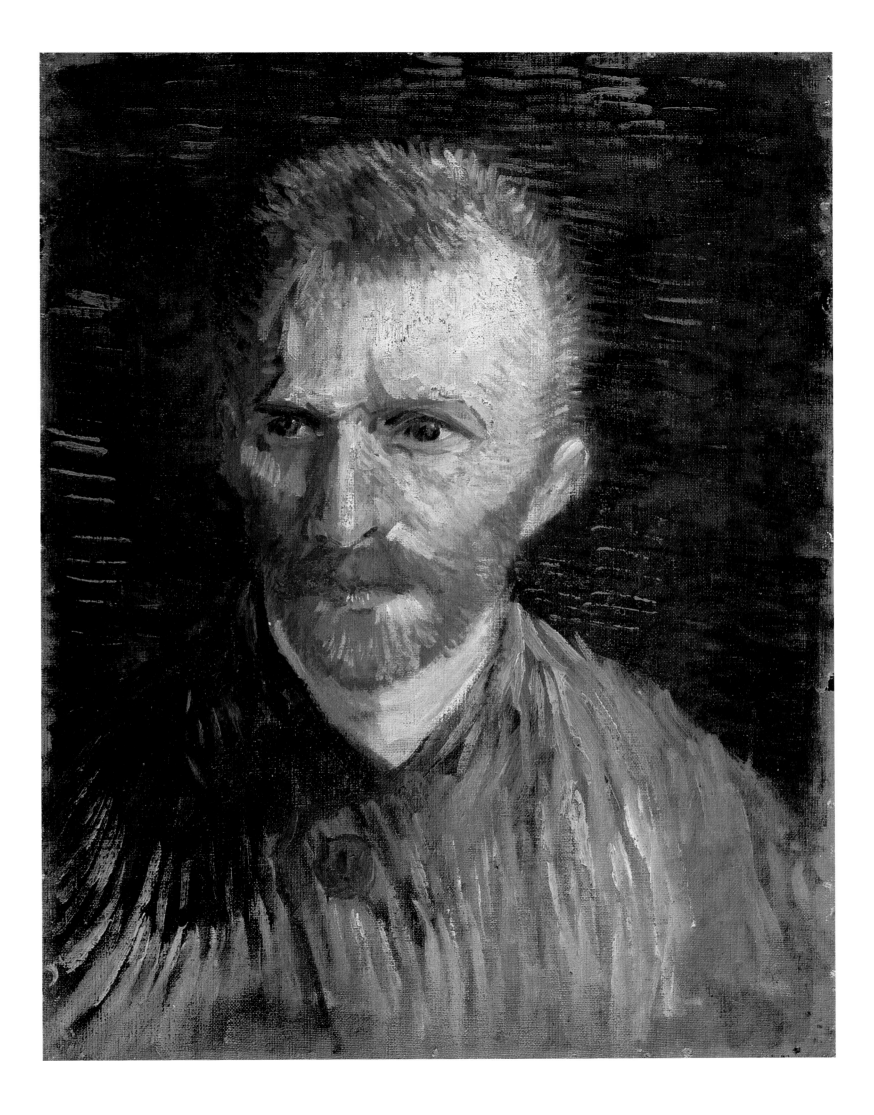

Vivre tout haut is simply one's duty—
one should not act like the Jesuits and their kind.

Vincent to Théo, Neunen,
December 1883–January 1884, Letter 348

12. *Self-Portrait,*
Paris, summer 1887, oil on canvas, 41 × 33 cm,
Amsterdam, Rijksmuseum Vincent van Gogh.

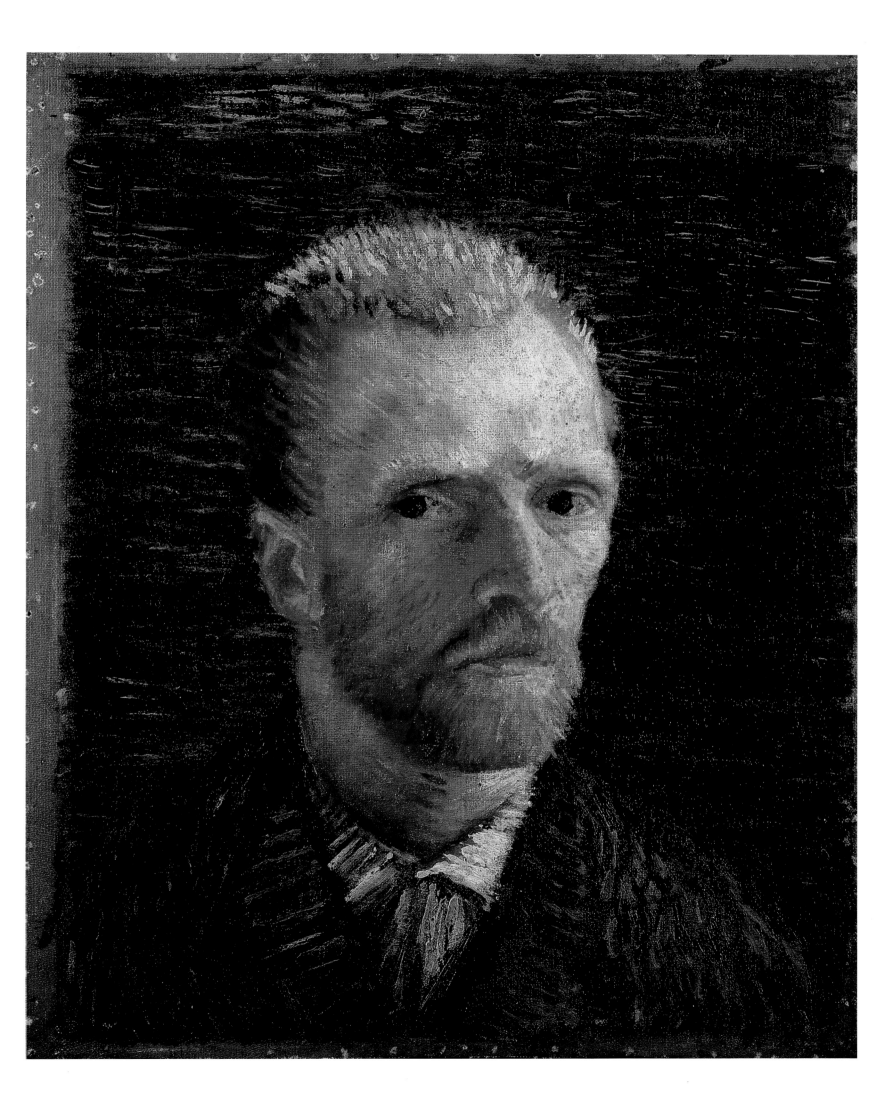

CHAPTER 7

Techniques

Let us try to master the mysteries of techniques to such an extent that people are deceived by it and will swear by all that is holy that we have no technique. [R43 D, April 1884]

Seeking to appear without technique, van Gogh ceaselessly sought, experimented with, experienced every possible technique. When in April of 1882, while drawing, he noted: "This is how I reason about the carpenter's pencil. What did the old masters use for drawing? Certainly not Faber B, BB, BBB, etc., etc., but a piece of rough graphite. Perhaps the instrument Michelangelo and Dürer used somewhat resembled a carpenter's pencil. But I was not there to see for myself, so I don't know; I only know that with a carpenter's pencil one can get effects quite different from those with thin Fabers, etc.

"I prefer the graphite in its natural form to that ground so fine in those expensive Fabers. And the shininess disappears by throwing some milk over it. When working outdoors with Conté crayon, the strong light prevents one from seeing clearly what one is doing, and one perceives that it has become too black; but graphite is more gray than black, and one can always raise it a few tones by working in it with the pen, so that the strongest graphite effect becomes light again in contrast to the ink.

"Charcoal is good, but if one works at it too long, it loses its freshness, and one must fix it immediately to preserve the delicacy of touch. . . . One can do great things with charcoal soaked in oil." [195 D, April 1882]

Any instrument will do for drawing. In February 1883, he asked Théo: "Will you do me a *very great* favor—send me a few pieces of that crayon by mail? There is a soul and life in that crayon—I think Conté pencil is dead. Two violins may look the same on the outside, but in playing them, one sometimes finds a beautiful tone in one and not in the other. Now that crayon has a great deal of tone or depth. I could almost say, 'That crayon knows what I want, it listens with intelligence and obeys'; the Conté pencil is indifferent and unwilling." [272 D, February 1883] And sometimes van Gogh gave away his secrets: "Lately I have been working with printer's ink, which is diluted with turpentine and applied with a brush. It gives very deep tones of black. Diluted with some Chinese white, it also gives good grays. By adding more or less turpentine, one can even wash it in very thinly." [278 D, April–May 1883] He tested the possibilities of each technique, and in putting them to the test put himself to the test as well: "Watercolor is not the most sympathetic means for him who particularly wants to express the boldness, the vigor, and the robustness of the figures. It is different when one seeks tone or color exclusively; then watercolor

is excellent. Now I must admit that one could make different studies of those same figures done from another point of view (namely, tone and color) and with another intention—but the question is, if my temperament and personal feeling primarily draw me toward the character, the structure, the action of the figures, can one blame me if, following this emotion, I don't express myself in watercolor, but in a drawing with only black or brown?" [297 D, May–June 1883] Technique always remained the means by which to reach new mysteries: "The reason I enjoy painting so much is not its agreeable aspect, but its throwing light on various questions of tone and form and material. I used to be helpless before them, but now by means of painting I can attempt them." [227 D, August–September 1882]

Van Gogh's reflections concerning technique were hardly formulaic, however. They comprised the means by which, through the years, he defined his will. Technique was the law of creation: ". . . Is it the purpose, the ne plus ultra, of art to produce those peculiar spots of color—that capriciousness of drawing—that are called the distinction of technique? Most certainly not. . . . So it is *necessary* to work at the technique, as it is one's duty to express better, more accurately, more earnestly what one feels—and the less verbosity, the better. As for the rest—one need not bother about that." [R43 D, April 1884] On the eve of his arrival in Paris, he announced: "Drawing in itself, the technique of it, comes easily enough to me. I am beginning to do it like writing, with the same ease. But at that very point it gets more interesting if one is not satisfied with the skill gradually acquired, but aims seriously and thoroughly at originality and broadness of conception—the drawing of the mass instead of the outlines, the solid modeling." [449 D, February 1886] Whatever the particular technique, it must serve to express the intensity of silence and of inner strength.

And he returned as well to ancient techniques. In Arles he had constructed a perspective frame: "I attach some importance to the use of the frame because it seems not unlikely to me that in the near future many artists will make use of it, just as the old German and Italian painters certainly did and, as I am inclined to think, the Flemish, too. The modern use of it may differ from the ancient practice, but in the same way isn't it true that in the process of painting in oils one gets very different effects today from those of the men who invented the process, Jan and Hubert van Eyck? And the moral of this is that it's my constant hope that I am not working for myself alone. I believe in the absolute necessity of a new art of color, of design, and—of the artistic life. And if we work in that faith, it seems to me there is a chance that we do not hope in vain." [469 F, March 1888] Van Gogh's aim was to pave the way toward the future—whether it be his own or not. And when he spoke of working "in that faith," it was much more

than a casual turn of phrase: The road he paved *was* a faith. As such, it was also an existing tradition from which to draw examples: "I am more convinced than ever that the true painters did not finish their things in the way that is used only too often, namely, correct when one scrutinizes it closely." [431 D, November 1885] On 10 September 1889, he wrote to Théo: "What a queer thing the *touch* is, the stroke of the brush. In the open air, exposed to the wind, to the sun, to the curiosity of people, you work as you can, you fill your canvas anyhow. Then, however, you catch the real and essential—that is the most difficult. But when after a time you again take up this study and arrange your brush strokes in the direction of the objects—certainly it is more harmonious and pleasant to look at, and you add whatever you have of serenity and cheerfulness." [605 F, 10 September 1889] Technique and the concern over technique that obsessed him had but one goal, and that was to forge a style: ". . . [Although] the search for style often harms other qualities, the fact is that I feel strongly inclined to seek style . . . but by that I mean a more virile, deliberate drawing." [613 F, September–November 1889] Such drawing, such style, as to permit him to define his art. "When the thing represented is, in point of character, absolutely in agreement and one with the manner of representing it, isn't it just that which gives a work of art its quality? That is why, as far as painting goes, a household loaf is especially good when it is painted by Chardin." [594 F, 9 June 1889] It was of this loaf that Van Gogh ate, a gesture whose mystery must be understood as that of another eucharist.

Challenges

I want you to understand clearly my conception of art. One must work long and hard to grasp the essence. What I want and aim at is confoundedly difficult, and yet I do not think I aim too high. . . . In either figure or landscape I should wish to express, not sentimental melancholy, but serious sorrow. In short, I want to progress so far that people will say of my work, 'He feels deeply, he feels tenderly'—not withstanding my so-called roughness, perhaps even because of it. [218 D, July 1882]

It was July 1882 when van Gogh wrote the above. And for the next eight years he would paint only that serious sorrow, despite himself, just as it was because he was who he was. There are no paintings by van Gogh that are other than self-portraits, and there are no self-portraits that are not also paintings of something else. Painting itself served always as a metamorphosis. The subject or intention was but circumstantial and contingent. The painting itself was an abstraction, a myth. "There is something infinite in painting—I cannot explain it to you so well—but it is so delightful just for expressing one's feelings. There are hidden harmonies or contrasts in colors that involuntarily combine to work together and could not possibly be used in another way." [226 D, August–September 1882] By "feelings" he does not mean moods, but rather flights of the soul, flights of extreme intensity and synthesis. To paint required just such states of communion, because to paint required transfiguration. It was precisely that painting which transmutes, or fails, that van Gogh set out to accomplish.

Writing on 8 February 1883, he described the onslaught of going beyond oneself, the savaging, the successive doubts, the despair, and the impatience: "This can't be helped, and it is period which one must go through. . . . In the studies, too, one is conscious of a nervousness and a certain dryness that is the very opposite of the calm, broad touch one is striving for, and yet it doesn't work well if one tries too hard to acquire that broadness of touch. This gives one a feeling of nervous unrest and agitation, and one feels an oppression, as on summer days before a thunderstorm." [265 D, 8 February 1883] Van Gogh's first years of painting had perhaps just that quality of suffocation, while the harvest years he strove for eluded him. "I *must* work and work hard, *I must forget myself in my work*; otherwise, it will crush me. [329 D, September–October 1883] Van Gogh never stopped working.

What sort of self-forgetfulness is embodied in his self-portraits? Whether model or painter, he remained but the servant, the tool of painting and never more than that. The canvases were not portraits of who he was. He founded himself in painting; painting confused and confounded him. (Like the word itself, *confound*, his portraits were paradoxical, serving to fuse and unite as well as to reveal and unmask.)

"More and more it seems to me that the pictures that must be made so that painting should be wholly itself, and should raise itself to a height equivalent to the serene summits the Greek sculptors, the German musicians, the writers of French novels reached, are beyond the power of an isolated individual; so they will probably be created by groups of men combining to execute an idea held in common." [B6 F, June 1888] He did not, however, name any names as being among those that might be included in such a group. The works would be seen, not as belonging to an individual signature, but as being essentially collective and anonymous. To paint with that ambition, with that desire, was to enter a life current that could evoke Time, Death, and Destiny. "And what do we care whether there is a resurrection or not, as long as we see a living man arise immediately in the place of the dead man? Let us take up the same cause again, continuing the same work, living the same life, dying the same death." [W8 F, September-October 1888]

"The work is an absolute necessity for me. I can't put it off; I don't care for anything but the work—that is to say, the pleasure in something else ceases at once and I become melancholy when I can't go on with my work." [288 D, May 1883] Year after year, before he was struck down by his first crisis as well as after he was committed, van Gogh said it over and over again: Painting was his salvation. Such were the conditions and the circumstances that broke him; painting itself remained the source of his strength. July 1883: "When I am at work, I have an unlimited faith in art and the conviction that I shall succeed; but in days of physical prostration or when there are financial obstacles, I feel that faith diminishing, and a doubt overwhelms me, which I try to conquer by setting to work again at once." [306 D, July 1883] During the same month he stated once more: "For the rest, it is miserable enough that I still feel very faint when I am not right at my work." [309 D, July–August 1883] And four years later he affirms: ". . . For me, for instance, it is a relief to paint a picture, and without it I should be more miserable than I am." [W1 D, summer or fall 1887]

No crisis would ever overcome that conviction, that faith. On the contrary. Three weeks after leaving the hospital in Arles, hardly more than a month after having cut off his earlobe and after having been seized by a violent access of dementia, he wrote: "Perhaps someday everyone will have neurosis, Saint Vitus' dance, or something else. But doesn't the antidote exist? In Delacroix, in Berlioz and Wagner? And really, as for the artist's madness of all the rest of us, I do not say that I especially am not infected through and through, but I say and will maintain that our antidotes and consolations may, with a little goodwill, be considered ample compensation." [574 F, 28 January 1889] To paint was to master insanity. March, 1889: "As far as I can judge, I

am not properly speaking a madman. You will see that the canvases I have done in the intervals are steady and not inferior to the others. I *miss* the work more than it tires me." [Emphasis by van Gogh; 580 F March 1889]

In August 1889, committed in an insane asylum at Saint-Paul-de-Mausole in Saint-Rémy, he wrote: "Besides, it is to be hoped that if sooner or later I get a certain amount better, it will be because I have recovered through working, for it is a thing that strengthens the will and consequently leaves these mental weaknesses less hold." [602 F, August 1889] And in September: "I am working like one actually possessed, more than ever I am in a dumb fury of work. And I think that this will help cure me." [604 F, September 1889] Elaborating further in the same letter: "I am struggling with all my energy to master my work, thinking that if I succeed, that will be the best lightning conductor for my illness. . . . for my work is progressing, and we have need of that, for it is more than necessary that I should do better than before, for that was not enough." [604 F, September 1889] January 1890: "My work at least lets me retain a little of my clarity of mind and makes possible my getting rid of this someday." [622 F, January 1890] Van Gogh's painting is not that of one insane. Inversely, it is that of a man trying determinedly to keep track of that which haunts him, the "inner, looming hopelessness" that so drained him. There exists no self-portrait of van Gogh insane. The two self-portraits he painted showing the bandaged ear are free of any trace of morbid complacency; they are possessed of his strength, his will, and his hope. To paint after that crisis, and most especially to paint himself, was to affirm his self-control and his sanity. The very thing his letters, their sentences broken, irregular, and out of breath, began to lack. "I am even inclined to think that the portrait will tell you how I am better than by letter, and that it will reassure you." [604 F, September 1889] All van Gogh's self-portraits are those of van Gogh saved.

CHAPTER 9

Theo

If I did not have Théo, it would not be possible for me to get what I have a right to. [W1 D, summer or fall 1887]

Van Gogh addressed those words to their sister Wilhelmina from Paris. "If I did not have Théo . . ." But who was Théo? And who was Vincent? Vincent, born at Groot-Zundert on 30 March 1853. Théodorus, born at Groot-Zundert on 1 May 1857. Vincent, artist. Théo, art dealer. Parallel biographies would be futile. Either one without the other would have ceased to exist. Vincent *was* Théo; Théo *was* Vincent. For thirteen years Vincent's letters affirmed their single identity. He wrote more than 650 of them to his brother. "My thoughts are always with you; no wonder that I write rather often." [333 D, October 1883]

January 1877: "When we meet again, we shall be as good friends as ever; sometimes I feel so delighted that we are again living on the same soil and speaking the same language." [85 D, January 1877] January 1882: "We are brothers, aren't we, and friends." [268a D, January 1882] July 1883: "In fact, I have no real friend but you, and when I am in low spirits, I always think of you." [302 D, July 1883] August 1883: "There is a bond between you and me that continuous work can only strengthen in the course of time. . . . And let's not forget that we have known each other from childhood and that thousands of other things can bring us more and more together." [312 D, August 1883] November 1883: "You and I are brothers, and what is more, friends, and if *misfortune* should happen to tighten these ties and knit us closer together, I should see so many favorable sides to this that the whole thing would appear to me anything but a misfortune." [339b D, November 1883]

For Vincent, alone, abandoned, scorned, Théo was his only refuge. October 1883: "I would like to help them still, and I cannot. I am at a point where I need some credit, some confidence and warmth, and look here, I find no confidence. You are an exception." [328 D, October 1883] December 1883: "But know this, brother, that I am absolutely cut off from the outer world—except from you." [343 D, December 1883] At the end of the same month he revealed this scruple: "But boy, it is so difficult for me, it becomes so much a matter of conscience that I should be too great a burden to you, that I should perhaps abuse your friendship when I accept money for an enterprise that perhaps will not pay." [344 D, December 1883] What would van Gogh have become without his brother's money? Nothing. Reading this letter of December, Théo must have been reminded of one written some months earlier, in May: "And with regard to my finances, know it well that whatever you can spare is as absolutely necessary to me as the air I breathe and that my productivity depends on it." [290 D, May 1883]

Van Gogh was still refering to *his* output. The use of the singular possessive form would not continue long. April 1885: "I repeat, let us paint as much as we can and be productive *and, with all our faults and qualities, be ourselves*; I say *us*, because the money from you, which I know costs you trouble enough to get for me, gives you the right, if there is some good in my work, to consider half of it your own creation." [399 D, April 1885] February 1886: "And I wish that we too might walk together somewhere at the end of our lives and, looking back, might say, 'firstly, we have done *this*, and secondly *that*, and thirdly *that*.' [450 D, February 1886] September 1888: At present I do not think my pictures worthy of the advantages I have received from you. But once they are worthy, I swear that you will have created them as much as I and that we are making them together." [538 F, September 1888] October 1888: "But have I set my heart on my work being a success? A thousand times *no*. I wish I could manage to make you really understand that when you give money to artists, you are yourself doing an artist's work, and that I only want my pictures to be of such a quality that you will not be too dissatisfied with *your* work." [Emphasis by van Gogh; 550 F, October 1888] Vincent . . . Théo . . . "For me the conclusion is that there is more resemblance than difference between you and me." [338 D, October–November 1883]

Remarkable fact: A few days before coming to join Théo in Paris in February 1886, van Gogh wrote: "It would not surprise me if, once having got used to the idea of living together, you will think it stranger and stranger that for fully ten years we have been so little together. Well, I certainly hope that this will be the end of it and that it will not begin again." [450 D, February 1886] For two years van Gogh shared the life of his brother, two years during which he painted himself over and over, facing the mirror, and never did he paint a portrait of Théo, never did he even draw him, unless by a rapid sketch. Théo is absent from van Gogh's work.

Van Gogh painted himself. Van Gogh wrote to Théo, who acted as another mirror. "We must one day stand face to face and look one another eye to eye," Vincent wrote to his brother in January 1877. [85 D, January 1877] Nine years later, when van Gogh joined Théo in Paris, it was not Théo but himself, in a different mirror, that he saw eye to eye. ". . . Your help was a kind of fence or shield between a hostile world and myself." [341 D, November 1883] Théo, with his money, with his concern ("Even if you don't have the money, boy, do write, for I need your sympathy, which is worth no less to me than the money" [246 D, November 1882]), with his constancy, never ceased being a bulwark and a buoy. He role was not that of a model.

There is no better or shorter way of improving your work than doing figures. And I always feel confident when I am doing portraits, knowing that this work has much more depth—it isn't the right word, perhaps, but it is what makes me cultivate whatever is best and deepest in me.

Vincent to Théo, Arles,
August 1888, Letter 517 in French

13. *Self-Portrait*,
Paris, summer 1887, oil on backed canvas, 43.5 × 31.5 cm,
Amsterdam, Rijksumuseum Vincent van Gogh.

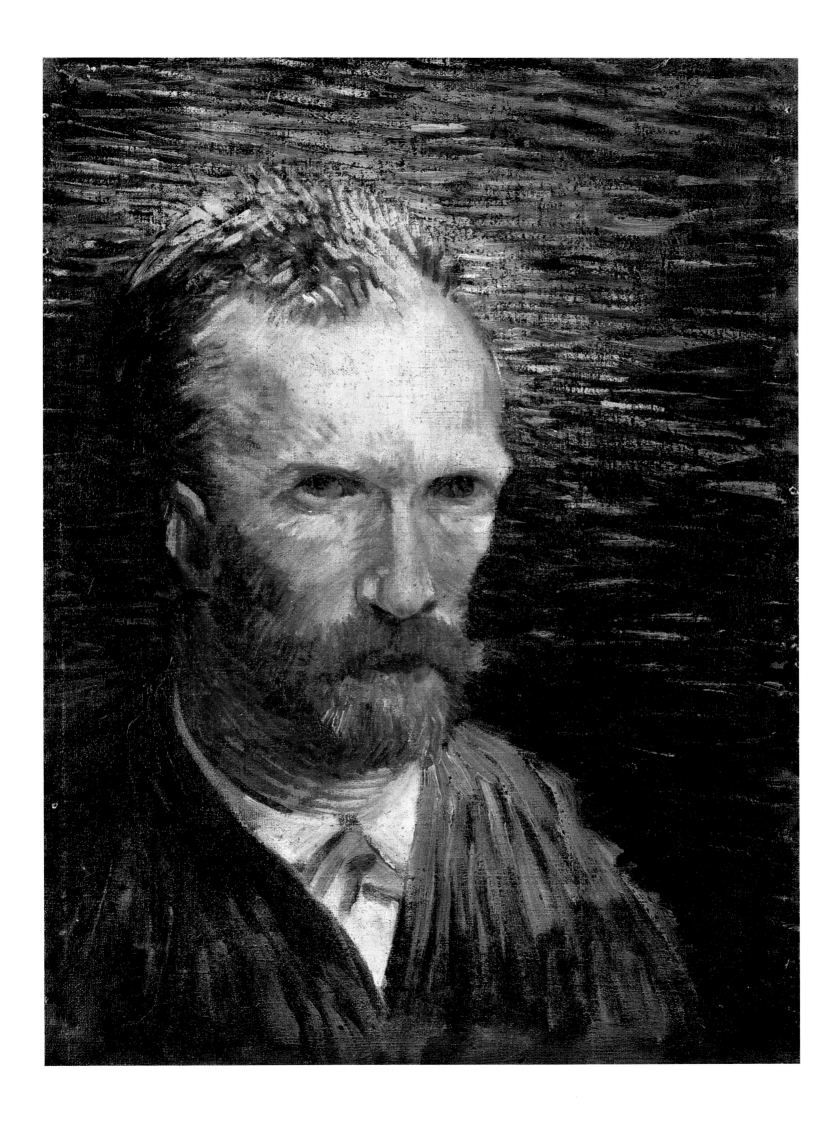

*That impression I can't help getting of myself
when comparing myself to others, namely that I look as if
I had been in prison for ten years, is not exaggerated.*

Vincent to Théo, Anvers,
February 1886, Letter 448 in Dutch

14. *Self-Portrait,*
Paris, summer 1887, oil on canvas 41 × 33.5 cm,
Hartford, Connecticut, Wadsworth Atheneum.

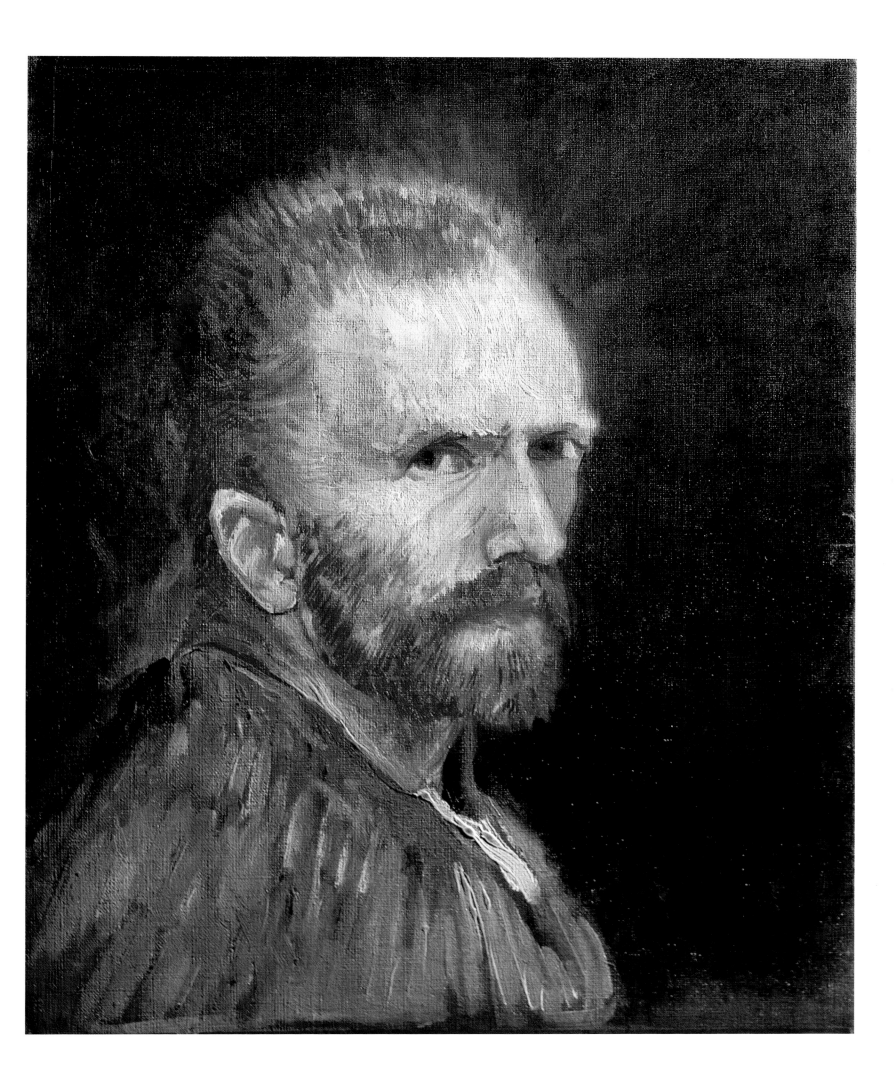

My own conscience is the compass which shows me the way,
although I know that it does not work quite accurately.

Vincent to Théo, Drenthe,
October–November 1883, Letter 336 in Dutch

15. *Self-Portrait*,
Paris, summer 1887, oil on canvas, 41.5 × 31 cm,
Amsterdam, Rijksmuseum Vincent van Gogh.

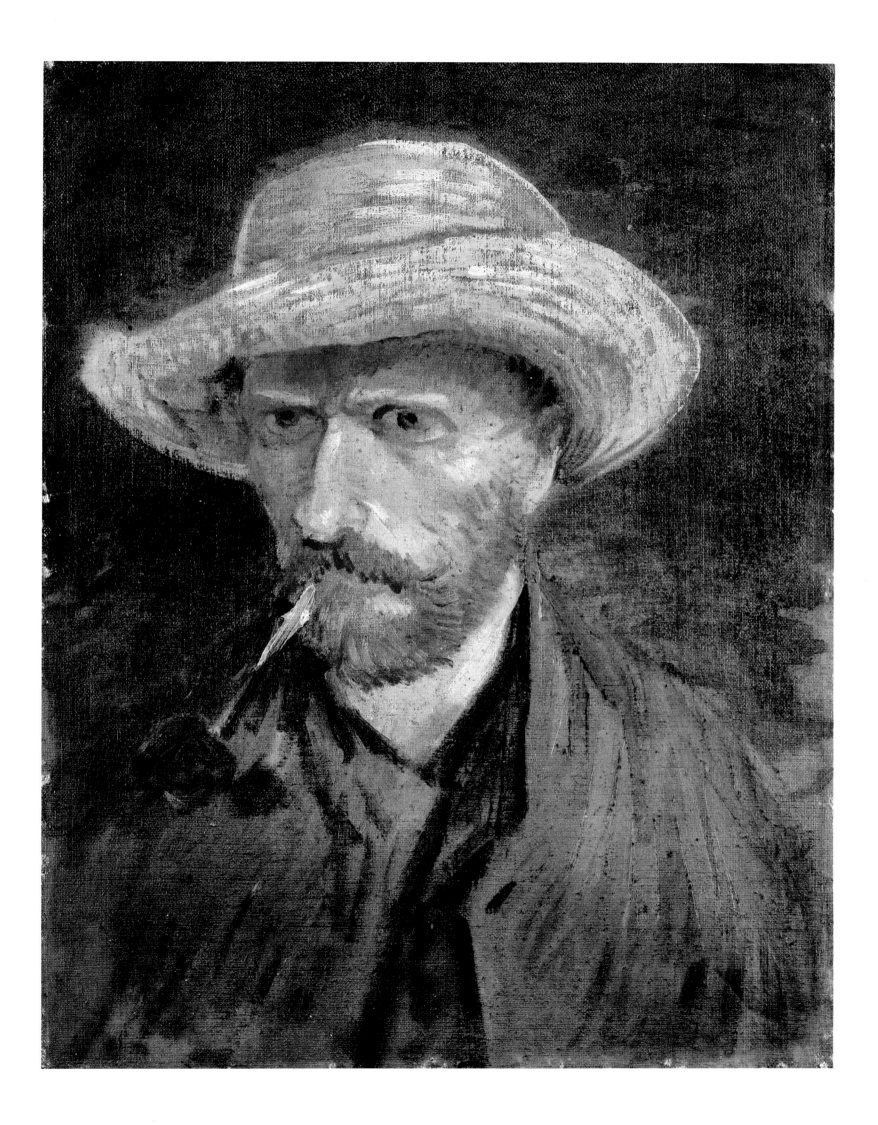

Society deceives nearly everyone and confounds nearly all theories.

Vincent to Théo, Nuenen,
August–September 1884, Letter 337 in Dutch

16. *Self-Portrait,*
Paris, 1887, oil on cardboard, 19 × 14 cm,
Amsterdam, Rijksmuseum Vincent van Gogh.

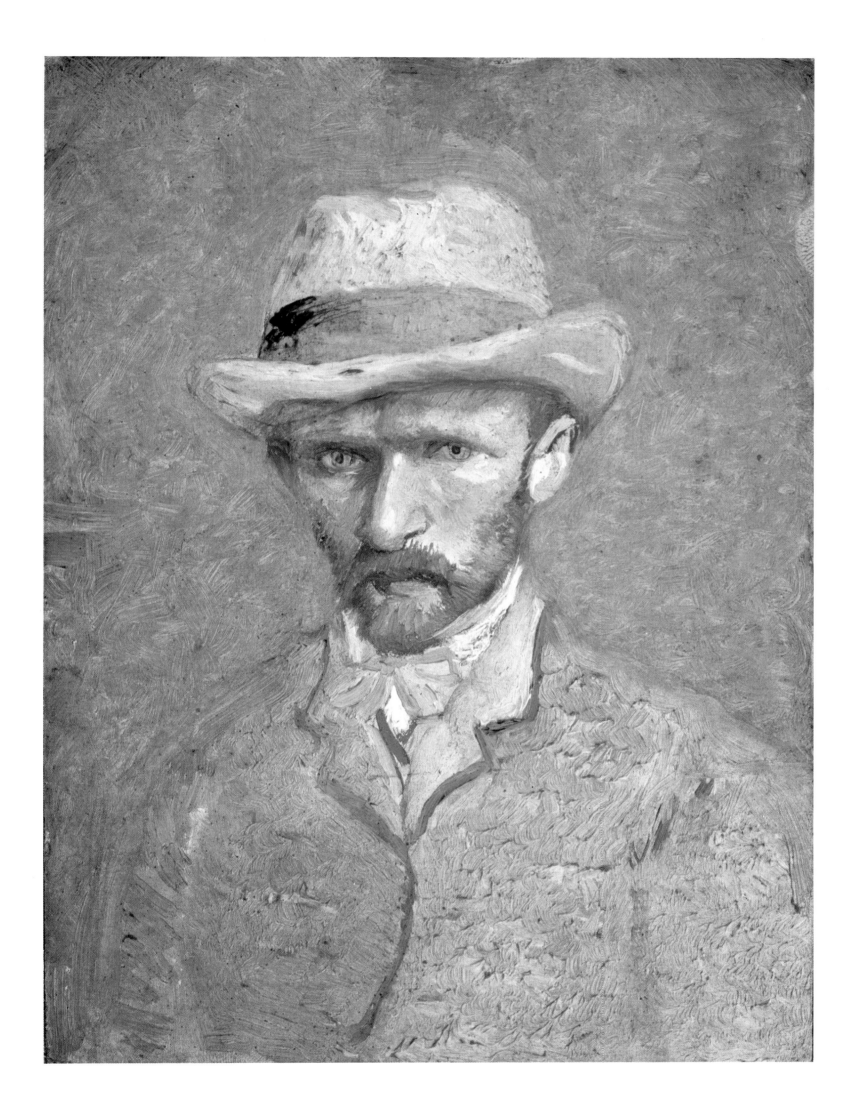

One must know the structure of the figures so thoroughly to get the expression—at least, I can't see it differently.

Vincent to Théo, The Hague,
April–May 1883, Letter 281 in Dutch

17. *Self-Portrait,*
Paris, summer 1887, oil on cardboard, 19 × 14 cm,
Amsterdam, Rijksmuseum Vincent van Gogh.

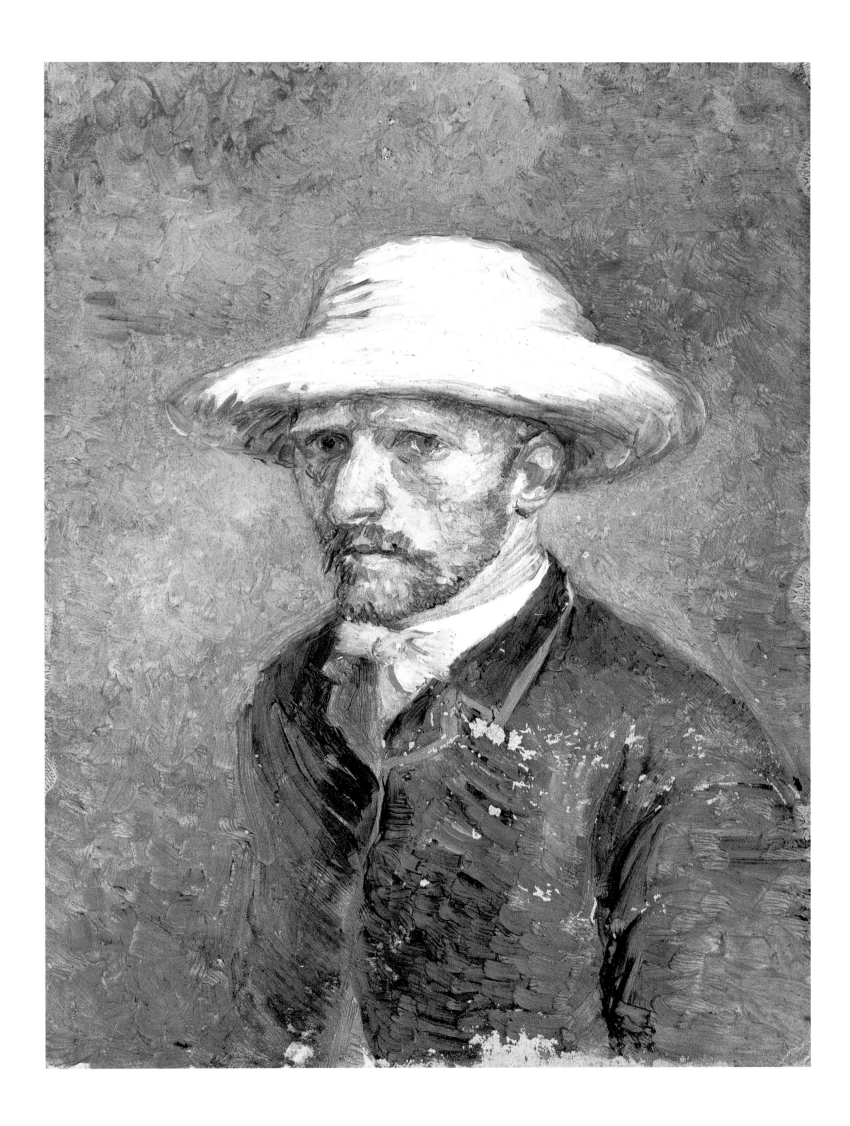

Happiness

After all, one is not in the world for one's own comfort, and one does not need to be better off than one's neighbor. Being a little better off helps so little after all. Anyhow, we cannot prevent the days of our youth slipping from us. If that were possible! But the real thing that makes one happy, materially happy—being young, and remaining so a long time— does not exist here—that doesn't even exist in Arabia or Italy, though it is better there than here. And I personally think that one has the greatest chance of remaining strong and renewing oneself under the present-day tiers état. Well, so I say that I try to find it in painting without any thoughts on the side. But I shall do well to keep my eye on portrait painting if I want to earn something. I know it is difficult to satisfy people as to the "likeness," and I dare not say beforehand that I feel sure of myself on that point. [433 D, November 1885]

These words of determination and doubt date to November 1885. Some months earlier at Nuenen, the parish priest had prohibited his parishoners from continuing to pose for this painter of *The Potato Eaters*, this van Gogh whom they accused of getting the young Gordina de Groot pregnant. At Anvers, in the room that he rented from the Brandels on the street called the Long Street of Images, van Gogh worked out the rigorous morality of the painter's life he knew to be his own, and weighed his chances. Paintings were made to be sold. Van Gogh settled on his form of employment. Several weeks afterward he wrote: "My best chance is in the figure, because there are relatively very few who do it, and I must seize the opportunity. I must work myself into it here, until I get into touch with good figure painters— Verhaert, for instance—and then I imagine portrait painting is the way to earn the means for greater things. I feel a power within me to do something. I see that my work holds its own against other work, and that gives me a great craving for work." [438 D, December 1885] To paint the figure. This aim represented not only a way to sell but involved as well facing an essential challenge.

This challenge had been there for years. From 13 February 1882: "I am so glad I have worked on the figure up to now. If I had done only landscapes, yes, then I should probably do something that would sell at a small price now, but then later I would be stranded." [174 D, 13 February 1882] In March he wrote: "For drawing the figure one must be more or less of a drudge or a beast of burden, more *homme de peine*." [181 D, March–April 1882] One month later: "What fine weather we are having; there are signs of spring everywhere. I cannot drop drawing from the figure—this comes first with me—but sometimes I cannot keep from working outdoors." [185 D, April 1882] In July he cited the effort required by figure drawing: "For understand clearly

that however much I may like landscapes, I love drawing the figure more. But it is the most difficult, and therefore costs me more study and work, and also more time." [219 D, July–August 1882]

But what did it matter! The challenge remained the same. "You see I am quite taken up by landscape . . . nevertheless, the figure remains the principal thing for me." [220 D, July–August 1882] Van Gogh applied rules of his own making: "In my opinion two things that remain eternally true and complement each other are: Do not quench your inspiration and your imagination, do not become the slave of your model; and Take the model and study it; otherwise, your inspiration will never get plastic solidity." [241 D, November 1882] Van Gogh worked ceaselessly at The Hague, as he had at Drenthe, as he had at Nuenen; the figure resisted, defied, and obsessed him. In July 1883, he wrote: "Last year I repeatedly tried to paint figure studies, but the way they turned out made me desperate. Now I have begun again, and now there is nothing that keeps me from carrying it out, because drawing comes so much more easily to me than last year. I used to get in a muddle then whenever I lost hold of my sketch while painting; and it took me a long time to make that sketch, so that when I could hire the model for only a short time, I made an absolute mess of it. But now I don't care in the last if the drawing is wiped out; and I am now doing them only directly with the brush, and then the form stands out enough for the study to be of use to me. Therefore, I say that I see the way before me more clearly. I know that I'll have to make many studies, but they won't cost me more trouble than the drawings, and therefore a great deal of painting must be done this year, and then there will come more light." [308 D, July 1883] In January 1885, he found that he knew where to apply his energies; more light meant new effort was warranted. "It will perhaps be best that I devote myself more, if not exclusively, to the figure. Nonetheless, the figure must always have a décor, and very often this means that it is unavoidable that the surroundings be drawn at the same time." [No letter number cited; January 1885]

For all the years that van Gogh sketched and painted, isolated figures were rare; more often they were set in a scene. "When I draw separate figures, it is always with a view to a composition of more figures, for instance, a third-class waiting room, a pawnshop, or an interior." [178 D, 3 March 1882] Van Gogh's models weed, weave, mend, or peel; they dig, churn, or read. These are scenes of field work, of waiting before the office of the lottery or the soup kitchen, or of groups passing along the beach at Scheveningen. And month after month Van Gogh draws over and again the same gesture of weariness and sadness: a man, a woman, seated, elbows resting on knees, holding head in hands. This is *Worn Out*, drawn at Etten in September

of 1881. It is Sien, tired, seated in a chair, drawn at The Hague in April of 1882, and it is an old man, fists closed over his eyes, drawn one year later, in April of 1883 at the same time as a woman seated on an overturned basket. But neither the humility, the ordinariness and inevitability of the gestures, nor the expressions of pain qualify the work as portraiture. At the time he arrived in Anvers, van Gogh had drawn but one portrait, that of his father, Théodore, in July 1881. And it was taken from a photograph. The long and intense commitment to the figure was not without risk. In July 1883, he reported: ". . . Without being under the constraint of a definite course, just to perfect my drawing, I have forced myself to study the figure assiduously, and through that very strain, by constantly exerting myself, I have drifted into this dryness." [303 D, July 1881]

It was in Anvers, in December 1885, that van Gogh began to paint portraits—one of a bearded old man seen in profile, another of a woman, perhaps a wet nurse, with her white hat tied under her chin, one of a common young woman with shoulder-length hair, another of a woman with a red ribbon in her hair. In Anvers for the first time he drew his own portrait as well, wearing a thick cap, using both sides of the same sheet of paper.

On 19 December 1885, he wrote: "But I prefer painting people's eyes to cathedrals, for there is something in the eyes that is not in the cathedral, however solemn and imposing the latter may be—a human soul, be it that of a poor beggar or of a streetwalker, is more interesting to me." [441 D, 19 December 1885] But not before Paris, and Arles, would the portrait find its rightful place. At summer's end in 1887, van Gogh wrote: "And when I was painting landscapes at Asnières last summer, I saw more color in it than before. Now I am seeking to paint portraits. And I must say that I paint none the worse for it, perhaps because I might speak considerable ill of painters, and of pictures too, quite as easily as I could speak well of them." [W1 D, summer or fall 1887] On 4 May 1888, he wrote: "I think there would be something to do here in portraits. Although the people are blankly ignorant of painting in general, they are much more artistic than in the north-in their own persons and their manner of life. I have seen figures here quite as beautiful as those of Goya or Velásquez. They will put a touch of pink on a black frock, or devise a garment of white, yellow, and pink, or else green and pink, or else *blue and yellow*, in which there is nothing to be altered from the artistic point of view." [Emphasis by van Gogh; 481 F, 4 May 1888] And one month later, to Koning: "For I suppose that all at once I shall make a furious onslaught on the figure, which I seem to be giving a wide berth at the moment, as if I were not interested in it, although it is what I really aim at. In the meantime I am getting rather sunburned. People here are sunburned yellow or

orange, and now and then red-ocher." [489a D, June 1888] And at the beginning of August, he tosses out: "I want to do figures, figures, and more figures. I cannot resist that series of bipeds from the baby to Socrates, and from the woman with black hair and white skin to the woman with yellow hair and a sunburned brick-red face." [B15 F, August 1888]

In letter after letter he describes the same discovery: There was no portraiture except by color. This was because, at Asnières, he saw more color than he had seen before, because people in Arles knew how to clothe themselves colorfully, because the skin itself had a color that became meaningful in portrait. Just as he was discovering color, he also discovered urgency. On 1 September 1888: "I feel that even so late in the day I could be a very different painter if I were capable of getting my own way with the models, but I also feel the possibility of going to seed and of seeing the day of one's capacity for artistic creation pass, just as a man loses his virility in the course of his life. That is inevitable, and naturally in this as in the other, the one thing to do is to be of good heart and strike while the iron is hot." [530 F, 1 September 1888] In the same letter he also spoke of conflicting demands he felt pulling at him.

"Oh! someday I must manage to do a figure in a few strokes." [542 F, September 1888] And such mastery would require patience. "I feel that while continuing to work, I must not hurry. After all, how would it be to put into practice the old saying 'You must study for ten years, and then produce a few portraits.' " [542 F, September 1888] Reconcile patience with spontaneity? Van Gogh knew he could. "But that's what I'm good at, doing a fellow roughly in one sitting. If I wanted to show off, my boy, I'd always do it, drink with the first comer, paint him, and that not in water colors but in oils, on the spot in the manner of Daumier. If I did a hundred like that, there would be some good ones among them. And I'd be more of a Frenchman and more *myself*, and more of a drinker. It does tempt me so—not drinking, but painting tramps. What I gained by it as an artist, should I lose that as a man? If I had the faith to do it, I'd be a notable madman; now I am an insignificant one, but you see I am not sufficiently ambitious for that fame to set a match to the powder. I would rather wait for the next generation, which will do in portraiture what Claude Monet does in landscape, the rich, daring landscape à la Guy de Maupassant." [Emphasis by van Gogh; 525 F, 5 August 1888]

Were the self-portraits van Gogh painted while in Arles the portraits of tramps he felt attracted to, or were they signs of the gravest and most painful renunciation? "I must say I cannot understand why I don't do studies after the figure, seeing that it is often so difficult for me to imagine the painting of the future theoretically as otherwise

than a new succession of powerful, simple portraitists, comprehensible to the general public." [B19a F, later October 1888] In the last days of October 1888, he wrote the following awesome sentence: "At the age of forty when I make a picture of figures or portraits in the way I feel it, I think this will be worth more than a more or less serious success at present." [558 F, October 1888] And in December: "If by the time I am forty I have done a picture of figures like the flowers Gauguin was speaking of, I shall have a position in art equal to that of anyone, no matter who. So, perseverance." [563 F, December 1888] "If by the time I am forty . . ." Van Gogh died at thirty-seven. Were his portraits but those of a failure? Van Gogh renounced real life in favor of painting. "Oh! it seems to me more and more that *people* are the root of every-thing, and though it will always be a melancholy thought that you yourself are not in real life, I mean, that it's more worthwhile to work in flesh and blood itself than in paint or plaster, more worthwhile to make children than pictures or carry on business, all the same you feel that you're alive when you remember that you have friends who are outside real life as much as you." [476 F, April 1888] Excluded by those who were themselves excluded, had van Gogh ever, by way of the portrait, lived the life of painting? In his garret in Auvers where he died, he awaited the time when a new generation of painters would *paint* the portrait he *saw*.

CHAPTER **11**

The Human Form

The key to many *things is the thorough knowledge of the human body, but it costs money to learn it.* [381 D, October 1884]

Thus wrote van Gogh in October of 1884. That fact, and the self-sacrifice it entailed, had already regulated his life for years and would continue to do so for years to come.

"The difficulty is also to find the models for this purpose; and if I can, I shall avoid having a nude model in the studio, so as not to frighten away other models. The fear that they will have to 'strip to the skin' for you is generally the first scruple you have to get rid of when asking someone to pose. At least, that has been my experience more than once." [182 D, March–April 1882] The view from March 1882. Mastery of the proportions of the body was necessary to van Gogh, who was then beginning to draw and to paint. But he well understood the limitations of this exercise. "Most certainly one must have a sound knowledge of the nude, but in reality we have to do with figures with clothes on." [R2 D, 15 October 1881] That fact also carried its responsibilities. "But what a tough job it is to make people understand how to pose. Folks are desperately obstinate about it, and it is hard to make them yield on this point: They want to pose only in their Sunday best, with impossible folds in which neither knees, elbows, shoulder blades, nor any other part of the body have left their characteristic dents or bumps. Indeed, that is one of the *small miseries of a draftsman's life.*" [Emphasis by van Gogh; 148 D, July 1888]

Van Gogh wanted first of all that there be the truth in his drawings and paintings. On 28 December 1885, from Anvers, he wrote to Théo: "I know that you are sufficiently convinced of the importance of being *true* so that I can speak out freely to you. If I paint peasant women, I want them to be peasant women; for the same reason, if I paint harlots I want a harlotlike expression. That was why a certain harlot's head by Rembrandt struck me so enormously." [442 D, 28 December 1885] (Which of Rembrandt's portraits did he consider to be that of a harlot? His *Girl at the Window* of 1645 doesn't seem a probable choice; his *Danae* lying nude is not a prostitute; nor is *Hendrickje in Bed*; nor *Bathing in the River*, where Hendrickje has her shirt hiked up to her thighs. . . .) While demanding truth from his models, prohibiting them from dressing up for sessions with him, and scrupulously seeking a verisimilitude, van Gogh attached primary importance to character. As such he deliberately disabused himself of the academic style of painting. July 1883: "Speaking of the expression of a figure, more and more I come to the conclusion that it is not so much in the features as in the whole attitude. There are few things I hate more than most of the academical *têtes d'expression.*" [299 D, July 1883] From 6 July 1885: "The time has

69

past—and I don't want it back—when it was enough for a figure to be academically, conventionally correct, or rather, though many still ask for this, a reaction is setting in—and I hope it will make some stir." [416, 6 July 1885] To "make some stir" meant imposing new rules. The first of these was the following: "I can tell you that for my part I shall try to keep a straight course, and shall paint the simplest, the most common things." [390 D, December 1884–January 1885] This "program" demanded first of all the recognition of something he mentioned in July 1885: "*Nothing seems simpler than painting peasants, ragpickers, and laborers of all kinds, but—no subjects in painting are so difficult as these commonplace figures*! As far as I know there isn't a single academy where one learns to draw and paint a digger, a sower, a woman putting the kettle over the fire, or a seamstress. But in every city of some importance there is an academy with a choice of models for historical, Arabic, Louis XV, in short, *all really nonexistent figures*." [418 D, July 1885]

Van Gogh recognized no higher authority or school and accepted the consequences. December 1885: "Ah, a picture must be painted—and then why not simply? Now when I look into real life, I get the same kind of impressions. I see the people in the street very well, but I often think the servant girls so much more interesting and beautiful than the ladies, the workmen more interesting than the gentlemen; and in those common girls and fellows I find a power and vitality that, if one wants to express them in their peculiar character, ought to be painted with a firm brush stroke, with a simple technique." [439 D, December 1885] This technique he insisted upon necessitated a metamorphosis. ". . . When one wants to paint, for instance, a head, and sharply observes the reality one has before one, then one may think: 'That head is a harmony of red-brown, violet, yellow, all of them broken—I will put a violet and a yellow and a red-brown on my palette, and these will break each other.' Of nature I retain a certain sequence and a certain correctness in placing the tones, I study nature, so as not to do foolish things, to remain reasonable; however, I don't care so much whether my color is exactly the same, as long as it looks beautiful on my canvas, as beautiful as it looks in nature. . . . What do I care whether the portrait of an honorable citizen tells me exactly the mild-and-watery bluish, insipid color of that pious man's face—which I would never have looked at? . . . A man's head or a woman's head, well observed and at leisure, is divinely beautiful, isn't it? Well, one loses that *general harmony* of tones in nature by painfully exact imitation; one keeps it by re-creating in a parallel color scale which may be not exactly, or even far from exactly, like the model." [429 D, October 1885]

After having discovered color in Paris, and after having seen the

luxuriant color in Arles, Vincent finally knew what there must be in a portrait:

"It is only that what I learned in Paris is leaving me, and I am returning to the ideas I had in the country before I knew the Impressionists. And I should not be surprised if the Impressionists soon find fault with my way of working, for it has been fertilized by Delacroix's ideas rather than by theirs. Because instead of trying to reproduce exactly what I have before my eyes, I use color more arbitrarily, in order to express myself forcibly. Well, let that be, as far as theory goes, but I'm going to give you an example of what I mean.

"I should like to paint the portrait of an artist friend, a man who dreams great dreams, who works as the nightingale sings, because it is his nature. He'll be a blond man. I want to put my appreciation, the love I have for him, into the picture. So I paint him as he is, as faithfully as I can, to begin with.

"But the picture is not yet finished. To finish it I am now going to be the arbitrary colorist. I exaggerate the fairness of the hair, I even get to orange tones, chrome and pale citron-yellow.

"Behind the head, instead of painting the ordinary wall of the mean room, I paint infinity, a plain background of the richest, intensest blue that I can contrive, and by this simple combination of the bright head against the rich blue background, I get a mysterious effect, like a star in the depths of an azure sky." [520 F, August 1888]

In September 1889, portrait painting was van Gogh's only remaining ambition, the only desire of a weary and distracted, institutionalized man. "Will it not be better if, provided I leave here sooner or later, I come back definitely capable of doing a portrait that has some character, than if I come back as I started? That is clumsily expressed, for I know well one cannot say, 'I know how to make a portrait,' without telling a lie, because that is infinite." [604 F, September 1889] In the same letter van Gogh announced that he was in the midst of painting two portraits of himself (illustrations 45 and 46). And these would be the last self-portraits he would paint. Why, at Anvers, paint others? He knew then that before him lay the infinite.

CHAPTER **12**

Models

Models are expensive, at least relatively expensive, and if I had money enough to have them often, I should be able to work much better. [141 D, 16 February 1881]

Van Gogh wrote those words in February 1881. He was twenty-eight, living in Brussels, in a narrow room at number 72 on the Boulevard du Midi. Just a few months earlier he had given up preaching to the poor of Cuesmes. He did not yet dream of earning a living as a painter. But he needed models. Van Gogh had no source of income except the money sent to him by Théo. And he would never have another source. Thus began the protracted lamentation, the anxiety and the misery, prompted by his need for a model—to have one meant sacrificing all other comforts; to be without one meant being unable to become what he had to become. Van Gogh's fate was having to choose between the misery of painting and the misery of not painting. And to have no other choice—ever.

His obsession with models was the leitmotif of his letters. From 19 November 1881: "I shall have to spend more on models. Now I spend 20, 25, or 30 cents a day, but I cannot do that every day, and it really is not enough; by spending a little more, I could make more rapid progress." [160 D, 19 November 1881] December 1881: ". . . Models are expensive: one florin fifty to two florins a day or more." [R7 D, December 1881] January, 1882: "I am all right, but the last few days I have been faint with suspense. I have been looking for models and found a few, but I cannot take them." [168 D, January 1882] And again that January: ". . . I have great trouble with models: I hunt for them, and when I find them, it is hard to get them to come to the studio; often they do not come at all. For instance, this morning a blacksmith's boy could not come because his father wanted me to pay a guilder an hour; of course, I refused to do it." [170 D, January 1882] A few days later: "For I have already had several models, but they are either too expensive or they think it's too far to come here, or they make objections afterward and do not come back. But I think I have hit on the right one in this old woman." [172 D, January–February 1882] From The Hague, 3 March 1882: ". . . I have all kinds of acquaintances in the neighborhood. Next Sunday I shall have a boy from the orphanage, a splendid type, but unfortunately I can have him only a short time. It is perhaps true that I cannot get on very well with people who are very conventional, but on the other hand, I can perhaps get on better with poor or so-called common people. . . . It strikes me to the heart when I think the model will have to wait for her money, because they need it badly. Up to now I have paid them regularly, but next week I should not be able to do so." [178 D, 3 March 1882]

In September, or perhaps October, of the same year: "I had a model for a few hours today, a boy with a spade, hod carrier by trade, a very intriguing type—flat nose, thick lips, and very coarse, straight hair— yet whenever he does something, there is grace in the figure, at least style and character. I think I shall have some good models this winter; the owner of the yard has promised to send me the ones who come to ask for work, which often happens in the slack season. I am always glad to give them a few sixpences for an afternoon or morning, for that is just what I want. I see no other way than to work from the model. Of course, one must not extinguish one's power of imagination, but the imagination is made sharper and more correct by continually studying nature and wrestling with it." [238 D, September–October 1882] January 1883: "I am working very hard at present, and I must not stop, but really the models eat me out of house and home." [259 D, January 1883] March: "I dare not ask too much of my models. If I paid them better, I should have the right to insist on longer poses and could make better progress." [274 D, March 1883] April: "My ideal is to work with more and more models, quite a herd of poor people to whom the studio would be a kind of harbor of refuge on winter days, or when they are out of work or in great need. Where they would know that there was fire, food, and drink for them, and a little money to be earned. At present this is so only on a very small scale, but I hope it will grow." [278 D, April 1883] A few days later: "I should wish to be able to spend more, both on models and on painting materials . . . but I only have enough steam for 'half speed,' and should like to go 'full speed.' " [280 D, April 1883]

May: "I have been working in the dunes for some days, but I long for a model; otherwise, I cannot go on." [283 D, May 1883] And more: "I shall again have to take a model every day, and struggle hard till I have got it down." [288 D, May–June 1883] June 1883: "I make progress with my figures, but financially I am losing ground and cannot keep it up." [297 D, June 1883] December 1884: "The fact is that now more than ever, I paint as long as I have money for models." [389 D, December 1884] And in February or March 1885: "And to me my work is valuable; I must paint a lot, and therefore I am continually in want of models." [388b D, February–March 1885] July 1885: "But as they are for the most part very poor, and especially many weavers are out of work, I can somehow manage to get them. But painting what I want, and especially improving the figures, is a question of money." [417 D, July 1885] Then the woeful lament would cease for some months.

In September 1888, it had begun anew: "I have a terrible lucidity at moments, these days when nature is so beautiful, I am not conscious of myself any more, and the picture comes to me as in a dream. I am rather afraid that this will mean a reaction and depression when the

bad weather comes, but I will try to avoid it by studying this business of drawing figures from memory. I am always finding my best powers frustrated by the lack of models, but I do not worry; I do landscape and color without fussing about where it will lead me. I know this, that if I went and begged the models, 'Now do pose for me, I beseech you,' I should be behaving like Zola's good painter in *The Masterpiece*." [543 F, September 1888] But then he who had for years reiterated his obsessive need for models drew and painted his own portrait—finally, after nearly five years during which he had refused to recognize that he could be his own model.

The narrow mirror in which he looked at himself—doubtless comparable to the one behind the nightstand that he painted into *Van Gogh's Bedroom*—allowed only for portrait painting. The white wooden frame cut off the head at the neck. (At the time he revived his plea for models, in September 1888, he had still before him six portraits to be painted in just such a mirror.) The models that van Gogh required posed for figure studies. After his arrival in Paris, he painted no more such studies. Instead, he painted portraits, whether with an identifiable subject or an anonymous one. Two paintings from 1886, *Portrait of a Woman* and *Bust of a Woman*, were portraits like those of Alexander Ried or the elder Tanguy. *Man in a Skull Cap* was a portrait like that of Agostina Segatori. In Arles, van Gogh painted more portraits than figures. His models were a Zouave, several Arlesiennes, an actor, members of the Roulin family, a farmer. The only figures van Gogh would paint in Arles were one sower, the women gathering grapes in, and the women in *The Promenade at Arles*; but the promenade was foremost a memory of the garden at Etten. The figures were a part of the past.

Strange sequence of events: after having painted the portrait of Mr. Trabu, the chief inspector of the Saint Paul asylum at Saint-Rémy-de-Provence, and that of his wife, after having painted two final self-portraits, and after having twice copied *Van Gogh's Bedroom*, a place he would never return to—van Gogh returned to painting figures. At the asylum, he took as his models the engravings of Lavieille, Leurat, or Belin-Dolet, themselves reproductions of works by Millet. By March or April of 1890, there remained no subject but that of weeders that he could paint without the help of an engraving. And at Auvers-sur-Oise he ceased to paint self-portraits. The fields were barren under a stain of torrid light, and barren too was the square facing City Hall opposite the Ravoux café, where on 27 July 1890, he arrived with his jacket drawn tightly around him to cover his blood-soaked shirt.

It appears that in order to paint, van Gogh required models who were strangers to him. None of van Gogh's portraits assume intimacy

with their subject. He drew a portrait of his father from a photograph. The young Rembrandt, at the time he was beginning to produce engravings, had his mother pose again and again. There exists no portrait of Cornelia Carbentus, van Gogh's mother, that was painted in her presence. Van Gogh worked instead from a photograph. And he painted his sister Wilhelmina from a photograph as well. There are no portraits of Théo, although the two brothers lived together for twenty-three months. Van Gogh posed for Gauguin, but he did not paint Gauguin. Sien, the prostitute with whom van Gogh lived for more than a year—from the end of January 1882, until September 1883—was no exception; no portraits were painted of her except as one model among others. (The first time that van Gogh alluded to her, on 3 March 1882, he wrote: "I have a new model now, though I drew her superficially once before. Or rather, it is more than one model, for I have already had three persons from the same family: a woman of forty-five, like a figure by Édouard Frère, then her daughter of about thirty, and a young child of ten or twelve. They are poor people, and I must say they are more than willing. I get them to pose, but not without difficulty, and only on condition that I promise them regular work. Well, that was exactly what I wanted so much myself, and I think it a good arrangement." [178 D, 3 March 1882]) And *Sorrow*, the painting for which she posed, was not a portrait.

The models who posed for van Gogh, for portraits or figures, were always strangers. They did not enter his life so much as cross his path, whether through need or by chance. Van Gogh painted only men and women he was to lose sight of. Strangers. What sort of stranger to himself then was van Gogh while posing for his self-portrait?

Try to take as many walks as you can and keep your love of nature, for that is the true way to learn to understand art more and more. Painters understand nature and love her and teach us to see her. Then there are painters who can only make good things, who cannot make anything bad, just as there are ordinary people who canot do anything that doesn't turn out well.

Vincent to Théo, London,
January 1874, Letter 13 in Dutch

18. *Self-Portrait*,
Paris, summer 1887, oil on canvas applied over cardboard, 42 × 31 cm,
Amsterdam, Rijksmuseum Vincent van Gogh.

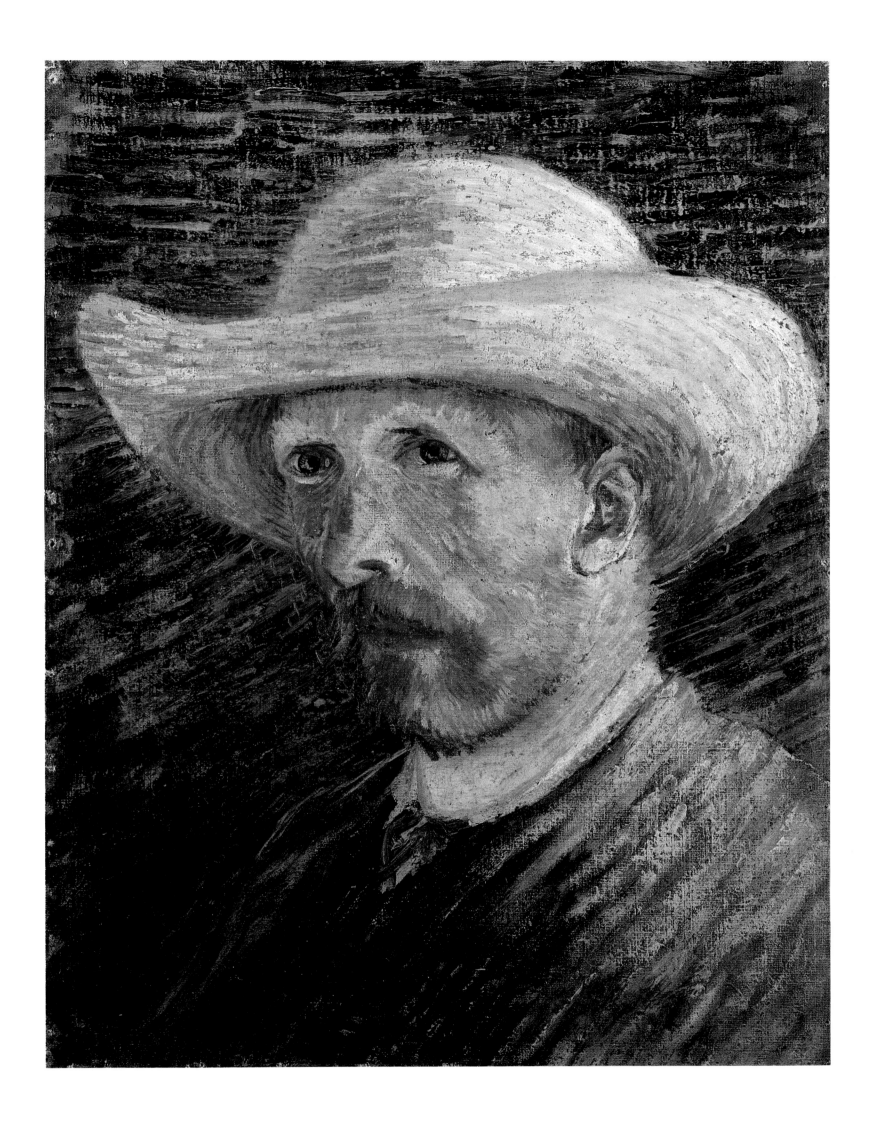

I am decidedly not a landscape painter; when I make landscapes, there will always be something of the figure in them.

Vincent to Théo, The Hague,
March–April 1882, Letter 182 in Dutch

19. *Self-Portrait*,
Paris, summer 1887, oil on cardboard, 41 × 33 cm,
Amsterdam, Rijksmuseum Vincent van Gogh.

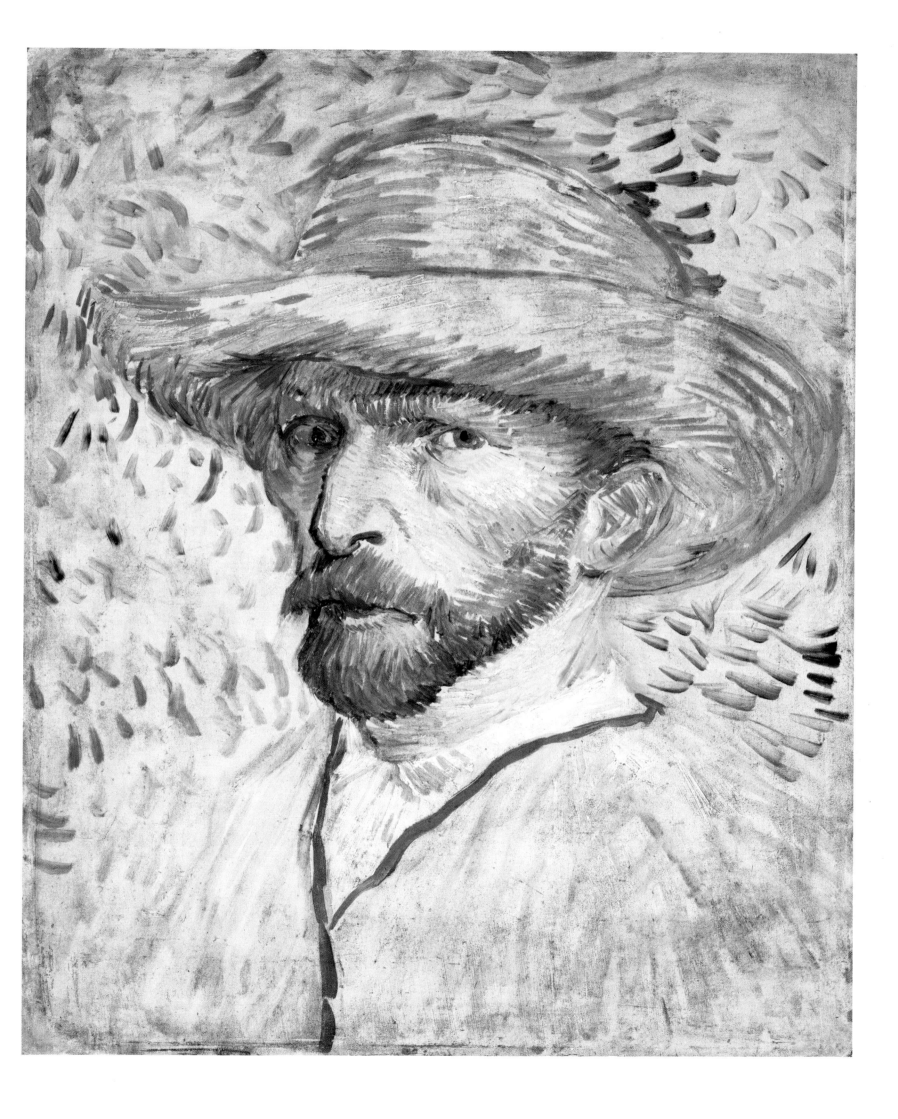

What am I in most people's eyes? A nonentity, or an eccentric and disagreeable man—somebody who has no position in society and never will have, in short, the lowest of the low. Very well, even if this were true, then I should want my work to show what is in the heart of such an eccentric, of such a nobody.

Vincent to Théo, The Hague,
July 1882, Letter 218 in Dutch

20. *Self-Portrait,*
Paris, summer 1887, oil on canvas applied over board, 35.5 × 27 cm,
Detroit, Institute of Arts.

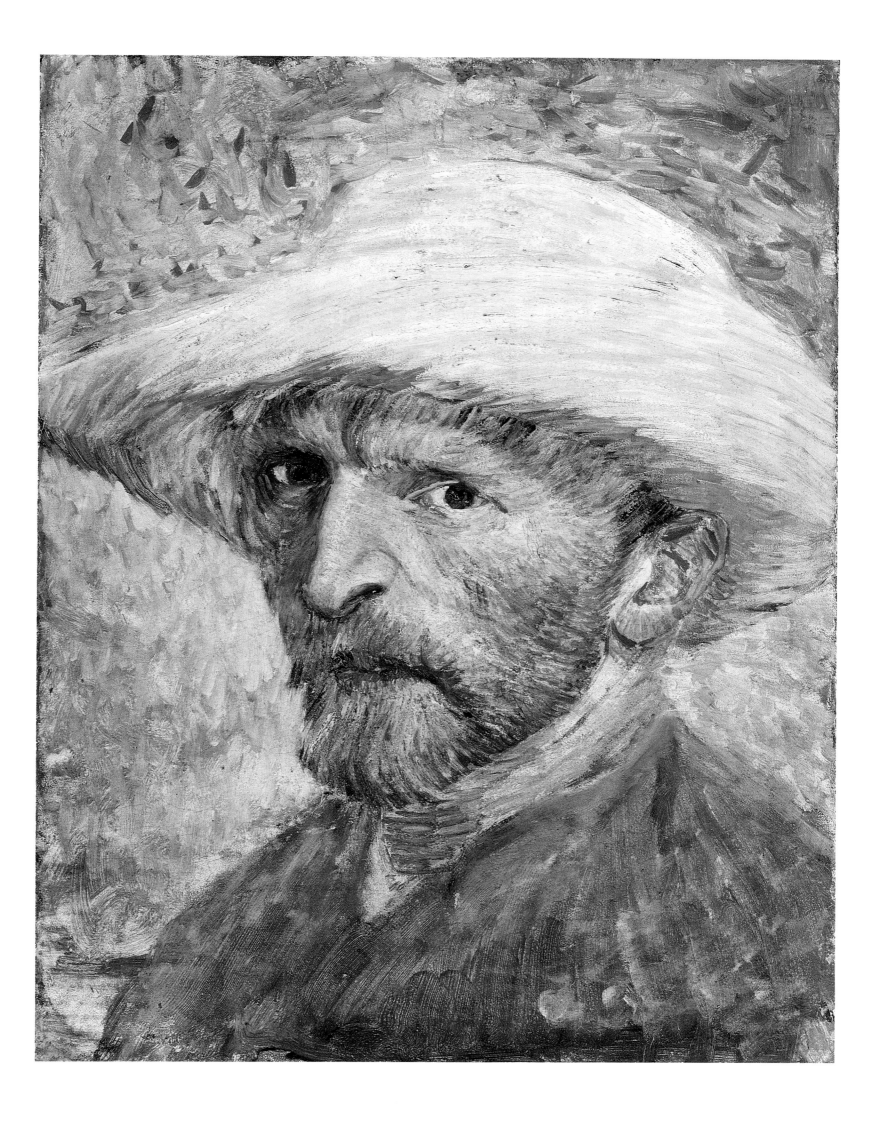

In short, when I give an opinion about persons, circumstances,
a society in which I do not move, you may understand
that I do not always speak justly, but let my
imagination roam without regard to reality, and that I see
things in a very fantastic way, just as things may appear strange
when seen against the light.

Vincent to Théo, The Hague,
July–August 1883, Letter 312 in Dutch

21. *Self-Portrait*,
Paris, summer 1887, oil on cardboard, 41 × 32 cm,
Amsterdam, Stedelijk Museum.

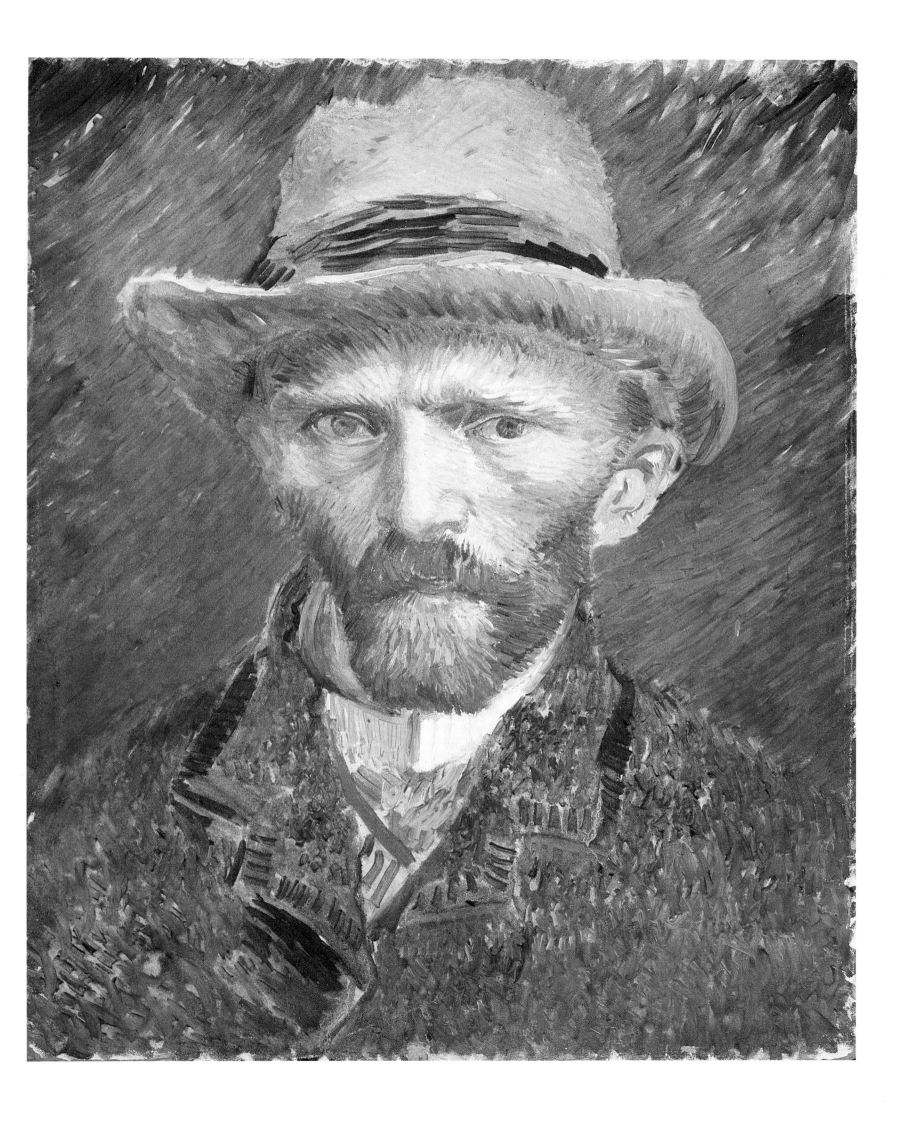

And in a picture I want to say something comforting, as music is comforting. I want to paint men and women with that something of the eternal which the halo used to symbolize, and which we seek to convey by the actual radiance and vibration of our coloring.

Vincent to Théo, Arles,
September 1888, Letter 531 in French

22. *Self-Portrait*,
Paris, later summer 1887, oil on canvas, 44 × 37.5 cm,
Amsterdam, Rijksmuseum Vincent van Gogh.

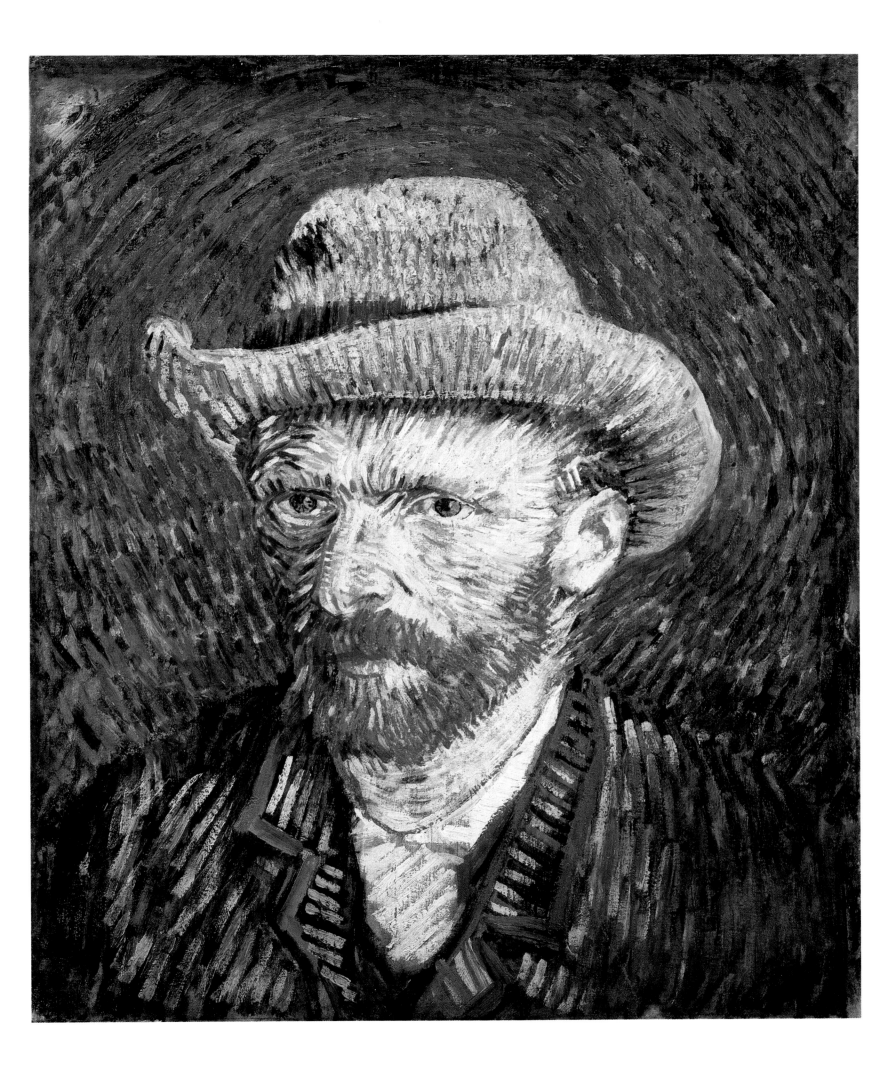

CHAPTER 13

Nature

It may take a longer or a shorter time, but the surest way is to penetrate deep into nature. [177 D, February 1882]

Van Gogh set out on that path in February 1882. He claimed essential nature as both school and master. "The real thing is not an absolute copy of nature, but to know nature so well that what one makes is fresh and true—that is what so many lack." [251 D, December 1882] More-over, it was through the mediation of nature that van Gogh discovered himself. "I very seldom work from memory—hardly practice that method. But I am getting so used to being confronted immediately with nature that I am keeping my personal feelings unfettered to a far greater extent than in the beginning—and I get less dizzy—*and I am more myself just because I am confronted with nature.*" [R37 D, May–June 1883] Van Gogh repeated that belief in November of 1883. "This is my firm belief. Whether one is more or less clever at the start, whether one has the advantage of favorable circumstances to a greater or to a lesser extent, is, to my way of thinking, far from being the main thing. One should start with the conviction that one is in need of intercourse with nature, with the conviction that one cannot lose one's way by taking this road, and that one's course will be straight" [339a D, November 1883] Neither delays nor doubts weakened van Gogh's faith.

Two years later, in October of 1885, nature was still the first principle, both as a point of reference and a basis for hope. "I mean that it would be foolish and stupid to always go on in that same way, but not that all my pains should be absolutely lost. *'On commence par tuer, on finit par guérir'* [We start off killing and end with a cure] is a doctor's saying. One starts with a hopeless struggle to follow nature, and everything goes wrong; one ends by calmly creating from one's palette, and nature agrees with it and follows. But these two opposites cannot be separated. The drudging, though it may seem futile, gives an intimacy with nature, a sounder knowledge of things." [429 D October 1885] To rediscover nature, the earth, the land was clearly the fundamental reason he went to Arles. It was not Provence he discov-ered there, but an Orient of fine prints and dreams. In March 1888, he wrote to Théo: "But, old boy, you know, I feel as though I were in Japan—I say no more than that, and mind, I haven't seen anything in its usual splendor yet. That's why—even although I'm vexed that just now expenses are heavy and the pictures worthless—that's why I don't despair of the future success of this idea of a long sojourn in the Midi. Here I am seeing new things, I am learning, and if I take it easy, my body doesn't refuse to function." [469 F, March 1888] To Émile Bernard: "I will begin by telling you that this country seems to me as beautiful as Japan as far as the limpidity of the atmosphere and

the gay color effects are concerned." [B2 F, March 1888] To his sister: "I am always telling myself that *here I am in Japan*. Which means that I have only to open my eyes and paint what is right in front of me, if I think it effective." [Emphasis by van Gogh; W7 F, early September 1888] And in this "Japan" he painted himself Japanese (see illustration 34).

Arles, in Provence, provided precisely the sort of nature he wanted to anchor himself to. In April 1888, he wrote: "I am still convinced that nature down here is just what one wants to give one color. So that it's more than likely I shall hardly ever budge from here." [480 F, April 1888] And on 10 May he added: ". . . But I feel that in these surroundings there is everything one needs to do good work. So it will be my own fault if I don't succeed." [485 F, 10 May 1888]

Van Gogh was alone—terribly alone with nature and alone because committed to the Saint-Rémy asylum. "I won't say that one might not venture on it after a virile lifetime of research, of a hand-to-hand struggle with nature, but I personally don't want to bother my head with such things. I have been slaving away on nature the whole year, hardly thinking of Impressionism or of this, that, and the other. And yet, once again I let myself go reaching for stars that are too big—a new failure—and I have had enough of it." [B21 F, December 1889] The path of nature, which van Gogh set out on six years earlier, had led to the incandescent light of stars that are too large and inaccessible. An infinity that both dazzled and repulsed. The notion of nature against which van Gogh measured himself was not a motif but a faith, a quest that demanded an ascetic devotion: "I think that if one has tried to follow the great masters attentively, one finds them all back at certain moments, deep in reality; I mean one will see their so-called creations in reality if one has similar eyes, a similar sentiment, as they had. . . . One must look much and long at nature before one becomes convinced that the most touching things the great masters have painted still originate in life and reality itself. A basis of sound poetry, which exists eternally as a fact and can be found if one digs and seeks deeply enough. '*Ce qui ne passe dans se qui passe*' [the residue that remains after the rest is gone], it exists." [Emphasis by van Gogh; 393 D, January 1885]

Van Gogh's portraits are analogous to the awesome stars in the sky over Saint-Rémy. They remain, *ce qui ne passe dans ce qui passe*; his presence outside the passage of time. Van Gogh, here, now, and always. The paintings keep alive the prayer and the summons, *hic et nunc et semper*.

The Motif

. . . Painting becomes stimulating and exciting to me, like hunting—in fact, it is a hunt for models and beautiful spots. [411 D, June 1885]

The hunt for van Gogh, this lucid, passionate, serene man, was always the same—at Drenthe, in the country around Nuenen, in Crau and Camargue, in the fields of Auvers-sur-Oise.

In Drenthe, in November 1883:

"The broad-fronted houses here stand between oak trees of a splendid bronze. In the moss are tones of gold green; in the ground, tones of reddish or bluish or yellowish dark lilac gray; in the green of the cornfields, tones of inexpressible purity; on the wet trunks, tones of black, contrasting with the golden rain of whirling, clustering autumn leaves hanging—in loose tufts, as if they had been blown there, and with the sky glimmering through them—from the poplars, the birches, the lime and apple trees.

"The sky smooth and clear, luminous, not white but a lilac that can hardly be deciphered, white shimmering with red, blue, and yellow in which everything is reflected and which one feels everywhere above one, which is vaporous and merges into the thin mist below— harmonizing everything in a gamut of delicate gray. . . .

"For the moment the whole country around Zweeloo is entirely covered—as far as the eye can see—with young corn, the very, very tenderest green I know.

"With a sky over it of a delicate lilac-white, which gives an effect—I don't think it can be painted, but it is for me the keynote that one must know in order to understand the keynotes of other effects.

"A black patch of earth—flat—infinite—a clear sky of delicate lilac-white. The young corn sprouts from that earth, it is almost moldy-looking with that corn. That's what the good fertile parts of Drenthe are basically; the whole in a hazy atmosphere. . . .

"The poor soil of Drenthe is just the same—but the black earth is even blacker still—like soot—not lilac-black like the furrows, and drearily covered with ever-rotting heather and peat. . . .

"That day passed like a dream; all day I was so absorbed in that poignant music that I literally forgot even food and drink—I had taken a piece of brown bread and a cup of coffee in the little inn where I drew the spinning wheel. The day was over, and from dawn till twilight, or rather from one night till the other, I had lost myself in that symphony.

"I came home, and sitting by the fire, I felt I was hungry, yes, very hungry. But now you see how it is here. One is feeling exactly as if one had been to an exhibition of the *Cent chef-d'oeuvres*, for instance;

what does one bring home from such a day? Only a number of rough sketches. Yet there is another thing one brings home—a calm ardor for work." [340 D, November 1883]

In Arles in April 1888:

"At the moment I am absorbed in the blooming fruit trees, pink peach trees, yellow-white pear trees. My brush stroke has no system at all. I hit the canvas with irregular touches of the brush, which I leave as they are. Patches of thickly laid-on color, spots of canvas left uncovered, here and there portions that are left absolutely unfinished, repetitions, savageries; in short, I am inclined to think that the result is so disquieting and irritating as to be a godsend to those people who have fixed preconceived ideas about technique. For that matter, here is a sketch, the entrance to a Provençal orchard with its yellow fences, its enclosure of black cypresses (against the mistral), its characteristic vegetables of varying greens: yellow lettuces, onions, garlic, emerald leeks.

"Working directly on the spot all the time, I try to grasp what is essential in the drawing; later I fill in the spaces that are bounded by contours—either expressed or not, but in any case *felt*—with tones that are also simplified, by which I mean that all that is going to be soil will share the same violetlike tone, that the whole sky will have a blue tint, that the green vegetation will be either green-blue or green-yellow, purposely exaggerating the yellows and blues in this case." [B3 F, April 1888]

At Auvers-sur-Oise in July 1890: "I myself am quite absorbed in the immense plain with wheatfields against the hills, boundless as a sea, delicate yellow, delicate soft green, the delicate violet of a dug-up and weeded piece of soil, checkered at regular intervals with the green of flowering potato plants, everything under a sky of delicate blue, white, pink, violet tones.

"I am in a mood of almost too much calmness, in the mood to paint this." [650 D, July 1890]

These descriptions trace the most intimate experience of painting; they are not particularly scrupulous or meticulous descriptions of any single drawing or painting. *The White Orchard, The Orchard in Flower, Apricot Trees in Flower near Arles, The Garden with Trees in Flower* are all the same painting revisited, as are *The Field of Green Wheat, The Field under a Stormy Sky*, or *The Field of Wheat with Crows.*

These landscapes are not simply motifs. Van Gogh grounded himself in what he saw. ". . . From dawn to dusk, or more precisely from one night to the next, I *lost* myself in that symphony," he wrote in Drenthe just as, seven years later in Auvers, he wrote: "I am entirely absorbed by that infinite expanse of fields of wheat." Van Gogh *became* what he painted. And the alchemy that is painting required that he

melt away, almost that he disappear, to do so. Communion, fusion, experience of a mystical nature.

Van Gogh's self-portraits constitute the quintessence of his presence. It was in himself that van Gogh dissolved. He mused: "I couldn't help thinking of Cézanne from time to time, at exactly those moments when I realized how clumsy his touch in certain studies is—excuse the word *clumsy*—seeing that he probably did these studies when the mistral was blowing. As half the time I am faced with the same difficulty, I get an idea of why Cézanne's touch is sometimes so sure, whereas at other times it appears awkward. It's his easel that's reeling." [B9 F, June–July 1888]

In the rooms on Laval or Lepic streets in Paris, in the yellow house in Arles, in his room in the asylum at Saint-Rémy, van Gogh's easel, drawn close to face him while he turned toward a mirror, did not reel in the wind. There is nothing in his portraits that could be described as clumsy.

To Speak of Oneself

I hate writing about myself, and I have no idea why I do it. [W4 D, June 1888]

Van Gogh wrote those words to his sister Wilhelmina in June 1888 and then offered a possible rejoinder: "Perhaps I do it in order to answer your questions." For fifteen years he wrote regularly to his brother Théo, telling him everything—what he attempted and when he failed, as well as the nature of his obsessions. He did not interrupt that correspondence—other than during the two years he lived in Paris, when there would have been no need to write to a brother sharing the same apartment—except for the period between October 1879 and July 1880, months spend at Cuesmes in the Borinage, where a miserable van Gogh was preaching, offering spiritual consolation and material aid, sacrificing himself in vain.

"... I am up against a stone wall and in a sort of mess. ... Involuntarily, I have become more or less a kind of impossible and suspect personage in the family, at least somebody whom they do not trust, so how could I in any way be of any use to anybody? Therefore, above all, I think the best and most reasonable thing for me to do is to go away and keep at a convenient distance, so that I cease to exist for you all." [133 F, July 1880] When at the age of twenty-seven he wrote those words he had not yet decided to become a painter. And becoming a painter changed nothing. He remained the same "impossible and suspect personage" who continued to "cease to exist." Worse, the choice of painting seemed both to justify and to render still more suspect his dissatisfied, impetuous, and rough nature. July 1883: "It is practically always so painful for me to speak to other people. I am not afraid of it, but I know I make an unfavorable impression. The chance of changing this is sometimes destroyed by the fact that one's work would suffer if one lived differently." [312 D, July 1883] January 1884: "In the daytime, in ordinary life, I may sometimes look as thick-skinned as a wild boar, and I can understand perfectly well that people think me *coarse*. When I was younger I thought, much more than now, that things depended on chance, on small things or misunderstandings that had no reason. But getting older, I feel it more and more differently, and see deeper motives." [345 D, January 1884] One of these was the necessity painting represented to him. "I tell you, I consciously choose the dog's path through life; I will remain a dog, I shall be poor, I shall be a painter, I want to remain human—going into nature. In my opinion the man who goes out of nature, whose head is always stuffed with thoughts of maintaining this and maintaining that, even if this causes him to go out of nature to such an extent that he cannot but acknowledge it—oh, in this way one is apt to arrive at a point

where one can no longer distinguish white from black—and—and one becomes the exact opposite of what one is considered and of what one thinks oneself to be." [347 D, December–January 1884] But I am not sure that the self-portraits showing van Gogh to be rough—jaws clamped down on a pipe, mouth tightly shut, with a coarse beard and a cap or hat of felt or straw—reflect his true character.

Van Gogh spent two years in Paris. He arrived there on 28 February 1886. While in Paris he painted twenty-seven self-portraits and began a twenth-eighth, which he would complete in Arles, where he headed on 21 February 1888. The sour look retained its intensity from canvas to canvas. The early ones are somber. A raw light cuts across the surface of the face against a dense background of brown and copper. The somber textures in the early work are overtaken, little by little, by the color as the brush strokes seem less and less to vibrate, dissolve, and break apart. And then the colors become arbitrary gashes that punctuate the whole painting. The blue of a background marks with indifference the ridge of a brow, flattens a wrinkle joining the wing of the nose to the corner of the upper lip, and heightens the ochers and reds of the beard. The portraits for which he wore a plain shirt or smock grew rare. Van Gogh had silk-lined jackets, stiff-collared shirts, loose neckties and bow ties. Of the self-portraits painted in Paris, the one known by its gray felt hat (see illustration 16) is the most urbane. Three years earlier he had admitted: ". . . I know full well myself that in many respects I personally am very difficult to deal with." [348 D, December 1883–January 1884]

By the time van Gogh left Paris, his self-portraits were almost entirely concerned with color. Van Gogh the model had not changed. Théo wrote: "Life is practically intolerable; no one can come to my home any longer because Vincent only picks a fight. . . . I hope he goes and finds someplace where he can be alone."

The situation had become a mess. At the end of his time in Arles, a resigned van Gogh confirmed: "And the future? Either I shall become wholly indifferent to all that does not belong to the work of painting, or . . . I dare not expatiate on the theme, seeing that this becoming exclusively a painting machine, unfit for and uninterested in anything else, may be so much better or worse than the average. It might be pretty easy for me to resign myself to the average, and so be it for the present, for I am now in the same mess as in the past." [W4 D, June or July 1888] The same word he had used at Cuesmes, eight years earlier. Still and always a mess.

When it became clear that Van Gogh would never return to the yellow house in Arles, he got rid of everything, with one exception: "As for the remaining furniture, by my faith there is, for example, the mirror that I wouldn't mind having. Tape strips of paper to the front

to prevent it from breaking." The mirror was the site of an essential metamorphosis.

The self-portraits he painted opposite this mirror did not resemble him less than those he'd painted in Paris; nor did they resemble him more. He never painted portraits of himself as a wild boar or a dog. But from canvas to canvas, his self-portraits increasingly resembled the kind of painting he made up. He sacrificed himself to painting, and his self-portraits were less and less concerned with him as subject than with him as painter, less of him than by him. They did not comprise any kind of official representation of the artist. Van Gogh did not paint himself in order to be recognized. By whom would he be recognized? His self-portraits were not destined for an academy or a gallery like the one in Florence, a kind of Pantheon for painters, for which Jules Breton, whom van Gogh admired, had painted his self-portrait on the back of a rosette of the Legion of Honor in 1879—portrait of a career. Van Gogh's painting was of a different order. It got the better of him, of both his character and his crises, and the expression on his face in his self-portraits was itself a kind of incarnation of painting. ". . . I shall always see with my own eyes, and render things originally." [434 D, November 1885] The very word *always* would remain an unchanging challenge, an expression of van Gogh's will and confidence, constituting his only true biography.

As for me, I am chained to misfortune and failure;
it is damned hard at times, but never mind, for all that
I do not envy the so-called fortunates and the ever successful,
as I can see through it too much.

Vincent to Théo, Nuenen
December 1883–January 1884, Letter 350a in Dutch

23. *Self-Portrait*,
Paris, 1887, oil on canvas, 41 × 31.5 cm,
New York, Metropolitan Museum of Art.

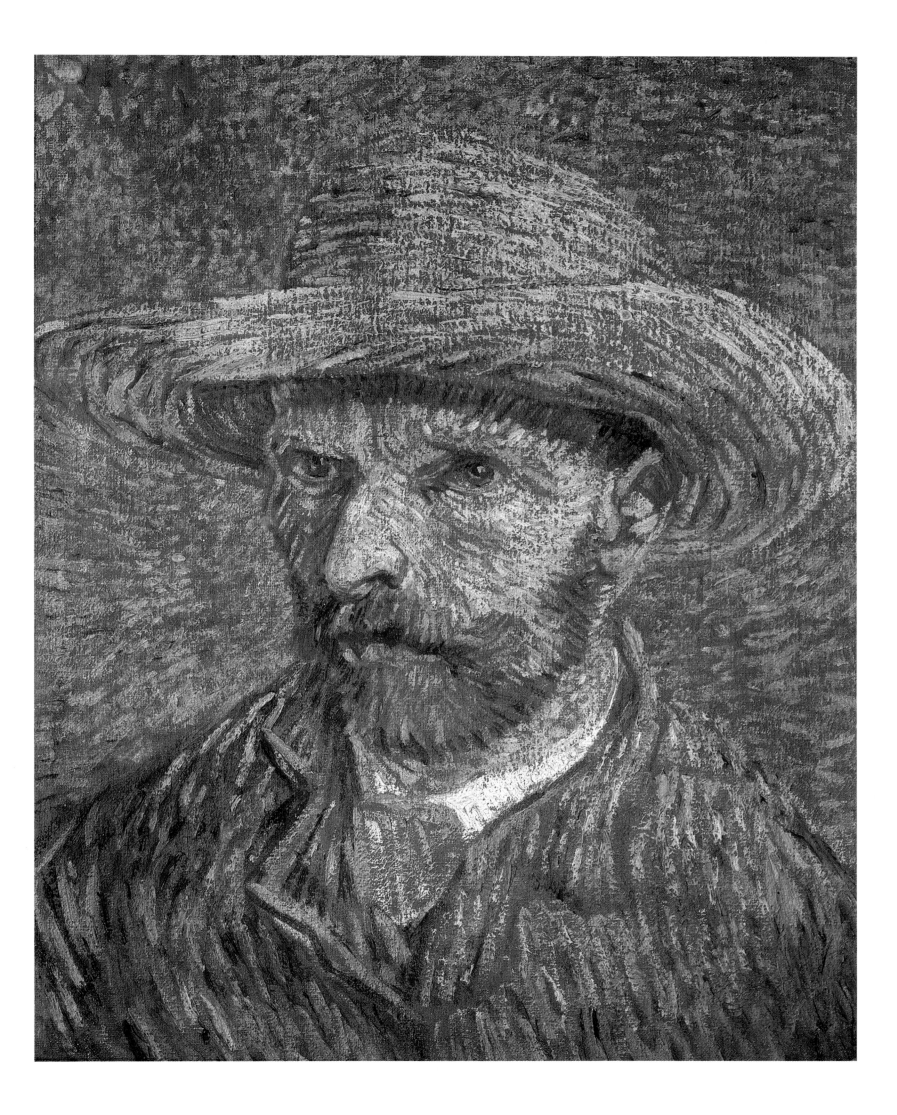

*I am forced to be the most disagreeable of all persons,
namely, I have to ask for money.*

Vincent to Théo, Nuenen,
July 1885, Letter 418 in Dutch

24. *Self-Portrait*,
Paris, summer 1887, oil on canvas, 41 × 33 cm,
Amsterdam, Rijksmuseum Vincent van Gogh.

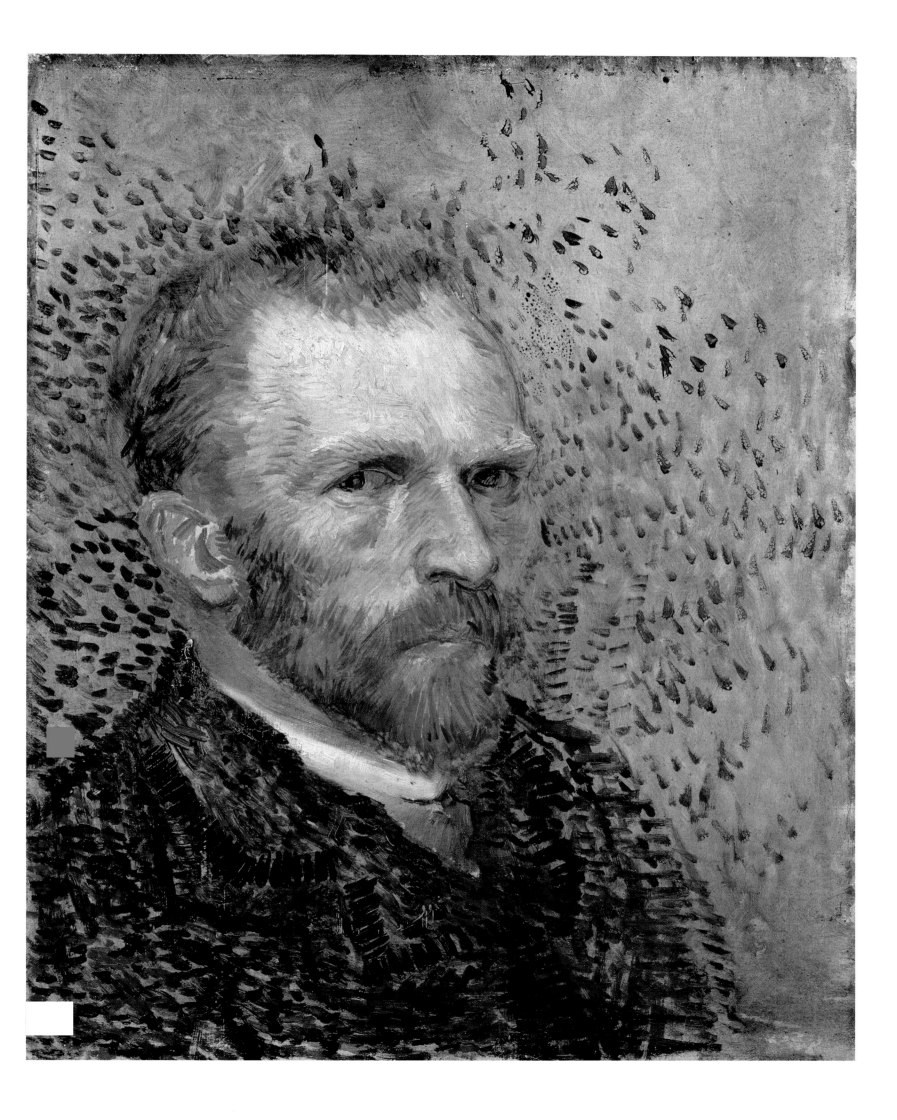

*I too should like to know approximately what I am,
the larva of myself, perhaps.*

Vincent to Émile Bernard, Arles,
early July 1888, Letter B9 in French

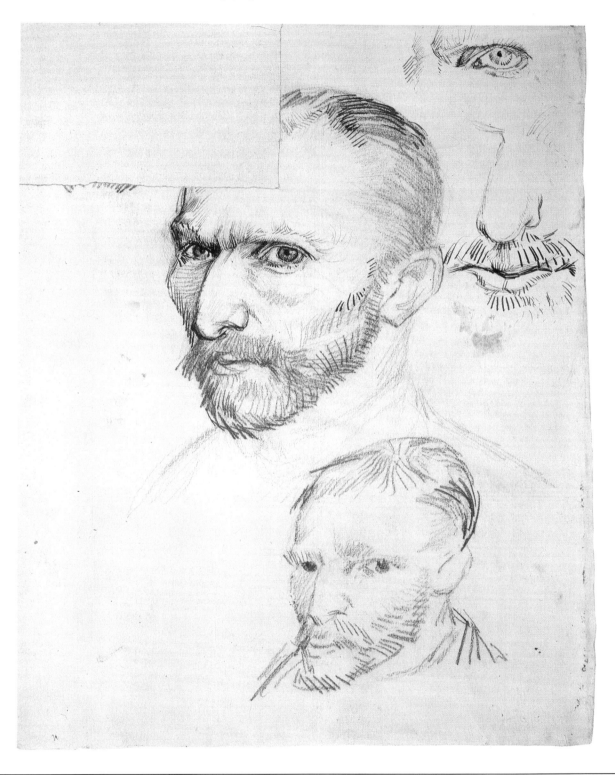

25. Two self-portraits and fragments of a third,
Paris, summer 1887, lead pencil and India ink on paper,
31.6 × 24.1 cm,
Amsterdam, Rijksmuseum Vincent van Gogh.

26. *Self-Portrait*,
Paris, summer 1887, oil on paper, 34.5 × 25.5 cm,
Otterlo, Rijksmuseum Kröller-Müller.

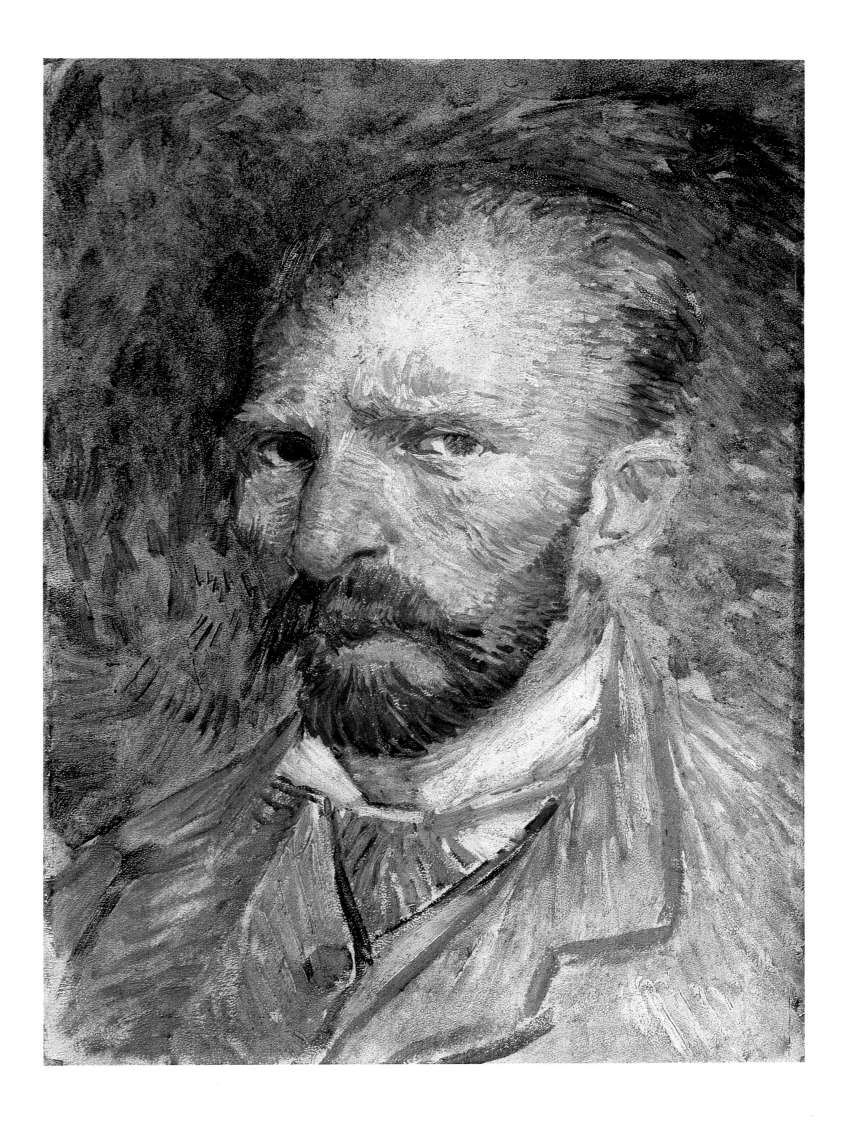

You do not know how paralyzing that staring of a blank canvas is; it says to the painter, "You can't do anything."
The canvas stares at you like an idiot, and it hypnotizes some painters, so that they themselves become idiots.

Vincent to Théo, Nuenen,
October 1884, Letter 378 in Dutch

27. *Self-Portrait*,
Paris, fall 1887, oil on canvas, 46.5 × 35.5 cm,
Zurich, Stiftung Sammlung E. G. Bürhle.

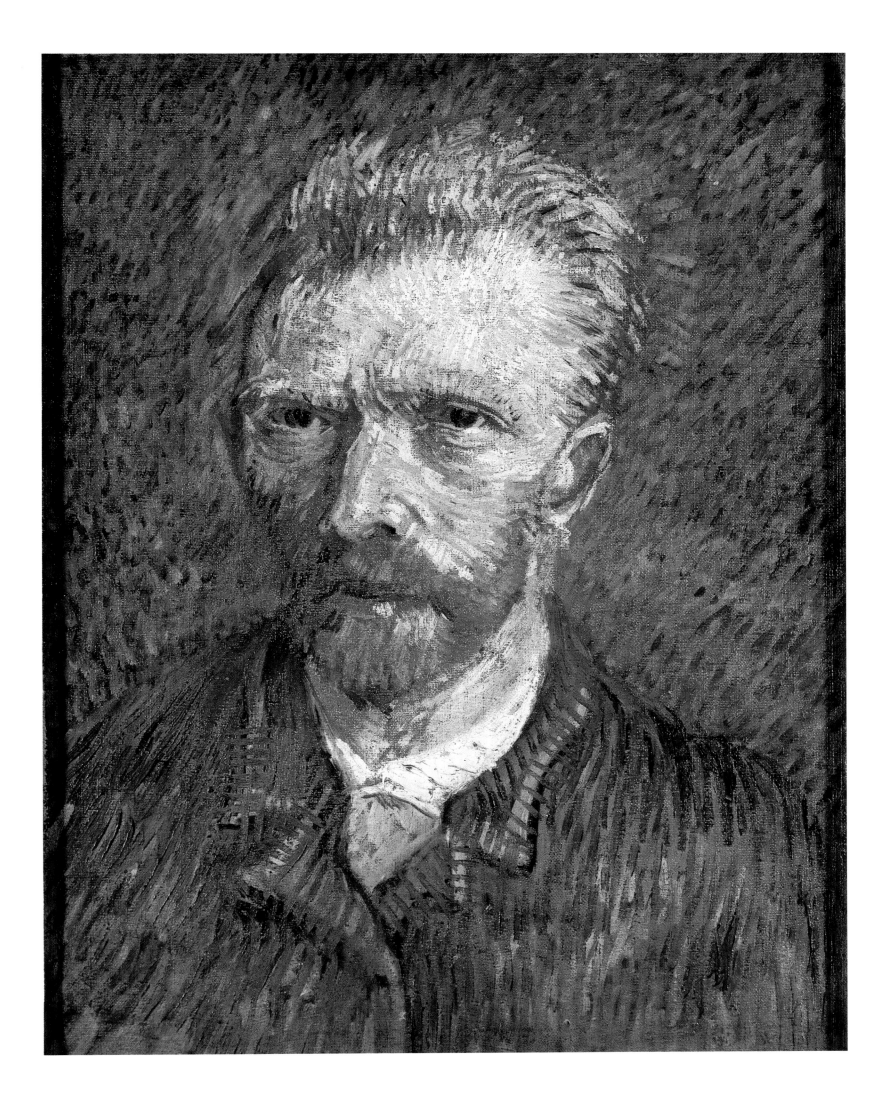

For love is something so positive, so strong, so real that it is as
impossible for one who loves to take back that feeling
as it is to take his own life. If you reply to this
by saying, "But there are people who put an end to their own
life," I simply answer, "I really do not think
I am a man with such inclinations."

Vincent to Théo, Etten,
7 November 1881, Letter 154 in Dutch

28. *Self-Portrait,*
Paris, fall 1887, oil on canvas, 47 × 35 cm,
Paris, The Louvre.

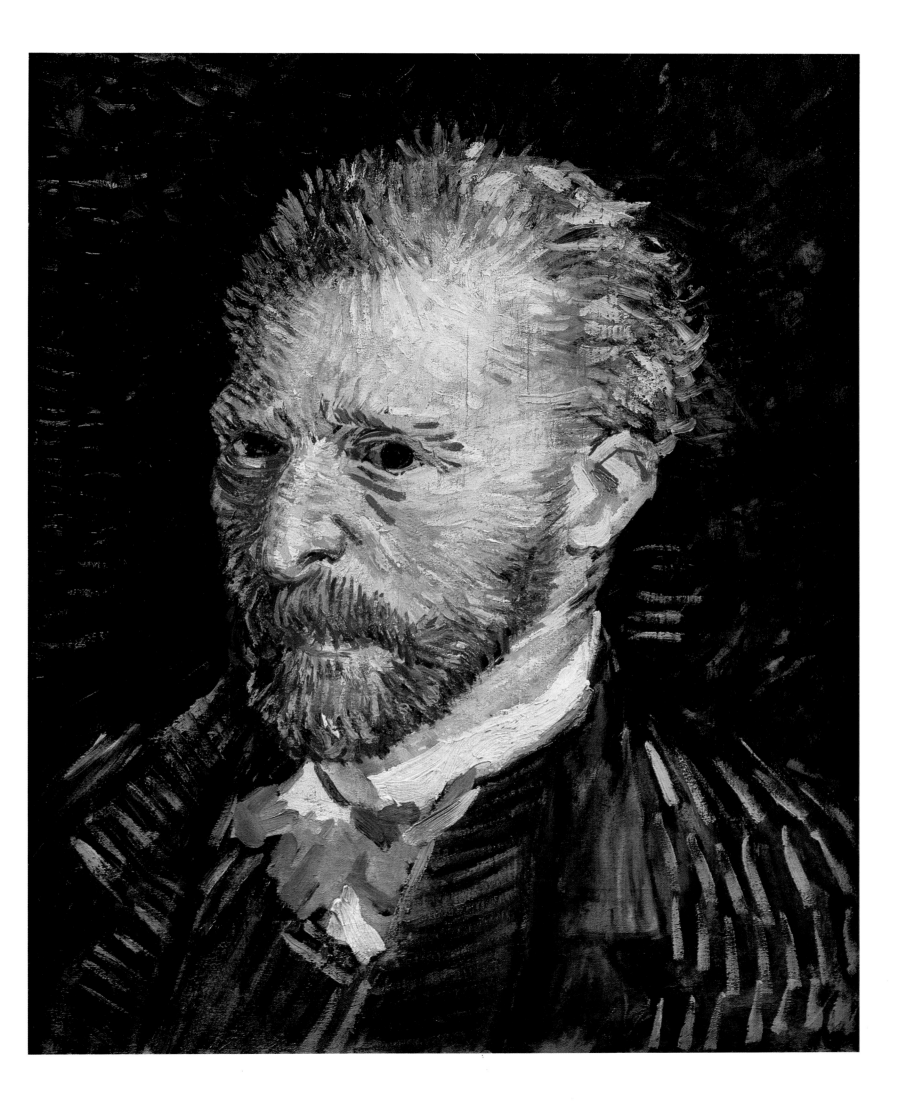

Van Gogh's Body

. . . Though the core is still all right, yet I am but a ruin compared to what I might have been. [453 D, February 1886]

Van Gogh's face was ageless. It was graven with proofs: hunger, illness, loneliness. At the age of thirty-three, when for the first time he painted himself, he was worn out, haggard, emaciated. His self-portraits, riddled with color, are not meant to show the effects of age, the passage of time. Hardly five years passed between the very first and the very last of them. Time could not be held accountable for van Gogh's ravaged face. He painted himself for barely five years, as if time had been delayed, as if these were portraits outside of time. And regardless of the way the subject was treated in the self-portraits, regardless of the brush stroke or the palette, the expression on the eyes in each was the same, a keen, scared, stupefied look. It was his intensity and his strength that he painted. These were first and foremost portraits of that expression in the eyes, portraits of an inaccessible van Gogh.

After the bandage was removed from his cut left ear, Van Gogh placed the mirror his used for painting himself to his right. The ear with its missing lobe did not appear. As in the other self-portraits painted prior to the crisis, van Gogh appears unscathed. There are no portraits of van Gogh with his ear cut. Although he did paint himself bandaged, he did not paint himself maimed.

The body of van Gogh was a body harried ceaselessly by pain. In the weeks before his arrival in Paris, van Gogh wrote: "When I compare myself to the other fellows, there is something stiff and awkward about me, as if I had been in prison for ten years. And the cause of this is that for about ten years I have had a difficult and harassed life, much care and sorrow and no friends. But that will change as my work gets better, and I shall know something and be able to do something. And I repeat, we are on the right track to accomplishing this. But do not doubt it, the way to succeed is to keep courage and patience and to work on energetically. And it is a fact that I must change my outward appearance somewhat. Perhaps you will say that has nothing to do with art, but on the other hand, perhaps you will agree with me! I am having my teeth seen to, for instance; there are no fewer than ten teeth that I have either lost or may lose, and that is too many and too troublesome, and besides, it makes me look over forty, which is not to my advantage." [448 D, February 1886]

A few months after having arrived in Paris, he wrote to his sister: "My own adventures are restricted chiefly to making swift progress toward growing a little old man, you know, with wrinkles and a tough beard and a number of false teeth, and so on. But what does it matter?

I have a dirty and hard profession—painting—and if I were not what I am, I should not paint; but being what I am, I often work with pleasure, and in the hazy distance I see the possibility of making pictures in which there will be some youth and freshness, even though my own youth is one of the things I have lost." [W1 D, summer or fall 1887]

Van Gogh was without bitterness. He accepted that the state of his appearance was his own doing. On 28 December 1885, he confessed to Théo having some years previously visited a doctor in Amsterdam: ". . . How glad I was when this doctor took me for an ordinary workingman and said, 'I suppose you are an ironworker.' That is just what I have tried to change in myself; when I was younger, I looked like one who was intellectually overwrought, and now I look like a bargeman or an ironworker." [442 D, 28 December 1885] But this bargeman had over the years dedicated his body to painting and to nothing else:

"Sometimes I cannot believe that I am only thirty years old, I feel so much older.

"I feel older only when I think that most people who know me consider me a failure and that it might really be so if some things do not change for the better; and when I think it might be so, I feel it so intensely that it quite depresses me and makes me as downhearted as if it were really so. In a calmer and more normal mood I am sometimes glad that thirty years have passed, and not without teaching me something for the future, and I feel strength and energy for the next thirty years, if I live that long.

"And in my imagination I see years of serious work ahead of me, and happier than the first thirty.

"How it will be in reality doesn't depend only on myself; the world and circumstances must also contribute to it.

"What concerns me and what I am responsible for is making the most of the circumstances and trying my best to make progress." [265 D, 8 February 1883]

He grew angry only at himself. "Sometimes I am perfectly furious with myself, for it isn't good enough to be either more or less ill than the rest; the ideal would be a constitution tough enough to live till eighty, and besides that, blood in one's veins that would be right good blood." [467 F, February–March 1888]

Did he hate the body on which his ability to paint, and thus the strength of his painting, depended? Resigned and angry sentences pepper his letters. July 1883: "Recently I have seen only too clearly that my physical condition influences my work." [304 D, July 1883] February 1886: "It is not at all pleasant, but necessity knows no law, and if one wants to paint pictures, one must try to stay alive and keep

one's strength." [448 D, February 1886] May 1888: "I don't see the whole future black, but I do see it bristling with difficulties, and sometimes I ask myself if they won't be too much for me. But this is mostly in moments of physical weakness, and last week I had such a fierce toothache that much against my will I had to waste time." [480 F, May 1888] In order to paint, he relentlessly called upon a body that, answering the summons, proved to be exhausted, broken, an obstacle to painting. This body, which caused him to lose time, which was shattered by crises like the ones at Arles, at Saint-Rémy, and at Auvers, was a traitor and could not have been otherwise. After April 1882, van Gogh knew what he could depend on: "I shall have to suffer much, especially from those peculiarities which I cannot change. First, my appearance and my way of speaking and my clothes; and then, even later on when I earn more, I shall always move in a different sphere from most painters because my conception of things, the subjects I want to make, inexorably demand it." [190 D, April 1882]

The body and face he saw in the mirror were sacrifices to painting. Van Gogh knew this. He painted himself about thirty times in four years, because it was urgent that he do so. On 27 July 1890, when he shot a bullet into his chest, he wasn't so much killing himself as putting on the finishing touches.

The course of time that affronted van Gogh was different from that which had challenged Rembrandt. Rembrandt, engraving, drawing, and painting his self-portrait, dealt with Time in its grandeur and power for more than forty years. The course of time for Rembrandt was cosmic; for van Gogh it was quotidian. Van Gogh dealt with urgency and immediacy: "I think the poor people and the painters have that feeling for the weather and the changing seasons in common. Of course, everybody feels it, but it is not so important to the well-to-do middle class, and it doesn't influence their general frame of mind very much. I thought something a navvy said typical, 'In winter I suffer as much from the cold as the winter corn does.' " [265 D, 8 February 1883] In September 1889, van Gogh wrote to Théo from the hospice at Saint-Rémy-de-Provence: "This blasted artistic life is shattering, it seems. My strength is returning from day to day, and I feel again that I already have almost too much. For it isn't necessary to be a Hercules to stick assiduously to the easel." [604 F, September 1889] He needed to have only enough strength to paint.

Painting Portraits of Oneself

. . . And it isn't an easy job to paint oneself. [W4, June or July 1888]

Van Gogh was alone. And the self-portraits he painted were those of his seclusion. To paint oneself was to plumb the very depths of one's isolation and then to continue desperately to paint despite what one found there.

Van Gogh's portraits separated themselves from their models. ". . . They thought that they were 'badly done,' because *it was only pictures full of painting* that I did. The poor little souls are afraid of being compromised and that people will laugh at their portraits." [Emphasis by van Gogh; 524 F, July–August 1888] And with his models either discouraged or frightened away, van Gogh was unable to paint. He had no choice if he was going to produce work in painting's essential form, portraiture—he would have to paint himself. In September 1888, he announced: "I purposely bought a mirror good enough to enable me to work from my image in default of a model." [537 F, 16 September 1888; see illustration 34] One year later, in September 1889, the situation was still the same as regards both his seclusion and its significance: "I am working on two portraits of myself at this moment—for want of another model." [604 F, September 1889; see illustrations 45 and 46]

The self-portraits of these years broke up his loneliness just as they filled the letters that nearly every day he sent to his brother. The monologue they comprise was the only voice that cut into the long silence of his days. He had no one to speak to and no one who spoke to him or looked after him. From the time van Gogh severed his ear lobe onward, the self-portraits he included with his letters became "health bulletins." Painting himself was no longer simply an evasion of his loneliness, but evidence that the crises that lacerated and depressed him had receded. To paint himself was an expression of his will to distance himself further from these crises, relegating them to the past. And portraiture could describe this better than words. "I am even inclined to think that the portrait will tell you how I am better than my letter, and that it will reassure you." [604 F, September 1889; see illustration 45] "[In] my portrait . . . you will see, I hope, that my face is much calmer, though it seems to me that my look is vaguer than before." [607 F, September–November 1889; see illustration 44]

To paint oneself was to exercise newfound lucidity. In the midst of the most complete isolation he had experienced in years, condemned to justify his debts and his expenses by fierce application to his work, he had to make up for the time lost when crises had thrown him outside of himself into an abyss of harsh noises and unearthly shrieks (van Gogh *heard* his crises approach, and it was this awful hissing

above all that terrified him). His self-portraits comprised a cure, a convalescence. It was no coincidence, then, if he inserted in them certain necessary landmarks: In January 1889, behind his *Self-Portrait with a Bandaged Ear* (illustration 42), a print by Sato Torakiyo on one side of his head and a standing easel on the other; and beside the green smock in the foreground the canvas was left partly unpainted. And in September, interned at Saint-Rémy, he shows that mark of his profession, the bent thumb though the palette gripping a bundle of paintbrushes (illustration 44). A print similar to those of Hokusai, Utagawa, Hiroshighe, and Toyokuni III painted in the autumn of 1887 after the elder Tanguy; a palette and paintbrushes; a canvas on an easel—van Gogh painted himself surrounded by the things with which he identified. The features of his face alone would not have sufficed. He needed the accoutrements of the painter in his studio as necessary epithets. These self-portraits were those of van Gogh's conscience. In them he was working to repossess himself, to rediscover, beyond his immediate, hopeless circumstances, his destiny, that which painting had assigned him: "I *should like* to paint portraits that would appear after a century to the people living then as apparitions." [Emphasis in the conditional tense by van Gogh; W22 F, June 1890]

And these apparitions were but "pictures full of painting."

CHAPTER 18

The Difficult Time

. . . It is less a golden age than an iron age for painters—I mean, it is not exactly easy for them to keep alive—no more than that. At least as far as I am concerned it is misère ouverte. [R57 D, September 1885]

The letters of van Gogh constituted one long lament, a bass continuum so powerful that it overcame his actual voice. His piercing misery appears to be the cause of his despair and eventual suicide—van Gogh destroyed by so many privations. But it wasn't the years of misery, but what painting demanded of him, that killed him. Van Gogh's undoing was the result of his having chosen the profession of painter, the consequence of his vocation. When he *chose painting*, he took vows of poverty. Painting required exorbitant tribute. His first priorities had to be the canvases to paint, the body of work to accomplish.

Letter after letter, over the years, the same fact was restated again and again: Painting devoured everything. July 1883: "In order to save time I have not spared myself, pinched on everything just to work on, but now I am absolutely drained. I can draw no more bills on my personal needs, on that side not a drop can be squeezed out, there is sickness and dryness." [303 D, July 1883] Later that same month: "Still, my health is not thoroughly or chronically upset; it has not been caused by excesses, but by too long a period with insufficient and unsubstantial food." [304 D, July 1883] And in September 1883, as always it was the work that must come first: "The most important thing is to get that *'quelque chose de mâle'* ['something manly'] more and more into my work. I don't believe you will need to take back that you notice something of it already, especially if I regain my strength. It is very troublesome that my stomach is upset by even the most ordinary food, and if I followed my inclination, I should only care to eat—sour apples. I don't indulge myself in this, but my stomach is weaker than it ought to be." [316 D, September 1883] And finally, in September 1884, just as painting prevailed over hunger, so did it prevail over exhaustion. "Recently I have been working very hard; I believe, what with other emotions, I have even overworked myself. For I am in a melancholy mood, and all these things have combined to upset me in such a way that there are many days when I am almost paralyzed." [380 D, September 1884]

On one occasion, and one only, van Gogh requested money from Théo for a reason other than painting. December 1885: "Write me again if you should have time. The end of the month will certainly be terrible unless you can help me a little more. A great deal may depend on my

being able to stick to my guns. And one must not look hungry or shabby either. On the contrary, one must try to make things hum." [438 D, December 1885] To make things hum . . . A few days later in Anvers, painting had regained pride of place as his exclusive obsession. ". . . In the whole time I've been here, I've had only three warm meals, and for the rest nothing but bread? In this way one becomes vegetarian more than is good for one—especially as it was the same thing in Nuenen for half a year, and even then I could not make ends meet on account of my color bill." [440 D, December 1885] He was no nearer to making ends meet in Anvers: "While all I have to live on is my breakfast served by the people I live with, and in the evening for supper a cup of coffee and some bread in the dairy, or else a loaf of rye bread that I have in my trunk." [442 D, 28 December 1885] And ever the same questions: "And I ask you, can one do what is absolutely necessary with what remains for one's own use after paying for painting materials, models, and rent?" [443 D, January 1885]

Three years later, in Arles, nothing had changed. April 1888: "So far I have spent more on my paints, canvas, etc., than on myself." [475 F, April 1888] "I ate something at noon, but already this evening I shall have to sup on a crust of bread. And the money is spent on nothing but the house, or else the pictures. It has been more than three weeks since I had so much as enough for a three-franc prostitute." [546 F, October 1888] Did he remember, on this evening in October 1888, the visit he had received in his "studio" in The Hague one day in March 1882? "And another thing touched me—very, very deeply. I had told the model not to come today—I didn't say why, but nevertheless the poor woman came, and I protested. 'Yes, but I have not come to pose—I just came to see if you had something for dinner.' She had brought me a dish of beans and potatoes. There are things that make life worth living after all." [180 D, March 1882]

Van Gogh's self-portraits were of the head only. In them, the body was nearly an abstraction, the traditional body of portraiture. It was this body, amputated by convention and by prudishness, that van Gogh painted. A bust has neither gut nor genitalia. Every canvas that he placed on the easel, each tube of paint that he pressed to the palette in order to paint himself was a missed meal, a missed visit to the brothel. A meal at four francs, a tryst at three francs. A frame: ". . . The frames I use cost me five francs at the outside, whereas the gilt frames, which are less strong, would cost thirty or more. And if a picture shows to advantage in a simple frame, why put gilt around it?" [W15 F, October 1889]

Each of van Gogh's self-portraits was both a gift and a renunciation. The miserable body posing was no more than a practical expedient. Only the other body mattered, that which was composed in paint. And it was this transfigured body that van Gogh nourished with zinc white, cobalt, emerald green, orange ore, ultramarine, and geranium lacquer.

It is possible that these great geniuses are only madmen,
and that one must be mad oneself to have boundless faith in them
and a boundless admiration for them. If this is true, I should
prefer my insanity to the sanity of the others.

Vincent to Emile Bernard, Arles, late July 1888
Letter B13 in French

29. *Self-Portrait,*
Paris, 1887, oil on canvas, 46 ×38 cm,
Vienna, Kunsthistorisches Museum.

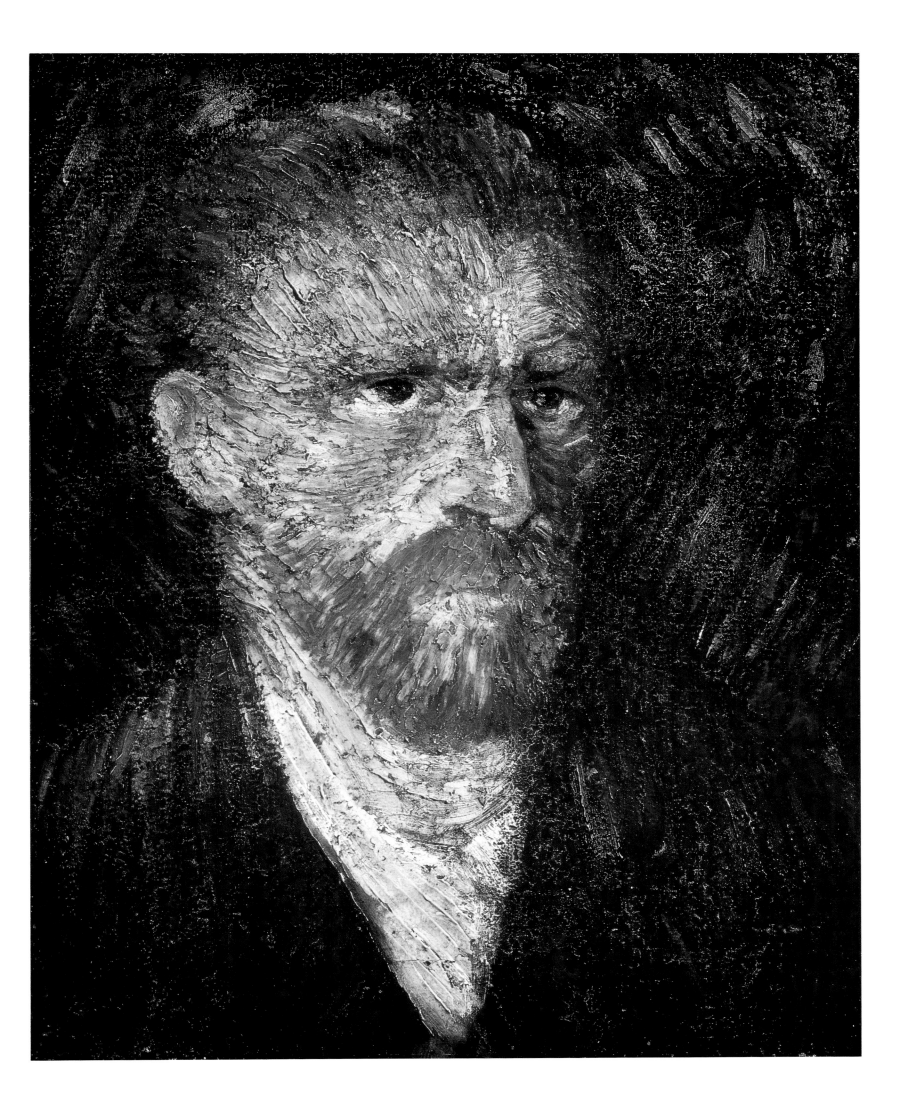

As for me, I am rather often uneasy in my mind,
because I think that my life has not been calm enough;
all those bitter disappointments, adversities, changes keep me
from developing fully and naturally in my artistic career.

Vincent to Wilhelmina, Arles, April 1889
Letter W11 in French

30. *Self-Portrait with Japanese Print,*
Paris, late 1887, oil on canvas, 44 × 35 cm,
Bâle, Kunstmuseum.

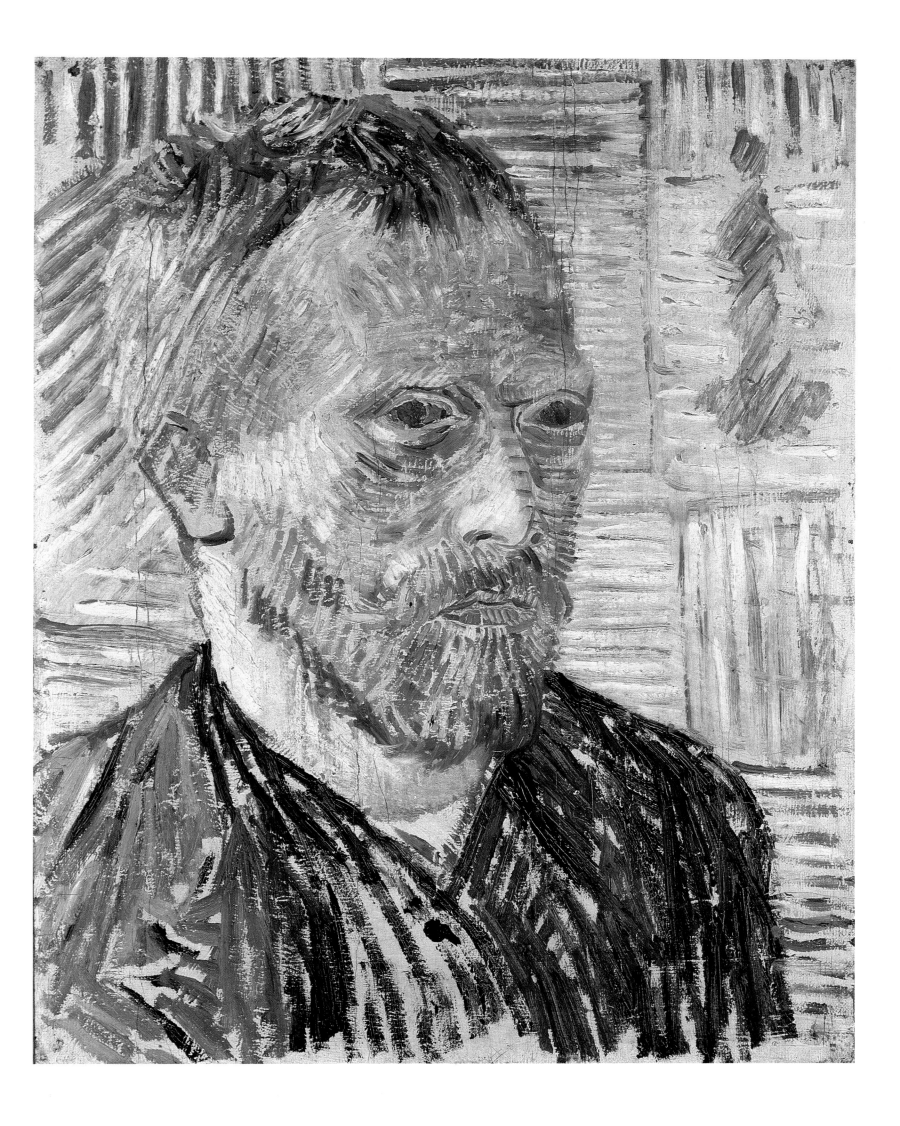

I don't think it improbable that some time I shall make things that will come into the public's hands, but it leaves me rather cold, and I don't consider it a pleasure at all.

Vincent to Théo, The Hague, November 1882
Letter 244 in Dutch

What strikes me here, and what makes painting so attractive, is the clearness of the air; you *cannot* know what this means, because this is exactly what we do not have in our country—but one distinguishes the color of things at an hour's distance; for instance the gray-green of the olive trees and the grass green of the meadows, and the pink-lilac of a dug-up field. In our country we see a vague gray line on the horizon; here even in the far, far distance the line is sharply defined, and its shape is clearly distinguishable. This gives one an idea of space and air.

Seeing that I am so busily occupied with myself just now, I want to try to paint my self-portrait in writing. In the first place I want to emphasize the fact that one and the same person may furnish motifs for very different portraits.

Here I give a conception of mine, which is the result of a portrait I painted in the mirror, and which is now in Théo's possession.

A pinkish-gray face with green eyes, ash-colored hair, wrinkles on the forehead and around the mouth, stiff, wooden, a very red beard, considerably neglected and mournful, but the lips are full, a blue peasant's blouse of coarse linen, and a palette with citron yellow, vermilion, malachite green, cobalt blue, in short all the colors on the palette except the orange beard, but only whole colors. The figure against a grayish-white wall.

You will say that this resembles somewhat, for instance, the face of—Death—in Van Eeden's book or some such thing—all right, but it is a figure like this—and it isn't an easy job to paint oneself—at any rate if it is to be *different* from a photograph. And you see—this, in my opinion, is the advantage that impressionism possesses over all the other things; it is not banal, and one seeks after a deeper resemblance than the photographer's.

However, at the present moment I took different, insofar as I am wearing neither hair nor beard, the same having been shaved off clean. Furthermore, my complexion has changed from green-grayish-pink to grayish-orange, and I am wearing a white suit instead of a blue one, and I am always very dusty, always more bristlingly loaded, like a porcupine, with sticks, painter's easel, canvases and further merchandise. Only the green eyes have remained the same, but of course another color in the portrait is the yellow straw hat, like a *hannekenmaaier's*,[1] and a very black little pipe—I live in a little yellow house with a green door and green blinds, whitewashed inside— on the white walls very brightly colored Japanese prints, red tiles on the floor—the house in the full sunlight—and over it an intensely blue sky, and—the shadows in the middle of the day much shorter than in our country. Well—can you understand that one may be able to paint something like this with only a few strokes of the brush? But can't you understand too that there are people who say, "This makes too queer an impression," not to mention those who think it a total abortion or utterly repulsive? But if only there is a likeness, but a likeness different from the products of the God-fearing photographer with his colorless phantoms—this is the aim.

Vincent to Wilhelmina, Arles,
June or July 1888, Letter W4 in Dutch

[1] Literally, "Little Jack the Mower (or Reaper)," seasonal laborers who in past centuries came to Holland from Western Germany as mowers or harvesters.

31. *Self-Portrait at the Easel*,
Paris, early 1888, oil on canvas, signed and dated on the lower right,
"Vincent 88," 65 × 50.5 cm,
Amsterdam, Risjksmuseum Vincent van Gogh.

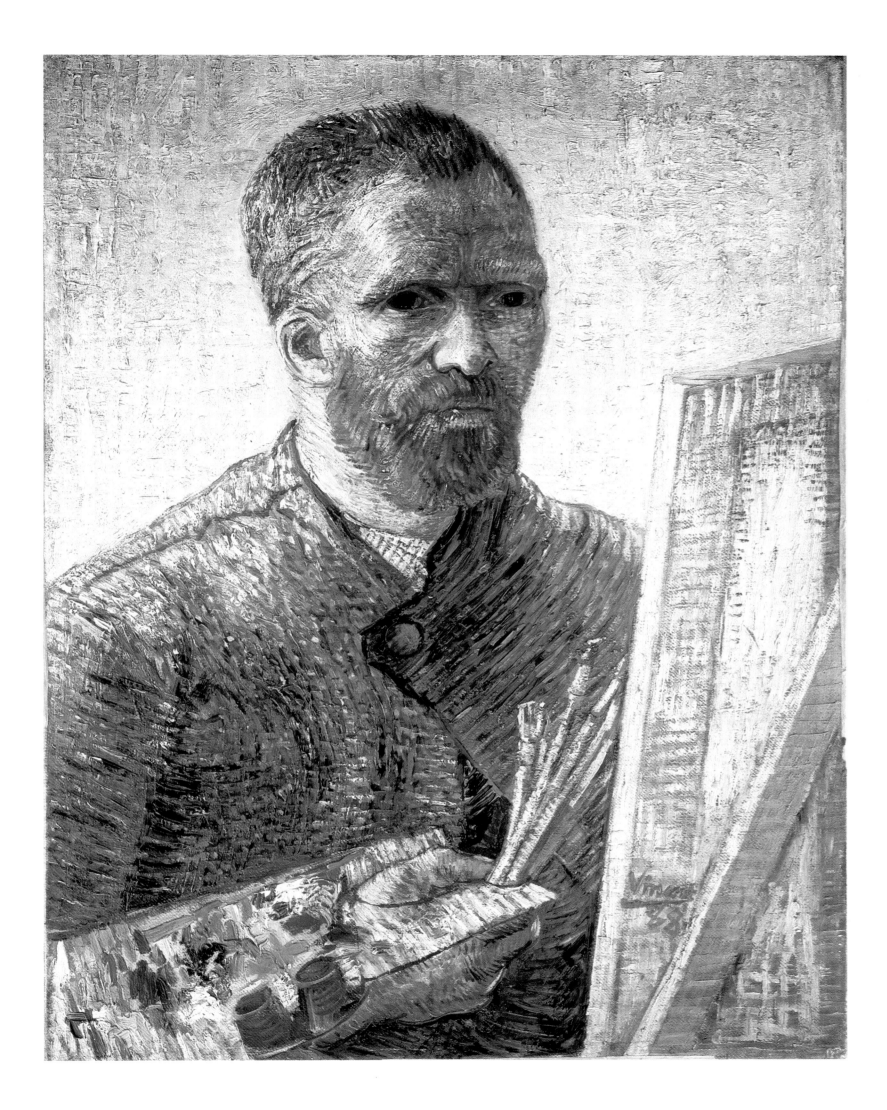

Ah, to paint figures as Claude Monet paints landscapes!
That still, in spite of everything, remains to be done.

Vincent to Théo, Saint-Rémy, May 1889
Letter 590 in French

32. *Self-Portrait*,
Arles, summer 1888, oil on canvas applied over board, 42 × 31 cm,
Amsterdam, Rijksmuseum Vincent van Gogh.

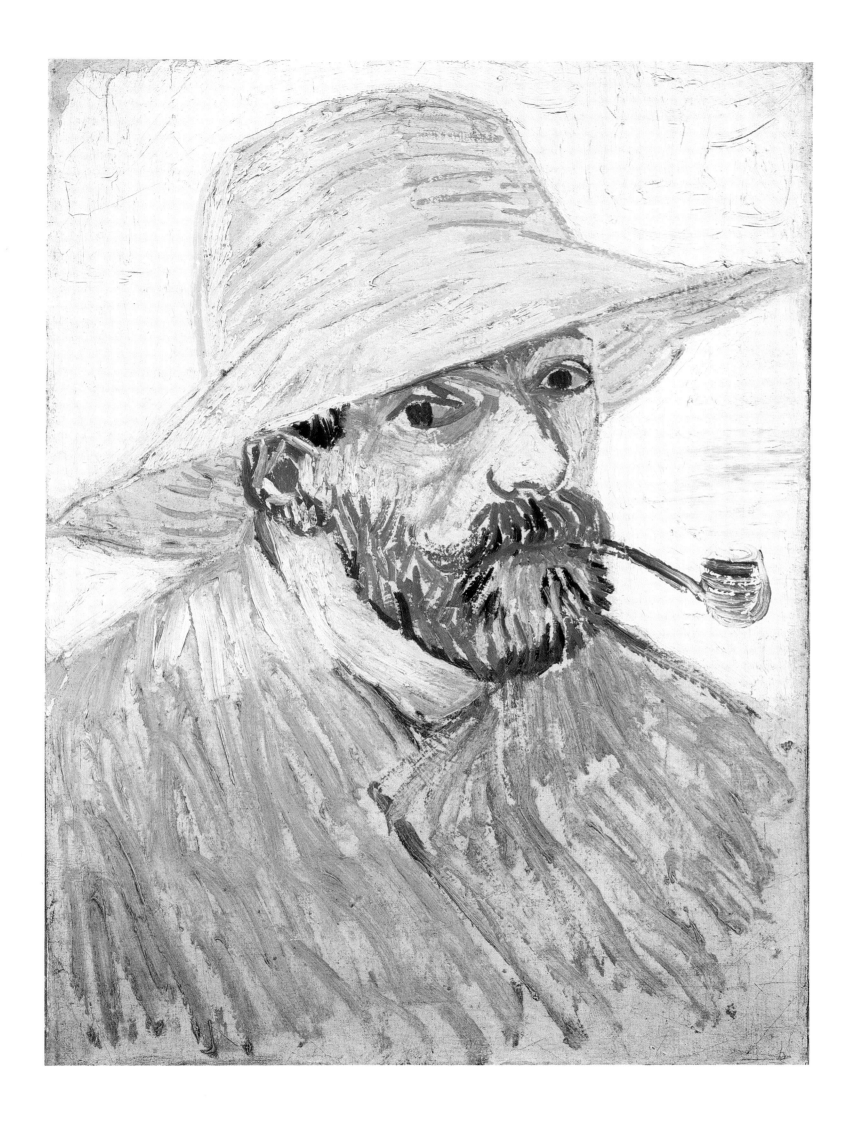

I always feel I am a traveler,
going somewhere and to some destination.

Vincent to Théo, Arles, August–September 1888
Letter 518 in French

My dear Théo,

I spent yesterday evening with the 2nd lieutenant; he expects to leave here on Friday, then he will stop a night at Clermont, and from Clermont he will send you a wire to tell you by what train he will arrive Sunday morning. The roll he is bringing contains 35 studies, among which there are many I am desperately dissatisfied with, but which I am sending anyway, since at all events they will give you a vague idea of the very fine subjects there are in this country.

For instance, there is a rough sketch I made of myself laden with boxes, props, and canvas on the sunny road to Tarascon. There is a view of the Rhône in which the sky and the water are the color of absinthe, with a blue bridge and figures of little black urchins; there is the sower, and a washing place, and others as well, which have not come off at all and are unfinished, especially one big landscape with brushwood. . . .

I am afraid that I shall not get a rather beautiful model; she promised, but then—as it appears—picked up some change by going on a long weekend, and now has something better to do. She was extraordinary, the expression like that one by Delacroix, the figure primitive and strange.

I endure these things with patience, failing any other way of bearing them, but this continual difficulty with models is maddening. One of these days I hope to make a study of oleanders. If I painted prettily like Bouguereau, people would not be ashamed to let themselves by painted, but I think that I have lost models because they thought that they were "badly done," because "it was only pictures full of painting" that I did. The poor little souls are afraid of being compromised and that people will laugh at their portraits. But it is almost enough to make you lose heart when you think that you could do something if people had more good will. I cannot resign myself to saying— "sour grapes"—it does not console me for not having more models. . . .

I already told Gauguin in my last letter that If we painted like Bouguereau we could hope to make money by it, but that the public will never change, and it likes only easy, pretty things. With a more austere talent, you cannot count on profit from your work; most of the people intelligent enough to like and understand impressionist pictures are and will remain too poor to buy them. Will Gauguin or I work the less for that?—no—but we shall be forced to submit deliberately to poverty and social isolation.

Vincent to Théo, Arles,
14 or 15 August 1888, Letter 524 in Dutch

33. *Self-Portrait on the Road to Tarascon*,
Arles, August 1888, oil on canvas, 48 × 44 cm,
destroyed by fire at the Kaiser Friedrich Museum of Magdebourg
during World War II.

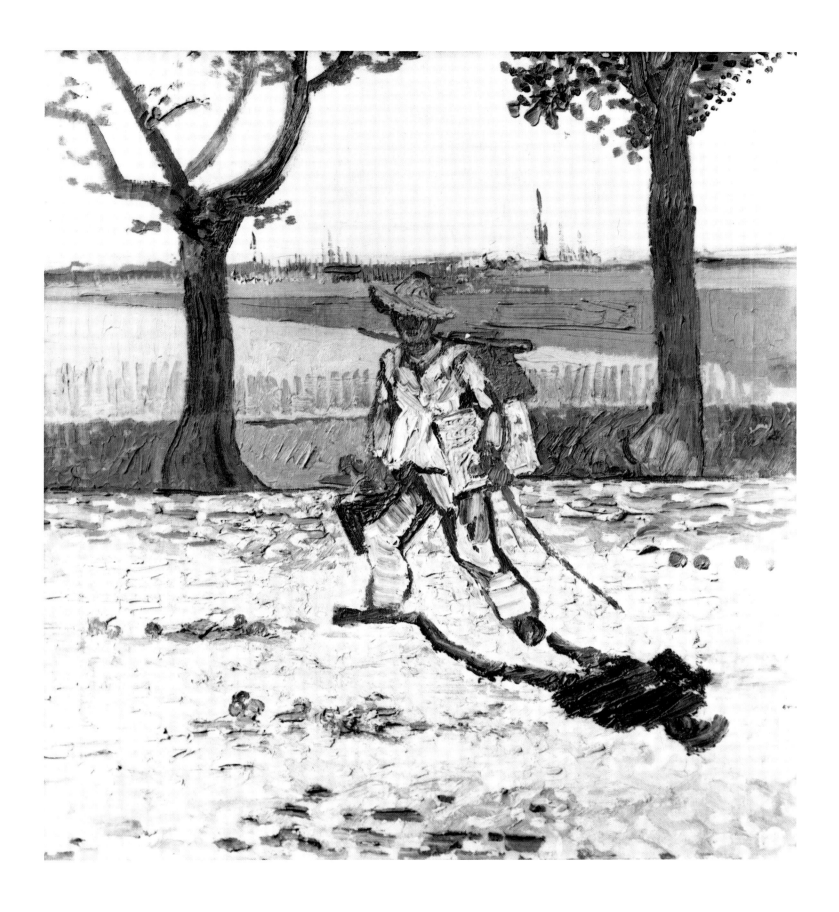

CHAPTER 19

Rembrandt

Rembrandt is above all a magician. [564 F, December 1888]

This magician haunted van Gogh. In October 1885, he visited the Rijksmuseum. To Théo: "*The Syndics* is perfect, is the most beautiful Rembrandt; but *The Jewish Bride*—not ranked so high, what an intimate, what an infinitely sympathetic picture it is, painted *d'une main de feu*. You see, in *The Syndics* Rembrandt is true to nature, though even there, and always, he soars aloft, to the very highest height, the infinite; but Rembrandt could do more than that—if he did not have to be literally true, as in a portrait, when he was free to idealize, to be poet, that means Creator. That's what he is in *The Jewish Bride*. How Delacroix would have understood that picture. What a noble sentiment, infinitely deep. '*Il faut être mort plusiers fois pour peindre ainsi*' ['*One must have died several times to paint like that*']; how true it is here. As to the pictures by Frans Hals—he always remains on earth—one can speak about them. Rembrandt is so deeply mysterious that he says things for which there are no words in any language." [Emphasis by van Gogh; 426 D, October 1885] As if terrified of having to paint, breathless, he continues: "Rembrandt is truly called magician . . . that's not an easy calling." [426 D, October 1885]

On 28 December 1885, in Anvers, he noted: "Yesterday I saw a large photograph of a Rembrandt which I did not know and which struck me tremendously; it was a woman's head, the light fell on the bust, neck, chin, and the tip of the nose—the lower jaw. The forehead and eyes in the shadow of a large hat, with probably red feathers. Probably also red or yellow in the low-necked jacket. A dark background. The expression, a mysterious smile like that of Rembrandt himself in his self-portrait in which Saskia is sitting on his knee and he has a glass of wine in his hand." [442 D, 28 December 1885].

In a letter to van Gogh in July, 1888, Émile Bernard movingly quoted a quatrain from Baudelaire's *Phares*:

> Rembrandt, mournful hospital filled wholly with sighs
> And decorated with but a great crucifix,
> Where sobbing prayers exhale filth,
> And rudely broken by a shaft of wintry light

Van Gogh's response:
"Ah, Rembrandt! . . . With all due admiration for Baudelaire, I venture to suppose, especially judging from those verses, that he knew almost nothing about Rembrandt. The other day I found and bought a little etching after Rembrandt, a study of a nude man, realistic and simple. He stands leaning against a door or a pillar, in a gloomy

interior; a shaft of light from above fleetingly touches the face, which is bent forward, and the mass of reddish hair. One might call it a Degas on account of the true and deeply felt animality of that body. But look here, did you ever really look at the *Ox* or *The Interior of a Butcher's Shop* in the Louvre? You haven't really looked at it, and Baudelaire infinitely less. It would be a huge pleasure for me to spend a morning with you in the Gallery of the Dutch Painters. One can hardly describe all that, but with the pictures before us I could show you marvels and miracles, which are the reasons why primitives don't have my admiration at all, that is to say primarily and most directly. . . .

"Thus Rembrandt has painted angels. He paints a self-portrait, old, toothless, wrinkled, wearing a cotton cap, a picture from nature, in a mirror. He is dreaming, dreaming, and his brush resumes his self-portrait, but only the head, whose expression becomes more tragically sad, more tragically saddening. He is dreaming, still dreaming, and, I don't know why or how, but just as Socrates and Muhammad had their familiar spirits, Rembrandt paints behind this old man, who resembles himself, a supernatural angel with a da Vinci smile.

"I am showing you a painter who dreams and paints from imagination, and I began by contending that the character of the Dutch painters is such that they do not invent anything, that they have neither imagination nor fantasy. Am I illogical? No. Rembrandt did not invent anything, that angel, that strange Christ—the fact is that he knew them; he felt them there." [B12 F, late July 1888]

Several days later, van Gogh wrote yet again to Émile Bernard: "In Rembrandt's studio that incomparable sphinx, Vermeer of Delft, found this extremely solid technique that has never been surpassed, which at present . . . we are burning . . . to find. Oh, I know we are working and reasoning with *colors*, just as they were with *chiaroscuro, tonal values*. But what do these differences matter, when the great thing after all is to express oneself strongly?" [Emphasis by van Gogh; B14 F, August 1888] And during his last stay at the Saint-Paul-de-Mausole insane asylum, he remembered: "And so what Rembrandt has alone or almost alone among painters, that tenderness of gaze which we see, whether it's in *The Men of Emmaus* or in *The Jewish Bride* or in some such strange angelic figure as the picture you have had the good fortune to see, that heartbroken tenderness, that glimpse of a superhuman infinitude that seems so natural there—in many places you come upon it in Shakespeare too. And then above all he is full of portraits, grave or gay, like *Six* and like *The Traveler*, and like *Saskia*. [597 F, June–July 1889]

What did Rembrandt and van Gogh have in common after all? Everything, nothing. Both signed work with their first names alone. But Rembrandt wished to be Rembrandt in his glory, whereas van

Gogh used Vincent so as to avoid a name that was unpronounceable in French. As for their careers, at the age when van Gogh first began to paint, Rembrandt was rich, lionized, loved. Rembrandt moved only from Leyde to Amsterdam. Van Gogh went to live in England and Belgium, and died an exile in France. At his death Rembrandt was mourned throughout Europe. The death of van Gogh, noted in the *Echo Pontoisien* with five lines of type on 7 August 1890, amounted to a bit of local color. At the age when van Gogh died, Rembrandt had not yet painted either *The Anatomy Lesson* or *Aristotle Contemplating the Bust of Homer*, neither *The Conjuration of Claudius* nor *The Drapers' Union* nor *The Jewish Bride*.

The body of Rembrandt is interred in Westerkerk cemetery. The parish priest of Auvers refused services for a suicide. For more than forty-two years, Rembrandt drew, etched, and painted more than one hundred self-portraits. In just four years, van Gogh drew and painted about thirty. The intensity of their quests was one—but it is difficult to say whether their quests shared a common meaning. They shared the same earth and also the same text, the Bible, upon which each man founded his faith.

Van Gogh gazed at Rembrandt's self-portraits, and what he saw in them, "that glimpse of a superhuman infinitude," so nearly resembled something in himself that it was like discovering, outside of time, his own lost brother.

The Impressionists

One has heard talk about the Impressionists, one expects a whole lot from them, and . . . when one sees them for the first time one is bitterly bitterly disappointed and thinks them slovenly, ugly, badly painted, badly drawn, bad in color, everything that's miserable. [W4 D, June–July 1888]

The disappointment spoken of was not van Gogh's own: "And consequently, though some of those twenty or so painters who are called Impressionists have become comparatively rich men, and rather big fellows in the world, yet the majority of them are poor devils, whose homes are cafés, who lodge in cheap inns and live from hand to mouth, from day to day. But in a single day those twenty whom I mentioned paint everything they lay eyes on, and better than many a big noise who has a high reputation in the art world. I tell you this in order to make you understand what kind of tie exists between me and the French painters who are called Impressionists—that I know many of them personally, and that I like them." [W4 D, June–July 1888]

When van Gogh found himself alone in Arles, not just the advice, but also the technique, the utterances, and even the style of living of one or another of the Impressionists remained important points of reference. "What Pissarro says is true, you must boldly exaggerate the effects of either harmony or discord that colors produce." [500, F June–July 1888] "Instinctively these days I keep remembering what I have seen of Cézanne's, because he has rendered so forcibly—as in "*The Harvest* we say at Portier's—the harsh side of Provence. . . . I must manage to get the firmness of coloring that I got in the picture that kills the rest. I'm thinking of what Portier used to say, that seen by themselves the Cézannes he had didn't look like anything, but put near other pictures, they washed the color out of everything else. He also used to say that the Cézannes did well in gold, which means the color scheme was pitched very high. So perhaps, perhaps I am on the right track, and I am getting an eye for this kind of country. We must wait and make sure." [497 F, June 1888]

"Degas lives like a small lawyer and does not like women, for he knows that if he loved them and fucked them often, he, intellectually diseased, would become insipid as a painter. Degas's painting is virile and impersonal for the very reason that he has resigned himself to be nothing personally but a small lawyer with a horror of going on a spree. He looks on while the human animals, stronger than himself, get excited and fuck, and he paints them well, exactly because he doesn't have the pretension to get excited himself." [B14 F, August 1888] Van Gogh continues, extracting a word of advice for Émile Bernard from Degas's example: "As for you, my poor dear comrade Bernard, I already told you in the spring: eat a lot, do your military

excercises well, don't fuck too much; when you do this your painting will be all the more spermatic." [B14 F, August 1888] And such was the sexual and painterly hygiene that van Gogh reserved for himself as well.

In January 1886, several weeks prior to the final group exhibit of the Impressionists, van Gogh wrote: "Whether Impressionism has already had its last say or not—to stick to the term *Impressionism*—I always imagine that many new artists in the figure may arise, and I begin to think it more and more desirable that, in a difficult time like the present, one seeks one's security in the deeper understanding of the highest art. For there is, relatively speaking, higher and lower art; people are more important than anything else, and are in fact much more difficult to paint, too." [444 D, January 1886]

The hierarchy Van Gogh was referring to was by no means that of official art, which continued to put its faith in the grandeur that the great historical subjects alone could lend to painting. Van Gogh's hierarchy was more an expression of his individual strength. He had not yet painted a self-portrait and would not start on one until after arriving in Paris. Perhaps in his mind he was hearing the words of Cézanne: "The culmination of art is the figure." [Quoted by Ambroise Vollard in *En Écoutant Cézanne, Degas, Renoir*, Paris, 1985]

What van Gogh was discovering was no less than his own role in the painting of his century. It would not be as part of the official salon: "Well, Art—the officially recognized art—and its training, its management, its organization, are stagnant-minded and moldering, like the religion we see crashing, and it will not last." [W4 D, June–July 1888] He acknowledged one rule: "But if one analyzes from up close, one sees that the greatest and most energetic people of the century have always worked against the grain, and they have always worked out of personal initiative—both in painting and in literature. (I do not know anything about music, but I suppose it has been the same there.) To begin on a small scale, to persevere *quand même* [nonetheless], to produce much with small capital, to have character instead of money, more audacity than credit." [454 D, February 1886] And he acknowledged a form of loneliness other than the loneliness of disappointment. In the summer of 1887, he wrote: "I will take myself off somewhere down south, to get away from the sight of so many painters that disgust me as men." [462 F, Summer 1887] His loneliness was the consequence of having such high expectations: ". . . In Impressionism I see the resurrection of Eugène Delacroix, but the interpretations of it are so divergent and in a way so irreconcilable that it will not be Impressionism that will give us the final doctrine. That is why I myself remain among the Impressionists, because it professes nothing and binds you to nothing." [539 F, September 1888]

Van Gogh was alone. He was without guaranties. But then there was the resurrection of Eugène Delacroix. At Auvers-sur-Oise in June 1890, van Gogh painted a *pietà* at the request of Dr. Gachet, using a Delacroix as his model. Under the hand of the dead Christ he wrote, "after Eug. Delacroix, near to God," and signed "Vincent." It was to be the last copy he painted. It was by way of the resurrection of Delacroix that the painting of van Gogh passed before he died. And that resurrection was also his own.

Colors

There are only three fundamental colors--red, yellow, and blue; "composites" are orange, green, and purple. By adding black and some white one gets the endless varieties of grays--red-gray, yellow-gray, blue-gray, green-gray, orange-gray, violet-gray. It is impossible to say, for instance, how many green-grays there are; there is an endless variety. [221 D 31 July 1882]

And it was not by chance that van Gogh emphasized the spectrum of grays. The apprenticeship of van Gogh in color was long. In September 1888, he wrote: "I have a lover's insight or a lover's blindness for work just now. Because these colors about me are all new to me, and give me an extraordinary exaltation." [541 F, September 1888] And his canvases were aflame.

The stages of his apprenticeship, of his invention, in color, are clearly discernible. From 15 August 1882: ". . . I feel a power of color in me that I did not possess before, things of broadness and strength." [225 D, 15 August 1882] Several days later, he wrote to Théo: "You see I am absorbed in painting with all my strength; I am absorbed in color—until now I have restrained myself, and I am not sorry for it. If I had not drawn so much, I should not be able to catch the feeling of and get hold of a figure that looks like an unfinished terracotta. But now I feel myself on the open sea—the painting must be continued with all the strength I can give it. . . . I know for sure that I have an instinct for color and that it will come to me more and more, that painting is in the very marrow of my bones. [228 D, August–September 1882]

A year later, in July 1888: "While painting recently, I have felt a certain power of color awakening in me, stronger and different than what I have felt till now. . . . I wonder what it will lead to, and how it will develop. I have sometimes wondered why I was not more of a colorist, Because my temperament decidedly seems to indicate it—but up till now it has developed very poorly. I repeat, I wonder how it will develop—but I see clearly that my last painted studies are different." [309 D, July 1883]

May 1885: ". . . One must take care in our days of clarity and lightness not to water the wine too much, not to mix too much white in the wine of the color, so that some passion remains and the effects do not become too tame and weaken the whole thing." [406 D, May 1885] Not until after his stay in Paris, and after his arrival in Arles, would color burst through his canvases. ". . . What is required in art nowadays is something very much alive, very strong in color, very much intensified." [W1 D, summer or fall 1887]

Van Gogh was no longer hesitating. *"All the colors that the Impression-*

ists have brought into fashion are unstable, so that there is all the more reason not to be afraid to lay them on too crudely—time will tone them down only too much." [Emphasis by van Gogh; 476 F, March–April 1888] In August 1888, he requested of his brother specially brayed [ground] colors to paint with: "If we painted like M. Gérôme and the other delusive photographers, we should doubtless ask for very finely brayed colors. But we on the contrary do not object to the canvas having a rough look. If then, instead of braying the color on the stone for God knows how many hours, it was brayed just long enough to make it manageable, without worrying too much about the fineness of the powder, you would get fresher colors, which would perhaps darken less. If he wants to make a trial of it with the three chromes, the malachite, the vermilion, the orange lead, the cobalt, and the ultramarine, I am almost certain that at much less cost I should get colors that would be both fresher and more lasting. Then what would the price be? I'm sure this could be done. Probably also with the reds and the emerald, which are transparent." [527 F, August 1888]

Van Gogh's self-portraits comprise a kind of history of the place of color in his work. It is a long way from the somber background from which his black felt hat projects, painted a few weeks after his arrival in Paris (Illustration 3), to the red and yellow wall from which his blue cap and green jacket jut out, painted in Arles (Illustration 43). It is a long way from the dense bog behind a pipe-smoking van Gogh (Illustration 6) to the flaming-cypress-like blue background of his last self-portrait (Illustration 45).

The colors forged in van Gogh's canvases were not realistic. They were the expression of an ambition. "Time will tone them down only too much." Their strength was such that they defied time. Van Gogh *knew* that he did not paint only for the eyes of his contemporaries.

I also made a new portrait of myself, as a study, in which I look like a Japanese.

Vincent to Wilhelmina, Arles,
8 August 1888, Letter W7 in French

The third picture this week is a portrait of myself, almost colorless, in gray tones against a background of pale malachite.

I purposely bought a mirror good enough to enable me to work from my image in default of a model, because if I can manage to paint the coloring of my own head, which is not to be done without some difficulty, I shall likewise be able to paint the heads of other good souls, men and women.

Vincent to Théo, Arles,
16 September 1888, Letter 537 in French

This morning I received your excellent letter, which I sent on to my brother; your concept of Impressionism in general, of which your portrait is a symbol, is striking. I can't tell you how curious I am to see it—but this much I know in advance: this work is too important to allow me to make an exchange. . . .

I have a portrait of myself, all ash-colored. The ashen-gray color that is the result of mixing malachite green with an orange hue, on pale malachite ground, all in harmony with the reddish-brown clothes. But as I also exaggerate my personality, I have in the first place aimed at the character of a simple bonze worshiping the Eternal Buddha. It has cost me a lot of trouble; yet I shall have to do it all over again if I want to succeed in expressing what I mean. It will even be necessary for me to recover somewhat more from the stultifying influence of our so-called state of civilization in order to have a better model for a better picture.

Vincent to Paul Gauguin, Arles,
late September 1888, Letter 544a in French

I have just received the portrait of Gauguin by himself and the portrait of Bernard by Bernard, and in the background of the portrait of Gauguin there is Bernard's on the wall, and vice versa.

The Gauguin is of course remarkable, but I very much like Bernard's picture. It is just the inner vision of a painter, a few abrupt tones, a few dark lines, but it has the distinction of a real, real Manet.

The Gauguin is more studied, carried further. That, along with what he says in his letter, gave me absolutely the impression of its representing a prisoner. Not a shadow of gaiety. Absolutely nothing of the flesh, but one can confidently put that down to his determination to make a melancholy effect, the flesh in the shadows has gone a dismal blue.

So now at last I have a chance to compare my painting with what the comrades are doing. My portrait, which I am sending to Gauguin in exchange, holds its own, I am sure of that. I have written to Gauguin in reply to his letter that if I might be allowed to stress my own personality in a portrait, I had done so in trying to convey in my portrait not only myself but an Impressionist in general, had conceived it as the portrait of a bonze, a simple worshiper of the eternal Buddha.

And when I put Gauguin's conception and my own side by side, mine is as grave, but less despairing. What Gauguin's portrait says to me before all things is that he must not go on like this, he must become again the richer Gauguin of the "Negresses."

I am very glad to have these two portraits, for hey faithfully represent the comrades at this stage; they will not remain like that, they will come back to a more serene life. . . .

Gauguin looks ill and tormented in his portrait!! You wait, that will not last, and it will be very interesting to compare this portrait with the one he will do of himself in six months' time.

Someday you will also see my self-portrait, which I am sending to Gauguin, because he will keep it, I hope.

It is all ashen gray against pale malachite (no yellow). The clothes are this brown coat with a blue border, but I have exaggerated the brown into purple, and the width of the blue borders.

The head is modeled in light colors painted in a thick impasto against the light background with hardly any shadows. Only I have made the eyes *slightly* slanting like the Japanese.

Write me soon and the best of luck. How happy old Gauguin will be.

A good handshake, and thank Freret for the pleasure he has given me. Good-by for now.

Vincent to Théo, Arles,
7 October 1888, Letter 545 in French

34. *Self-Portrait*,
Arles, September, 1888, oil on canvas, signed in the lower right,
"Vincent," and dedicated in the upper left, "To my friend Paul G.," 62 × 52 cm,
Cambridge, Massachusetts, Fogg Art Museum.

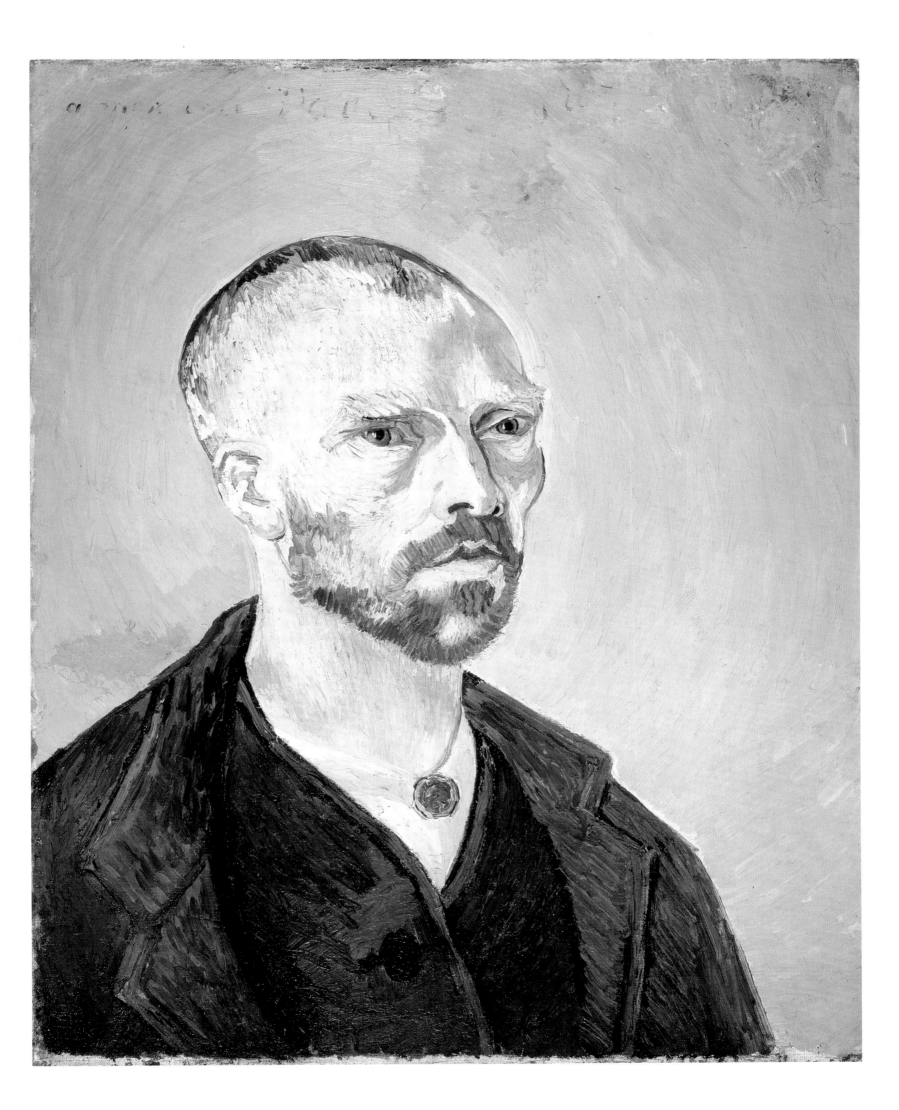

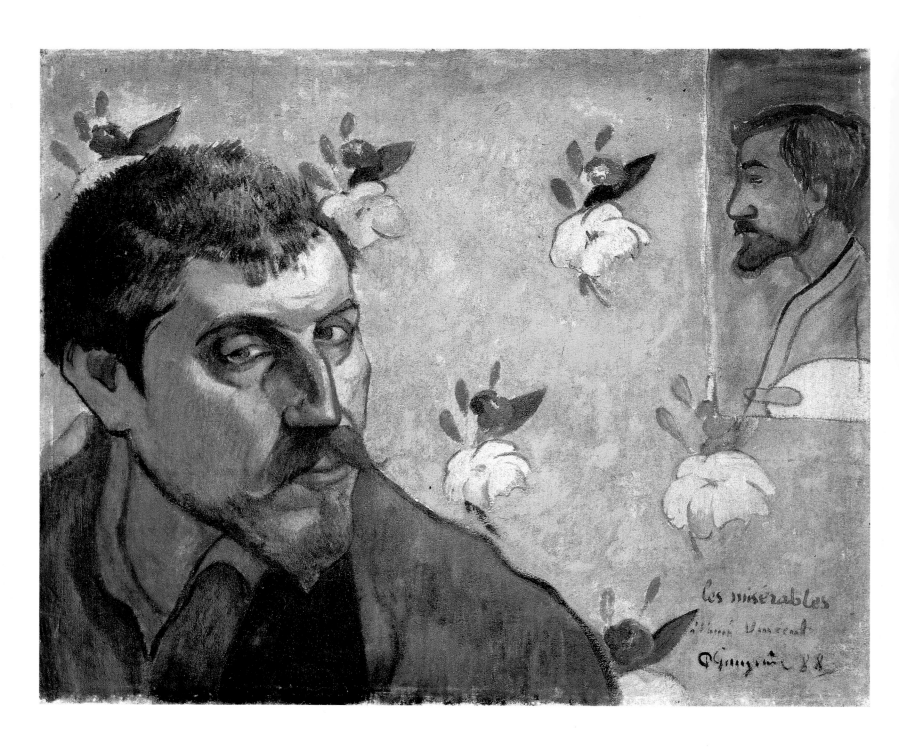

My dear Vincent,

We have done what you asked, not in the way you asked, but what difference does it make so long as the thing gets done: our two portraits. Being without silver white, I used lead white [ceruse], so you may find that the colors turn dull and heavy, although in the execution I had other concerns besides those of color. I feel the need to explain what I was trying to do—not because you wouldn't see for yourself, but because I don't think I've reached that aim in my work. The mask of the bandit, a man like Jean Valjean, badly dressed and powerful in a brutish way, who has an inner nobility and an inner kindness. The rutting blood engorges the face while the colors of the furnace that encircle the eyes show the bath of fire that floods our painter's heart. The design of the eyes and nose, similar to that of the flowers on the Persian rug, turns upon an abstract and symbolic art. The little-girlish background of flowers attests to our artistic virginal inno-cence. And this Jean Valjean, pushed outside of the law by an oppressive society, with his love and his strength, is he not the image of today's Impressionist? And by painting him with my features, you've got my personal image, whereas our portraits of all poor victims of society wreaks vengeance on their behalf when done well. —Ah my dear Vincent, you'll have plenty to amuse yourself with all those painters stewing in their mediocrity like pickles in vinegar. And whether they be long or twisted with holes they are and will always be just pickles.

Gauguin to Vincent, Pont-Aven,
on or about 25 September 1888

Your brother's letter troubles me; with his good heart he has too much of a tendency to fix things. Thus the portrait I made for him is not to sell, it is for him, to exchange or not exchange, especially since it was executed briskly, and I fear on sight it may prove a disappointment. The descrip-tion of what I'd wanted to express in the painting has created in his mind a beauty greater than that of the painting itself.

Gauguin to Théo, Pont-Aven,
on or about 29 September 1888

I painted a self-portrait at Vincent's request. I think that it is one of the best things I've done: something so abstract that it is absolutely incomprehensible. A bandit's head to start with, a Jean Valjean (*Les Misérables*), personifying an abstract painter, discredited and yet always chained to the world. The design is unique and completely abstract. The eyes, mouth, and nose are like the flower pattern on the Persian rug, also personifying the symbolic side. The color is far from nature; imagine a vague memory of broken pottery beside a roaring fire! All the reds and purples striped by sparks as if from a furnace seen through the eyes—the site of struggle for the painter's thoughts. All one chromium background sprinkled with infantile bouquets of flowers. The room of a virginal young girl. The Impressionist is a virgin, not yet sullied by the putrid kisses of the Fine Arts.

Gauguin to Schuffenecker, Quimperlé,
8 October 1888
(*Oviri, écrits d'un sauvage*,
Paris: Gallimard, 1974, pp. 40–42)

Herewith yesterday's letter, which I am sending you, such as it is. From it you will see what I think of Gauguin's portrait. Too dark, too sad. I do not say that I do not like it as it is, but he will change, and he must come. Yes, indeed, they spend less than I, yes—but—if I was with two others as he is—if he spent a little more it would be better. Once more, one must not do flesh with Prussian blue. Because then it ceases to be flesh; it becomes wood. And there is nothing so urgent for Gauguin, nothing better for him to do, than to join me. However, I venture to think that with regard to coloring, the other Breton pictures will be better than the portrait he has sent me, done, after all, in haste. And I am far from judging studies such as that. However, you will see for yourself.

Vincent to Théo, Arles,
October 1888, Letter 547 in French

I arrived in Arles toward morning and awaited the dawn in an all-night café. The proprietor looked at me and exclaimed, "I know you, you're the friend."

A self-portrait which I had sent to Vincent was the explanation for the man's outcry. Showing him my por-trait, Vincent had explained that I was a friend who would soon be arriving.

Gauguin, *Oviri, écrits d'un sauvage*, p. 291

35. Gauguin, Paul, *Self-Portrait with Portrait of Émile Bernard*,
1888, oil on canvas, signed, dated, and dedicated in the lower right,
"Les Miserables to our friend Vincent, P. Gauguin 88," 45 × 56 cm,
Amsterdam, Stedelijk Museum.

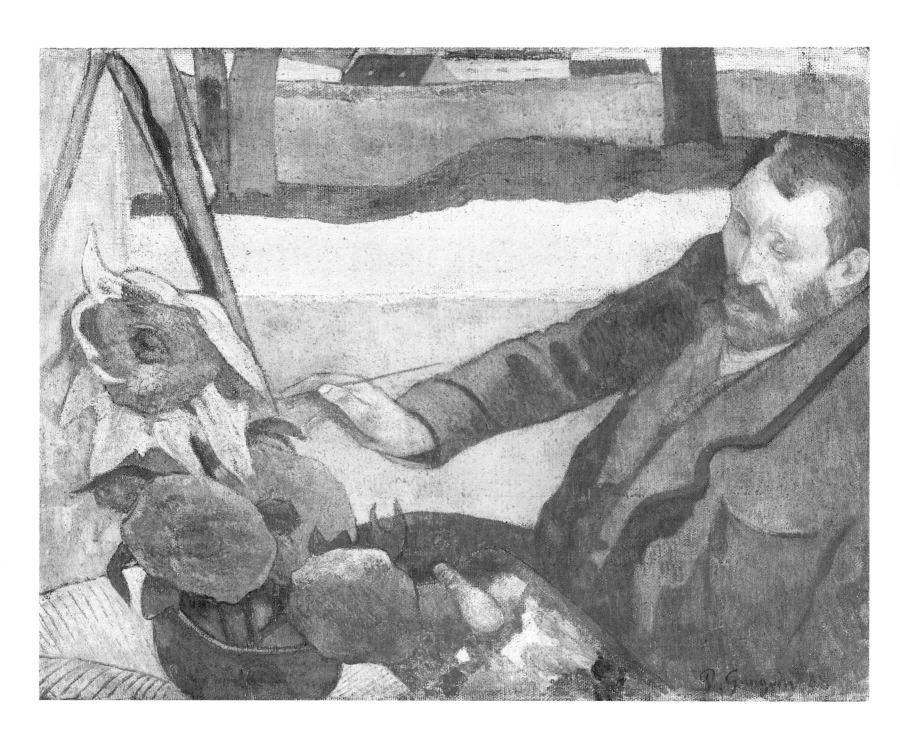

Have you seen the portrait that he did of me, painting some sunflowers? Afterward my face got much brighter, but it was really me, very tired and charged with electricity as I was then.

<div align="right">
Vincent to Théo, Saint-Rémy,

10 September 1889, Letter 605 in French
</div>

Gauguin works a lot. I very much like a still life, background and foreground yellow; he is working on a portrait of me which I do not count among his useless undertakings.

<div align="right">
Vincent to Théo, Arles,

November 1888, Letter 560 in French
</div>

I have lately finished a portrait of your brother, a theme study (the painter of sunflowers) on a size-30 canvas. The landscape in it may not be so accurate, but I think it captures something of him, and if you like it, please keep it, unless it doesn't please you.

<div align="right">
Gauguin to Théo, Arles,

on or about 20 September 1888
</div>

I had the idea of doing his portrait as he painted the still life which pleased him so, sunflowers. And after I'd finished, he said to me, "That's me, all right, but me having gone crazy."

The same evening we went out to a café. He ordered a light absinthe. Suddenly he threw the glass and its contents at my head. I avoided being hit and took hold of him. I led him from the café, we crossed Victor Hugo Place, and a few minutes later Vincent found himself in his bed, where, in a few seconds, he fell asleep until morning.

Upon waking, he said to me very calmly, "My dear Gauguin, I have a vague recollection of having offended you yesterday evening."

"I forgive you willingly and with all my heart," I told him, "but what happened yesterday could happen again, and if I were to be hurt, I might lose control of myself and strangle you. Allow me to write to your brother to tell him I am returning to Paris."

<div align="right">
Gauguin, Paul, Oviri, écrits d'un sauvage, p. 295.
</div>

36. Gauguin, Paul, *Van Gogh Painting Sunflowers,*
1888, oil on canvas, signed and dated on the lower left, "P. Gauguin 88," 73 × 92 cm,
Amsterdam, Rijksmuseum Vincent van Gogh.

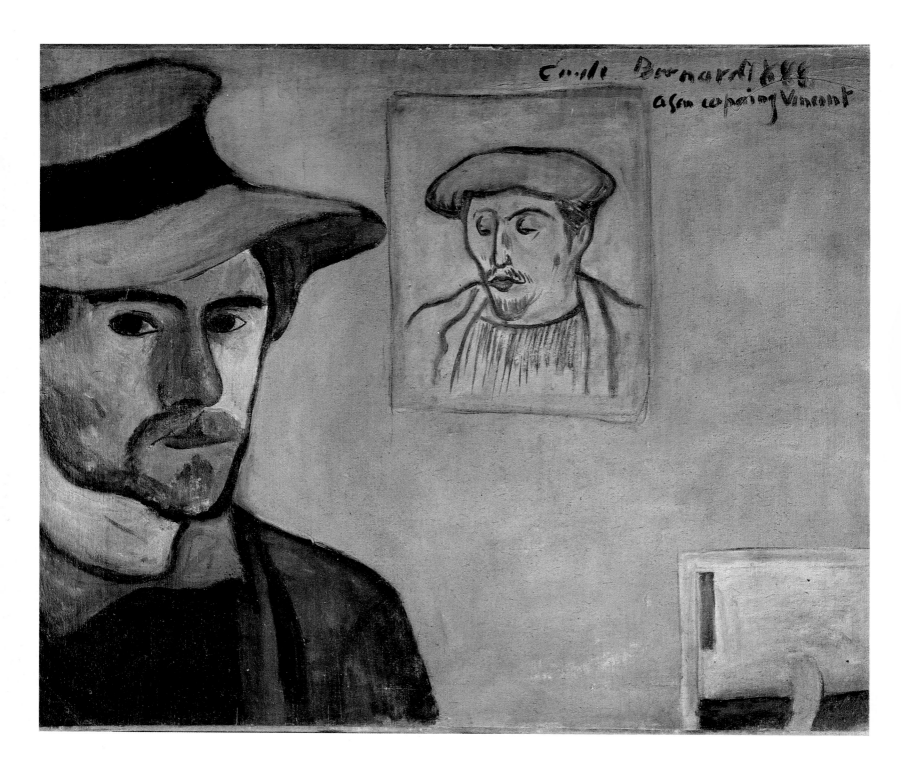

I do not think your self-portrait will be either your last or your best, although on the whole it is terribly you.

<div align="right">Vincent to Émile Bernard, Paris,
summer, 1887, Letter B1 in French</div>

For a long time I have thought it touching that the Japanese artists used to exchange works among themselves very often. It certainly proves that they liked and upheld each other and that there reigned a certain harmony among them, and that they were really living in some sort of fraternal community, quite naturally, and not in intrigues. The more we are like them in this respect, the better it will be for us. It also appears that the Japanese earned very little money, and lived like simple workmen.

<div align="right">Vincent to Émile Bernard, Arles,
late September 1888, Letter B18 in French</div>

Red hair (goatee, coarse moustache, close-cropped head), eagle eyed and tight lipped; average height, thick-set but not in a common way; lively in his movements; a staccato gait. Such was van Gogh, always with his pipe and a canvas, an etching or a piece of cardboard. Vehement in conversation, interminable when explaining or developing his ideas, little able to stand being contradicted. All this too was van Gogh. And then there were the dreams.

Dreams! Huge exhibitions, philanthropic phalanteries [socialistic communities of the type planned by Fourier] for artists, support groups in the south, and elsewhere, for the progressive invasion of public places in order to reeducate the masses who sometime in the past had understood art. . . .

Dutch, Protestant, son of a pastor, van Gogh seemed destined for the clergy; but although he followed this path at first, he quit it for painting. Excessive in everything, he certainly ruffled the feathers of the strict doctrine of his teachers. Infatuated with art, he got to know Israëls and took him as his first model. Rembrandt was next. Then he came to France, worked at the Goupil gallery, where his brother Théodore soon replaced him. Thanks to that brother, he was free to paint. He went straight to Cormon and quickly became disgusted. He tried the pointillistic technique, which annoyed him, and finally began to spread his wings after seeing the work of Monticelli, Manet, Gauguin, etc. . . . But he did not depend on any of them. Van Gogh is more personal than any of them. In love with the Japanese, the Indians, the Chinese, and whatever sings, laughs, and resonates, he found in these innate artists the surprising techniques of his harmonies, the extraordinary flights of his drawing, just as he found in his own depths the delirious nightmares with which he unremittingly overwhelms us.

<div align="right">Émile Bernard, La Plume, 1891</div>

<div align="center">37. Bernard, Émile, Self-Portrait,
1888, oil on canvas, signed, dated, and dedicated in the upper right,
"Émile Bernard, 1888, to his friend Vincent," 46 x 55 cm,
Amsterdam, Rijksmuseum Vincent van Gogh.</div>

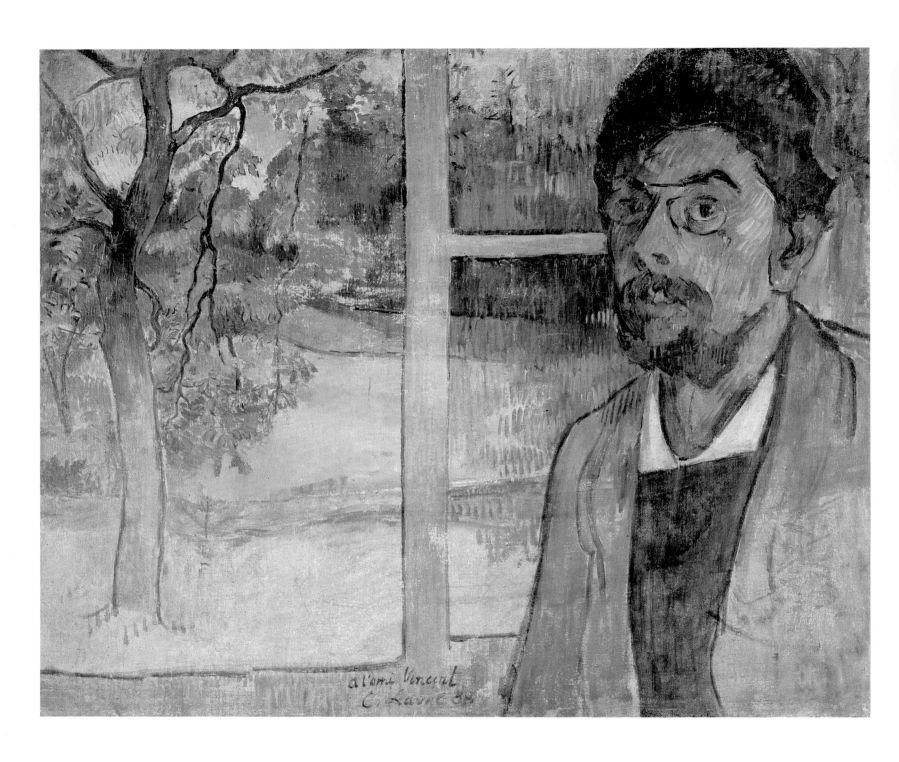

You will also be pleased to hear that we have an addition to the collection of portraits of artists. A self-portrait by Laval, extremely good.

The portrait of Laval is very bold, very distinquished, and will be just one of the pictures you speak of, those one gets hold of before other people have recognized the talents.

I think it excellent that you are taking a Luce. Has he a self-portrait by any chance?

<div align="right">

Vincent to Théo, Arles,
November–December 1888, Letter 562 in French

</div>

Now what really is it that we are now beginning to catch a timid glimpse of, original and enduring? *Portraiture.* You may say that is an old story, but it is also new. We shall talk of this again—but let's keep looking out for portraits, especially by artists such as Guillaumin, and the portrait of the girl by Guillaumin, and carefully keep my portrait by Russell that I am so fond of. Have you framed the portrait of Laval? I don't think you've told me what you thought of it. I thought it amazing, the look of the eyes through the glasses—such a frank look.

<div align="right">

Vincent to Théo, Saint-Rémy,
September 1889, Letter 604 in French

</div>

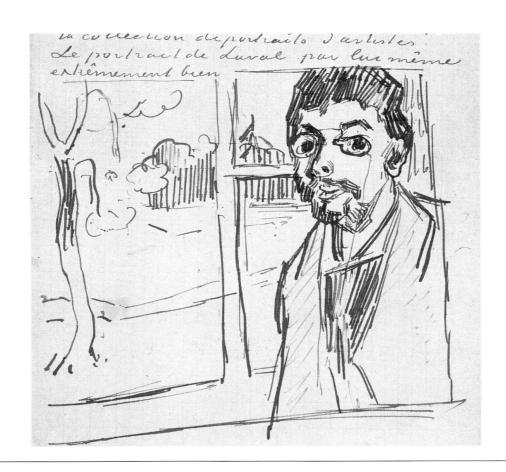

38. Laval, Charles, *Self-Portrait with Landscape*,
1888, oil on canvas, signed, dated and dedicated at bottom center,
"To his friend Vincent, C. Laval 88," 50 x 60 cm,
Amsterdam, Rijksmuseum Vincent van Gogh.

Ah! portraiture, portraiture with the thoughts, the soul of the model in it, that is what I think must come.

Vincent to Théo, Arles,
September 1888, Letter 531 in French

That's enough for today. If you have the address of Laval, Gauguin's friend, you can tell Laval that I am very much surprised that his friend Gauguin did not take a portrait of myself, which I had intended for him, away with him to be handed over. I have another new one for you too.

Vincent to Théo, Arles,
17 January 1889, Letter 571 in French

39. *Self-Portrait*,
Arles, November–December 1888, oil on canvas, dedicated and signed in the lower right,
"To friend Laval, Vincent," 46 × 38 cm,
New York, private collection.

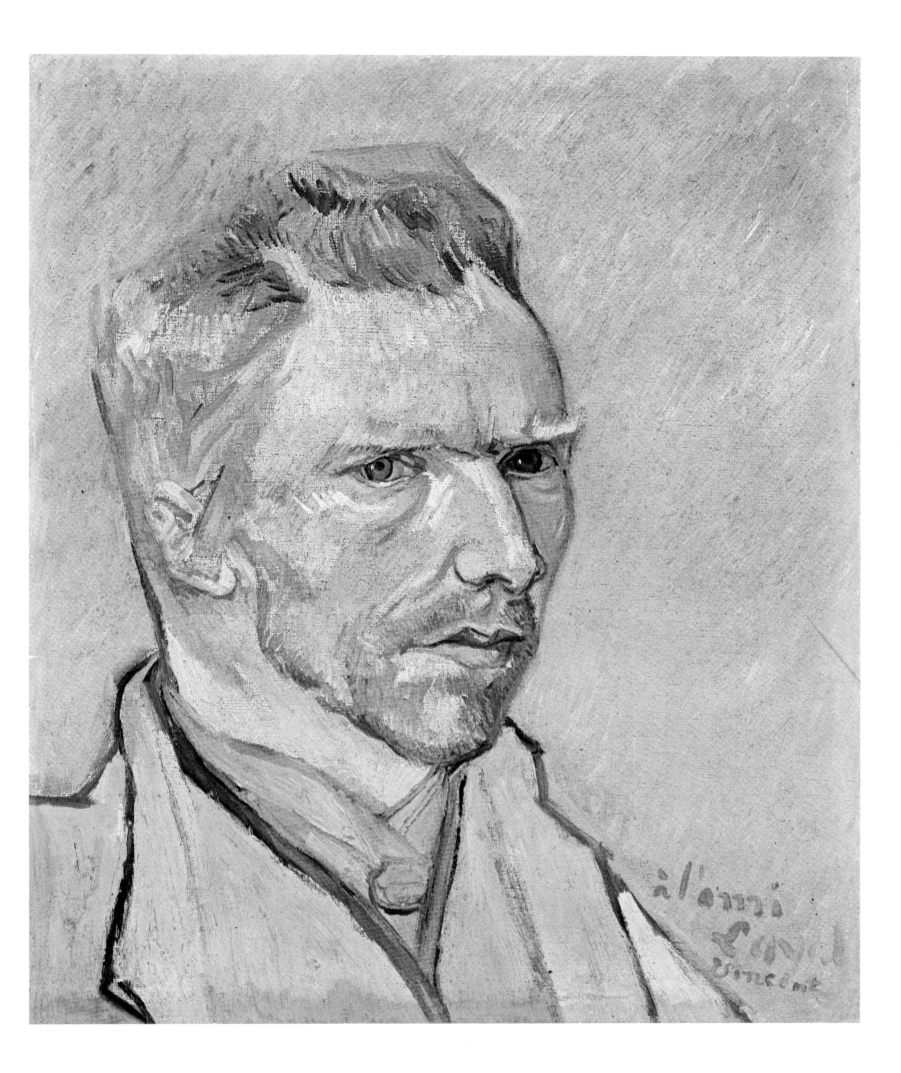

The Name of van Gogh

In the future my name ought to be put in the catalog as I sign it on the canvas, namely Vincent and not van Gogh, for the simple reason that they do not know how to pronounce the latter name here. [471 F, March 1888]

Vincent was his only signature.

On 30 March 1852, Anna Cornelia van Gogh brought into the world a stillborn child. The name that had been chosen for him was Vincent Willem. One year later to the day, on 30 March 1853, Vincent Willem van Gogh was born.

Vincent.

The name he had been given was that of another, of a "twin." The name of a cause for mourning that was always present. In December 1876, van Gogh, aged twenty-three, a mystical preacher whose faith was at a feverish pitch, wrote to Théo: "Can a woman forget her sucking child, that she should not have compassion on the son of her womb? Yea, they may forget, yet will I not forget thee. Hear now this, thou afflicted, and drunken, but not with wine: ". . . Behold, I have taken out of thine hand the cup of trembling, even the dregs of the cup of my fury; thou shalt no more drink it again." [82a D, December 1876] And he asked: "Who shall roll us away the stone from the door of the sepulchre?" [82a D, December 1876]

Was that stone ever rolled away? Was the cup of trembling taken from his hand?

The first death van Gogh had to exorcise was that of his very name. Vincent Willem van Gogh. In one of the first letters that he wrote to Théo, he requested: "Don't forget to write 'V. W. van Gogh'; otherwise it might be confused with uncle Vincent's mail, he is only called 'V,' you know." [7 D, 5 May 1873]

Vincent loathed the name *van Gogh*. In anger he wrote to Théo: ". . . If you were to become more and more a 'van Gogh,' a character like Father or C. M., and if by always being in business you should acquire a conception of life entirely different from mine—namely, a commercial spirit—more or less a political personality—well, putting it bluntly, in that case I should prefer to have no intimate relations with you; then, instead of strengthening the ties between us, I would rather part company, both understanding that we are not well matched." [345a D, December 1883]

His surname appeared to him as an insult. ". . . But I ask you point-blank how we stand—are you a 'van Gogh' too? I have always looked upon you as 'Théo.'" [345a D, December 1883] Finally, van Gogh scornfully throws out: "When I read over the letters you've sent me recently, I see in them that you exert yourself to make it look as though I am the one to blame if we part company. This is such a dear

little van Goghish trick, such a nice bit of self-righteousness; for my part I shall not grudge you it if it means something to you." [362 D, March 1884]

Van Gogh signed but five of his self-portraits, and of these one appears to have been signed postfactually and two involved dedications, one "to my friend Paul G.," the other "to friend Laval." [See illustrations 4, 6, 31, 34, and 39.] These he signed as he would have signed a letter.

Van Gogh signed portraits that he "addressed." As missives, his self-portraits attested to his presence. By painting himself van Gogh achieved both embodiment and transfiguration. Why would he sign other self-portraits when they could not be sold? Why sign portraits instead of other genres? Regardless of the model or the subject for a painting, van Gogh but rarely signed finished work—only about one in seven. More than seven hundred of his canvases are "anonymous." After leaving Arles, sick, he signed no more paintings. Not one of the paintings done at the Saint-Rémy-de-Provence asylum are signed; not one of those done at Auvers-sur-Oise. Absent to himself, dispossessed of himself, his name no longer signified anything. At Auvers he painted no self-portraits. The suicide of van Gogh, who no longer painted self-portraits or signed what he painted, had already begun.

He had never signed any other way but Vincent. He never signed but in exile. Before his arrival in Paris toward the end of February 1886, van Gogh, who had been painting for five years, had signed only a dozen canvases, of more than two hundred painted. . . . When, in France, he finally became a painter, he was stuck with a name that was unpronounceable. A name that gagged in the throat with a sound of belching, one that French pronunciation naturally ridiculed. Gogh as in *goguette* (pleasure party), *goguenard* (jeering), or worse, *gogues*, the word for jail or toilet. An unacceptable name.

Better by far to keep the first name only, Vincent. Like Rembrandt. But if Rembrandt abandoned his other names when he signed, Rembrandt Harmenszoon van Rijn, Rembrandt Harmenszoon Leydensis, it was to wish himself the equal of the glorious Italians whom one knew by only their first or last names: Giorgione, Masaccio, Titian, Leonardo, Michaelangelo, Raphaël. . . . Van Gogh was not thinking of these painters. They were not his models. In September 1888, he confided: "That queer fellow Giotto, whose biographer says that he was always in pain and always full of ardor and ideas, there, that's what I should like to achieve, such a self-confidence that makes you happy and gay and alive in all conditions." [543 F, September 1888] To sign "Vincent" was not to force the pantheon's gate. During a period of exile, carrying a surname both hated and unpronouncable, it meant simply trimming to the bare essential. And it meant signing a name

one shared in memory with another. Vincent was unnameable, was without a proper name, without identity. The self-portraits represented . . . no one. In none of them did he wish to play a part. And it was only in the self-portrait he dedicated to Gauguin, in which he painted himself as a bonze (Buddhist priest), that he seemed to play a part, but even there it was, so he wrote, but an exaggeration of his own personality; in the simple worshiper of the eternal Buddha he saw himself. The only modification he made to his face was to have "made the eyes *slightly* slanting like the Japanese." [Emphasis by van Gogh; 544 F, September–October 1888]

Van Gogh facing himself, facing a self-portrait, existed in the portrait and only there. (Why sign paintings with a name that was not yours alone?) The paintings' silent and breathless succession embodied the necessity. To be the painting even though it be anonymous. Van Gogh's signature, on the rare occasions it appeared, was that of the painting, not the man. "On one marine there is an excessively red signature, because I wanted a red note in the green." [524 F, August 1888]

Van Gogh . . . a name that in French was as difficult to spell as it was to pronounce. On 15 April 1904, fourteen years after Van Gogh's death, Cézanne wrote to Émile Bernard: "You have an understanding of what needs doing, and know how to turn your back quickly on the Gauguins and the Gogs" (*sic*). [Letter cited in *Conversation avec Cézanne*, critical edition by P. M. Doran (Paris, 1978).] Only this once did Cézanne put Van Gogh's name in writing . . . to heap scorn on it.

CHAPTER 23

The Studios

There is but one Paris, and however hard living may be here, and if it became worse and harder even—the French air clears up the brain and does good—a world of good. I have been in Cormon's studio for three or four months, but I did not find that so useful as I had expected it to be. It may be my fault, however; anyhow I left there too as I left Antwerp and since I worked alone, and fancy that since I feel my own self more.
[459a, summer or fall 1886]

The date of the letter quoted above is uncertain—summer or fall of 1886. When van Gogh left the Cormon studio—Cormon was a painter of historical subjects—he wanted to be, and indeed was, a painter apart. He had finished his studies. He had been a student at the Beaux Arts academy of Brussels from October 1880, to April 1881; had worked at Etten with Anthon G. A. van Rappard; Tersteeg had counseled him at The Hague, as had Anton Mauve, at whose home he had first painted in oil at the end of 1881. Because of disagreements with Mauve concerning plaster models, which van Gogh refused to use, and because of the reproaches of Tersteeg, who could not accept van Gogh's being supported by Théo, van Gogh broke away. He continued to paint alone. Prints and magazines such as *Graphic* were his only models and his only points of reference during the years of solitude. What advice did van der Weele give him while they painted side by side in the dunes near The Hague during the summer of 1883? What did van Rappard bring him in Nuenen where he visited van Gogh for several days in May 1884 and in October of the same year? Van Gogh had been the pupil of Verlat at the School of Fine Arts of Anvers, where he enrolled on 18 January 1886. Evenings he drew nude studies after models who posed in the studio of Franz Vinck. At the end of February he was in Paris.

Over a period of six years, he managed never to spend more than six or seven months in a row in a studio at an academy or an art school, although he had spent nearly five years painting without interruption. At the Cormon studio, van Gogh realized that he had nothing more to learn. There remained only for him to paint by himself. The first self-portraits he painted were a kind of anointing: He did not paint himself until he knew himself to be a painter.

There is but one self-portrait of van Gogh shaven (Illustration 40, I am not including the two self-portraits with the bandaged ear, when he had had to shave the blood-soaked beard). It was painted in Arles in September of 1888. A tentative smile—the only one. He painted this peaceful portrait while he was fixing up the yellow house on Lamartine Square. It was a time of resolutions: "Here my life will become more and more like a Japanese painter's, living close to nature like a petty

145

tradesman. [540 F, September 1888] It was this self-portrait, nearly serene, that he hung on the wall of his room in Arles. And he quoted the portrait when he painted the room (Illustration 41). The smile of the portrait and the mood of the room were in harmony. "I have wanted to express an absolute restfulness," he wrote to Gauguin [B22 F, October 1888], as he did to Théo: ". . . Color is to . . . be suggestive here of *rest* or of sleep in general." [Emphasis by van Gogh; 554 F, October 1888]

This portrait in his room over the bed served the same role as crucifixes or other pious images do when hung on the wall in the same position in tradesmen's homes. They must lead to meditation and prayer. In 1888, van Gogh no longer had the missionary's faith he had had ten years earlier. Painting was now the eucharist that saved him. For years, van Gogh read again and again *The Imitation of Christ*. He knew every psalm. Which sentences came into his mind before the self-portrait hanging in his room? Perhaps these: "What can be the good in possessing and accumulating many material things? Only that they be scorned and uprooted from the heart. And let this not apply to money and riches only, but also to the pursuit of honors, vainglory and all else which passes with the world. No place is a sure refuge if you lack the will; and the peace you are seeking in the world does not last if the heart is without its true support, which is to say, if you do not have faith in Me."

Van Gogh had faith only in painting. Not money, nor riches, nor honors, nor vainglory; none of what "passes with the world" concerned him. Painting required all his will, and the yellow house was a refuge.

To look at this portrait, and this room, was to be able to set at a distance that which might haunt or frighten one's spirit. "I know in this above all my frailty, that the most horrible imaginings enter my spirit far easier than they can be made to leave." This too he would have read in *The Imitation of Christ*. But it was no longer a question of reading, contemplating, and praying, but of painting. It may be this was not entirely different. . . .

His shaven portrait, repainted on the wall of his room, had its place as an icon.

CHAPTER **24**

Solitude

Often whole days pass without my speaking to anyone, except to ask for dinner or coffee. And it has been like that from the beginning. [508 F, July 1888]

Van Gogh wrote those words at the beginning of July 1888. The beginning he refers to was probably his arrival in Arles in late February.

Five years earlier in The Hague he had written: "I do miss the necessary intercourse with other painters here, and I don't see any chance of improving this." [297 D, June–July 1883] There was no change, and the situation drained him. "As for me, if I could find some people whom I could talk to about art, who felt and wanted to feel—I should gain an enormous advantage in my work—I should feel more myself, be more myself." [336 D, October–November 1883] To leave The Hague for Drenthe changed nothing. "Drenthe is splendid, but one's being able to stay there depends on many things, depends on whether one is able to stand the loneliness." [344 D, November 1883] At Nuenen his isolation was the same. If, in 1884, he could write, "Friends whose cordiality makes up for the bother the work causes are of great value to a painter" [365 D, April 1884], it was not because he was surrounded with such friends. Van Gogh was far from everything. Impressionism? ". . . I have indeed concluded that it is different from what I thought, but it's not quite clear to me what it really is," he wrote in July 1884. [371 D, July 1884] In October: "But here in Holland it is rather difficult to find out what Impressionism really means." [383 D, October 1884] In April of 1885 he was none the wiser. "There is a school—I believe—of Impressionists. But I know very little about it. But I do know who the original and most important masters are, around whom—as around an axis—the landscape and peasant painters will revolve. Delacroix, Corot, Millet, and the rest. That is my own opinion, not properly formulated." [402 D, April 1885] Van Gogh had to dream up paintings, having no other way of seeing paintings but his memory: ". . . When I got off to Amsterdam for a few days, I enjoyed seeing pictures again immensely. For sometimes it is damned hard to stand completely outside the world of painters and pictures, and to have no contact with others. Since then I have felt the longing to go back to them, at least for a time. Having been entirely out of it for a few years and having wrestled with nature sometimes helps, and one may get a new store of courage and also of health by it, of which one can never have too much, for a painter's life is often hard enough." [434 D, November 1885]

Van Gogh's sorrow was first of all that of solitude. This was what prevented him, up until his arrival in Paris, from being fully a painter. Van Gogh painted no self-portraits before Paris because not until his arrival in Paris could he be a painter among other painters.

Saint Luke

The patron saint of painters—Saint Luke, physician, painter, evangelist— whose symbol is, alas, nothing but an ox, is there to give us hope. [B8 F, June 1888]

The metaphors van Gogh used to describe himself comprised a rare bestiary. He termed himself a wild boar on account of his being coarse; he called himself a dog because he was poor. "As you know, the symbol of Saint Luke, the patron saint of the painters, is an ox. So one must be as patient as an ox if one wants to labor in the artistic field. But the bulls are lucky enough not to have to work at that filthy painting." [B7 F, June 1888] Was there a part of van Gogh that was wild and untameable . . . and another part, tame, docile, gelded, that depended entirely on painting?

"What often vexes me is that painting is like having a bad mistress who spends and spends and it's never enough. . . . And another thing, any additional money you might be able to send me invigorates the canvases, not me personally. The only choice I have is between being a good painter and a bad one. I choose the former. But the demands of painting are like those of a ruinous mistress; one can do nothing without money and there is never enough." [502 F, June–July 1888]

Illness

But as for considering myself as completely sane, we must not do it. [576 F, 3 February 1889]

Thus wrote van Gogh on 3 February 1889. Only to add, "People here who have been ill like me have told me the truth. You may be old or young, but there will always be moments when you lose your head." [576 F, 3 February 1889] The wind in Arles is his madness. Why worry about a common ordinary madness, why worry that the mistral blows? Van Gogh knew he wasn't crazy. He'd known it for years and had always taken exception to the deviations people accused him of. October 1883: "They said I was out of my mind, but I knew myself that it was not true, for the very reason that I felt my own disease deep within me, and tried to remedy it. I exhausted myself in hopeless, unsuccessful efforts, it is true, but because of that fixed idea of reaching a normal point of view again, I never mistook my own desperate doings, worryings, and drudgings for my real innermost self." [332 D, October 1883] He was ill because he lived when he did and because "unfortunately we suffer from the circumstances and the ills of the times in which we live, for better or for worse." [595 F, 19 June 1889] He did not write *I* but *we*. The plural form was less shocking to him than the singular.

Van Gogh was never ill but from painting. "They pester me because of my smoking and eating, but what's the use? After all, with all their sobriety, they only cause me fresh misery." [579 F, 19 March 1889] How explain that if he smoked, and drank, these were chaste acts all in the service of painting, because painting alone required all his strength and aroused him; how explain that if he smoked, and drank, it was because sometimes for weeks on end there wasn't enough money left over after paying for painting supplies to pay for a visit to the brothel, so he quieted himself with absinthe, wine, and tobacco? What wore van Gogh out and damned him wasn't the sacrifice but the fact that it didn't work. He let himself be duped by the cynicism of creation: "Meanwhile you do understand that if alcohol has undoubtedly been one of the great causes of my madness, then it came on very slowly and will go away slowly too, assuming it does go, of course. Or the same thing if it comes from smoking. But I should only hope that it—this recovery . . . the frightful superstition of some people on the subject of alcohol, so that they prevail upon themselves never to drink or smoke. We are already ordered not to lie or steal, etc., and not to commit other crimes great or small, and it would become too complicated if it were absolutely indispensable to have nothing but virtues in the society in which we are very undeniably planted, whether it be good or bad." [585 F, 21 April 1889]

To be able to begin to live as a man in a society that scorned or at best ignored him, and continue to paint, he needed to stay sober as he had stayed chaste. Yet another task. His role seemed clear: "In present-day society we artists are only the broken pitchers." [579 F, 19 March 1889] *We* again. When hurt, van Gogh choose to lose himself in a more impersonal pronoun than *I*. He was a painter among painters, ill from never having been loved. He shared his life with only one woman, Sien, a pregnant prostitue with a child when he met her at The Hague. The relationship lasted for less than two years. He loved her despite her weariness, which over time had made her ugly, despite her gonorrhea, despite her mania and her neglect. And in the end he left her, had to leave her, and thereafter remained alone, with no recourse but for "the kind of women at two francs, originally intended for the Zouaves." [522 F, August 1888] Alone with his painting. "There is always some pretty annoying fatality in life. Well, painters die, or go mad with despair, or are paralyzed in their production, because nobody likes them personally." [W8 F, September-October 1888]

Van Gogh was ill from being a painter among painters. But painting himself signified that he was holding his own. "Well, I with my mental disease, I keep thinking of so many other artists suffering mentally, and I tell myself that this does not prevent one from exercising the painter's profession as if nothing were amiss." [605 F, 10 September 1889]

Having a Home

How I'd like to settle down and have a home! [532 F, September 1888]

Thus exclaimed van Gogh at the beginning of September 1888. A few days later he would be able to move into the "yellow house"—named after the color of its façade—at 2 Lamartine Place, that he'd rented to the Ginoux for the summer.

Upon his arrival in Arles on 20 February, he had stayed for several weeks at 30 Cavalry Street, in the Carrel hotel-restaurant. Then he'd stayed at the Alcazar Café. Furnished rooms, shacks, garrets, improvised studios—such were the lot of van Gogh during the years of wandering; since quitting the Groot-Zundert vicarage at the age of twenty he had had no home. (Only once had he moved into a place, and that was at The Hague, with Sien and for her. "Besides, one is attached to a house one has arranged oneself, and feels at home in it.") [298 D, June–July 1883]

The yellow house . . . "I wanted to arrange the house from the start not for myself only but so as to be able to put someone else up too. Naturally this has swallowed up the greater part of the money. With the rest I have bought twelve chairs, a mirror, and some small necessities." [534 F, September 1888] In his list he places the mirror ahead of the small neccessities. "I want to make it really *an artist's house*—not precious, on the contrary *nothing precious*, but everything from the chairs to the pictures having character. . . . I cannot tell you how much pleasure it gives me to find a big serious job like this. For it's going to be, I hope, a real scheme of decoration that I'm starting on now." [Emphasis by van Gogh; 534 F, September 1888]

Van Gogh had dreamed of such an artist's house for a long time. Now it was becoming a reality. At the end of 1883 he wrote: "The artist's life, with its miseries great and small, its calamaties, sufferings and disturbances, has at least a certain freedom, a certain openness, something distinctly human; it has the advantage of not having to maintain a status quo, to not even have to think about such things." In the house he was decorating, van Gogh awaited Gauguin.

On 18 September 1888, van Gogh crossed the threshold for the first time of his own house, something he'd so wanted in order to paint there, in order to live there in the company of painters, and to talk with them about painting. On 24 December having cut his ear, bleeding and delirious, van Gogh was put in a room at the Arles Hospital.

Altogether van Gogh lived less than a hundred days in the yellow house from which madness escorted him.

On 7 January 1889, he left the hospital. He was committed again on the 9th of February. He was released several days later, but only to be returned to the hospital by the police and at the insistence of the

mayor after a petition against him received twenty-four signatures. Once again, in April, he returned as far as the yellow house on the arm of Signac. It was with a painter that he closed up the house that he had dedicated to painting and to the life of those dedicated to painting. "To do good work one must eat well, be well housed, have one's fling from time to time, smoke one's pipe and drink one's coffee in peace." [B17, September 1888]

Van Gogh's Bedroom in Arles (illustration 41) is a kind of credo: Described is the humble cell that the painter's life, once chosen, has imposed. Locked away at Saint-Rémy, van Gogh copied the painting twice (illustrations 47 and 48). Regret for a moment of lost equilibrium.

CHAPTER 28

Sex

Painting and fucking a lot are not compatible; it weakens the brain. Which is a bloody nuisance. [B7 F June 1888]

In the same way that painting determined van Gogh's poverty, so did it regulate his chastity. Women fit into his painter's life only as a matter of hygiene. Relations with women are necessary only so far as they contribute to the work. January 1882: "And I tell you frankly that in my opinion one must not hesitate to go to a prostitute occasionally if there is one you can trust and feel something for, as there really are many. For one who has a strenuous life it is necessary, absolutely necessary, in order to keep sane and well." [173 D, January 1882] But it was not only a question of keeping sane and well. "If we want to be really potent males in our work, we must sometimes resign ourselves not to fuck much, and for the rest be monks or soldiers, according to the needs of our temperament. The Dutch, once more, had peaceful habits and a peaceful life, calm, well regulated." [B14 F, early August 1888]

The notion of a regulated life, comparable to those of a monastic order, obsessed van Gogh. The canvases he painted in his studio were rites and sacrifices in a mystery. Van Gogh wanted all his manhood to be devoted to his work alone. He had at all costs to avoid the brothel. There he would lose everything, including the strength to paint. "Alcohol and tobacco have something good in them as well as something bad—it's relative—they're anti-aphrodisiacs—I have to say that's what I believe. And the role they play in the fine arts is thus not always an execrable one. And in the end one ought not to forget to laugh a little at the irony. Since virtue and sobriety, I fear it well, would lead me once again into those quarters where very quickly I lose the compass completely; I must try for once to show less passion and more fellowship."

It was in "those quarters," in Arles, that on the night of 23 December 1888, van Gogh carried the lobe of his left ear in an envelope. The self-portraits of van Gogh, his life of poverty and chastity ruled by painting, are those of a monk. When van Gogh smoked his pipe or sat himself down in before a glass of wine, he was accomplishing a ritual ceremony.

*All through my life, or at least most of it, I have sought something
other than a martyr's career, for which I am not cut out.*

Vincent to Théo, Saint-Rémy,
May 1889, Letter 590 in French

My dear Théo,

Many thanks for your letter and the 100-fr. note it contained. Milliet also came this morning, bringing me the package of Japanese stuff and other things. Among them I very much like the cabaret in two sheets, with the line of violet girl musicians against the yellow lighted wall—I did not know that print, and there are several others which were unknown to me; there is one, a woman's head, which must belong to a good school.

I have just bought a dressing table with everything necessary, and my own little room is complete. The other one, Gauguin's or another lodger's, still needs a dressing table and a chest of drawers, and downstairs I shall need a big frying pan and a cupboard.

There is no hurry for any of this, and already I can see myself earning enough to be safe for a long time to come.

You cannot think what peace of mind it gives me, I am so set on making an artist's home, but one for practical use, and not the ordinary studio full of knickknacks.

I am also thinking of planting two oleanders in tubs in front of the door.

After all we shall probably spend several times fewer hundreds of francs than Russell, for example, will spend thousands. And truly, even if I could choose between the two, for my own part I shall rather have the hundred-franc method, so long as every piece of furniture is solid and big.

But the room where I shall put up anybody who comes this way will be like a boudoir, and when it is finished, you will see that it will not be a haphazard production, but a deliberate creation.

The text of Bing's *Japon* is rather dry, and leaves something to be desired; he says there is a great individual art, but though he gives a few scraps of it, he gives you no real impression of the character of that art.

Have you read *Madame Chrysanthème* yet?

The sense of tranquility that the house has brought me mainly amounts to this—that from now on I feel I am working to provide for the future, so that after me another painter will find a going concern. I shall need time, but I am obsessed with the idea of painting such decorations for the house as will be worth the money spent on me during the years in which I was unproductive.

Mother's photograph gave me very great pleasure, because you can see that she is well, and because she still has such a lively expression. But I do not care for it at all as a real likeness; I have just painted my own portrait, in my own ashen coloring, and unless we are painted in color, the result is nowhere near a speaking likeness. Just because I had taken a terrific amount of trouble to get the combination of ashen and gray-pink tones, I could not like the portrait in black and white. Would Germinie Lacerteux really be Germinie Lacerteux without her color? Obviously not. How I would like to have painted portraits of our own family.

For the second time I have scraped off a study of Christ with the angel in the Garden of Olives. You see, I can see real olives here, but I cannot or rather I will not paint any more without models; but I have the thing in my head with the colors, a starry night, the figure of Christ in blue, all the strongest blues, and the angel blended citron-yellow. And every shade of violet, from a blood-red purple to ashen, in the landscape.

I have been to get five size 30 stretchers, so I have even more ideas. I'm having the pictures that I'm keeping here framed in oak and walnut.

It will take time, but you'll see later one.

I hope that you will give me some details of your visit to Maurin. I like the drawing of the two women in the carriage tremendously.

Even if it is some time before anyone comes here to stay with me, it won't make me change my mind about this step being urgent and being useful in the long run. This art that we are working in, we feel it has a long future before it, and one must be quietly settled, like steady people, and not like decadents. Here my life will become more and more like a Japanese painter's, living close to nature like a petty tradesman. And that, you well know, is a less lugubrious affair than the decadent's way. if I can live long enough, I shall be something like old Tanguy.

After all, we don't really know anything about our own personal future, but we nevertheless feel that impressionism will last. Good-by for the present and good luck, and many, many thanks for all you kindness. I think that I shall put the Japanese things downstairs in the studio. A handshake.

Vincent to Théo, Arles,
September 1888, Letter 540 in French

40. *Self-Portrait,*
Arles, September 1888, oil on canvas, 40 × 31 cm,
Switzerland, private collection.

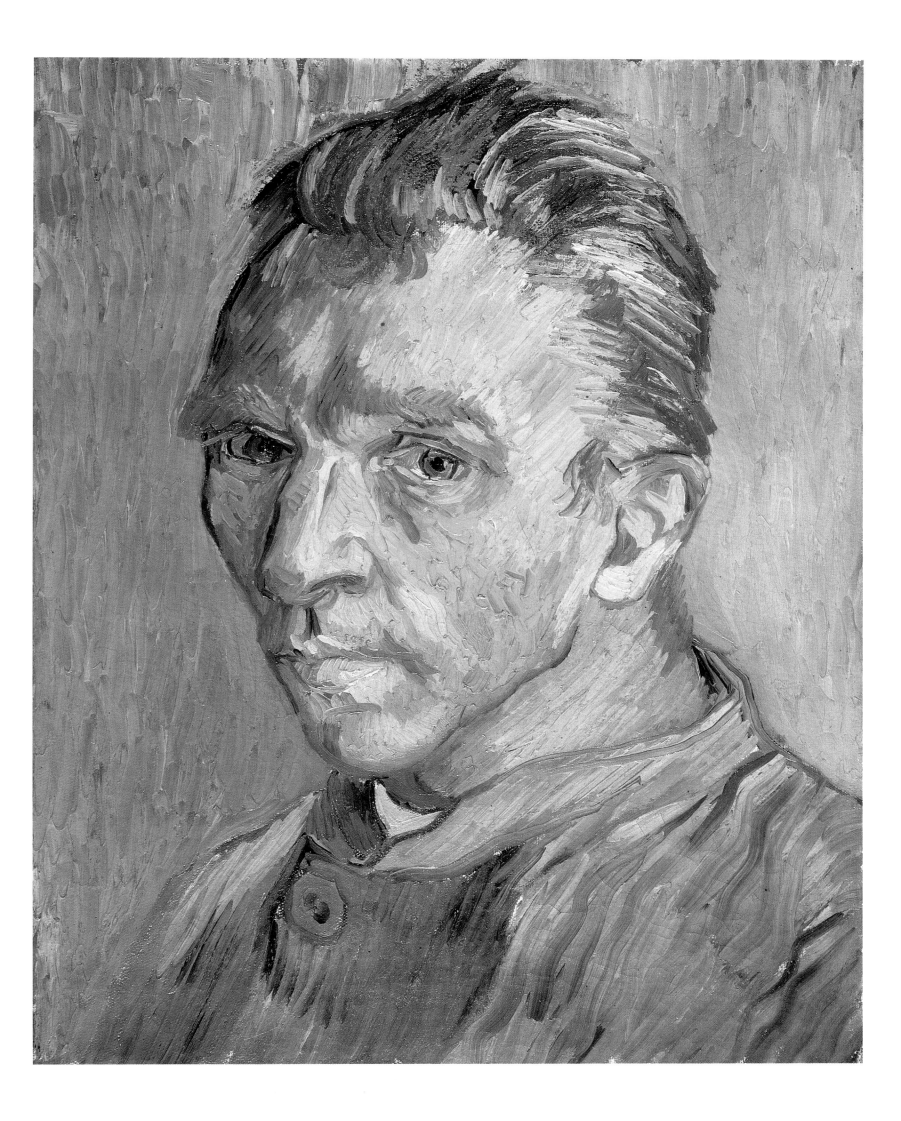

My dear Théo,

At last I can send you a little sketch to give you at least an idea of the way the work is shaping up. For today I am all right again. My eyes are still tired, but then I have a new idea in my head and here is the sketch of it. Another size-30 canvas. This time it's just simply my bedroom, only here color is to do everything, and giving by its simplification a grander style to things, is to be suggestive here of *rest* or of sleep in general. In a word, looking at the picture ought to rest the brain, or rather the imagination.

The walls are pale violet. The floor is of red tiles.

The wood of the bed and chairs is the yellow of fresh butter, the sheets and pillows very light greenish-citron.

The coverlet scarlet. The window green.

The toilet table orange, the basin blue.

The doors lilac.

And that is all—there is nothing in this room with its closed shutters.

The broad lines of the furniture again must express inviolable rest. Portraits on the walls, and a mirror and a towel and some clothes.

The frame—as there is no white in the picture—will be white.

This by way of revenge for the enforced rest I was obliged to take.

I shall work on it again all day, but you see how simple the conception is. The shadows and the cast shadows are suppressed; it is painted in free flat tints like the Japanese prints. It is going to be a contrast to, for instance, the Tarascon diligence and the night café.

I am not writing you a long letter, because tomorrow very early I am going to begin in the cool morning light, so as to finish my canvas.

How are the pains—don't forget to tell me about them.

I know that you will write one of these days.

I will make you sketches of the other rooms too someday.

With a good handshake,

Vincent to Théo, Arles,
October 1888, Letter 554 in French

This bedroom is something like the still life of the Parisian novels with the yellow, pink, and green covers, you remember it. But I think the workmanship is more virile and simple. No stippling, no hatching, nothing, only flat colors

in harmony. I do not know what I shall undertake next, for my eyes are still tired even yet. And in just such moments after hard work—and all the more the harder it is—I feel my own noodle empty too, you know.

Vincent to Théo, Arles,
October 1888, Letter 555 in French

I have done, still for my decoration, a size-30 canvas of my bedroom with the white deal furniture that you know. Well, I enormously enjoyed doing this interior of nothing at all, of a Seurat-like simplicity; with flat tints, but brushed on roughly, with a thick impasto, the walls pale lilac, the ground a faded broken red, the chairs and the bed chrome yellow, the pillows and the sheet a very pale green-citron, the counterpane bloodred, the washstand orange, the washbasin blue, the window green. By means of all these very diverse tones I have wanted to express an absolute restfulness, you see, and there is no white in it at all except the little note produced by the mirror with its black frame (in order to get the fourth pair of complementaries into it). Well, you will see it along with the other things, and we will talk about it, for I often don't know what I am doing when I am working almost like a sleepwalker.

Vincent to Paul Gauguin, Arles,
on or about 20 October 1888, Letter B22 in French

My house will seem to me more lived-in now that I am going to see the portraits in it.

Vincent to Émile Bernard, Arles,
early October 1888, Letter B19 in French

When I saw my canvases again after my illness, the one that seemed the best to me was the bedroom.

Vincent to Théo, Arles,
23 January 1889, Letter 573 in French

I shall send you back the bedroom, but you must not think of retouching this canvas if you can repair the damage. Copy it, and then send back this one, so that I can have it recanvased.

Théo to Vincent,
16 June, 1889, Letter T10

41. *Van Gogh's Bedroom in Arles*,
Arles, October 1888, oil on canvas, 72 × 90 cm,
Amsterdam, Rijksmuseum Vincent can Gogh.

What I am trying to do most is to bring life into it.

Vincent to Théo, Nuenen,
April 1885, Letter 403 in Dutch

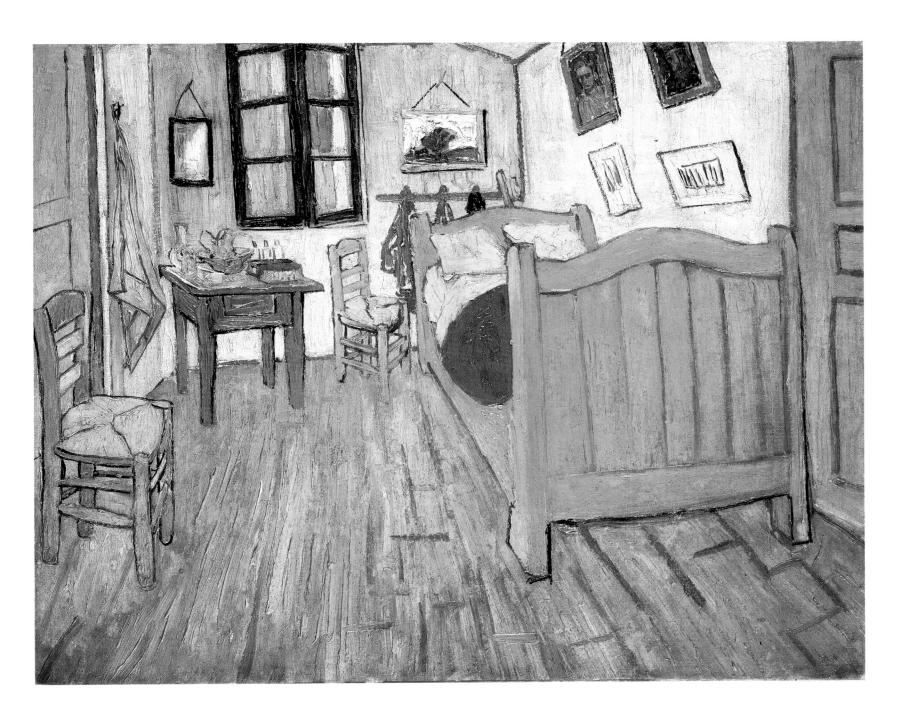

*Our life is an appalling reality,
and we ourselves are infinitely driven.*

Vincent to Théo, Nuenen,
January 1884, Letter 345 in Dutch

When evening came I threw together something to eat and then felt the need to go for a walk alone in the laurel-scented air. I had already crossed most of Victor Hugo Square, when I heard behind me the familiar small, quick, irregular steps. I turned just as Vincent fell upon me wielding an open razor. The look I gave him must have been a potent one, because he stopped in his tracks, lowering his head, and then took off running back in the direction of the house.

Was it cowardly of me not to try to disarm and calm him? I've put it to my conscience and do not think I acted wrongly. Whoever wishes to can cast stones at me. I headed for a good Arles hotel where, after asking what time it was, I took a room and went to bed. I was agitated, however, and didn't fall asleep until about 3:00 A.M., rising quite late, at about 7:30 A.M. Reaching the square I saw that a large crowd had gathered. Near our house there were police and a small man in a bowler hat who was the police commissioner.

Here's what had happened. Van Gogh had reentered the house and immediately cut off the lower part of his ear. It must have taken some time to stanch the bleeding, since the next day a number of washcloths soaked with blood were strewn about the two ground-floor rooms. Blood had dirtied both rooms and the stairway leading to our bedroom.

Once he was ready to go out, his head covered in a dark Basque béret, he went straight to the kind of house where strangers find comfort and gave to the sentry an envelope containing his ear, which he had washed well. "Here," he said, "is something to remember me by," and then he fled back home, where he went to bed and slept. He did have the presence of mind first to close the shutters and to place a lighted lamp on a table by the window.

Ten minutes later, the whole street where the ladies of the night work was bustling and everyone was talking about what had happened.

I knew none of this when I arrived at our house, to be confronted by the man with the bowler hat, speaking in a severe voice, who asked me point-blank: "What have you done to your friend?"

"I don't know—"

"But of course you do. . . . He is dead."

I do not wish on anyone such a moment, and it took me several long minutes before I could think, or check the beating of my heart.

Anger, indignation, sorrow, and shame under the harrowing glances from the crowd suffocated me as, stuttering, I said: "Very well, sir, come in and we will talk inside."

Vincent lay in bed, completely buried in the covers, cowering like a dog; he seemed lifeless. Gently, I felt his body; its warmth was a sure sign of life. For me this was a shot in the arm, and I regained my wits and my energy.

In a whisper I said to the police commissioner: "Be so kind, sir, as to see that this man is revived with much care, and if he asks after me, tell him that I've left for Paris. The sight of me might be fatal to him."

I have to admit that from this moment on the police commissioner was as decent as possible; sensibly, he sent for a doctor and a car.

Once revived, Vincent asked after his friend, his pipe and his tobacco, and even thought to ask for the box downstairs that held our money. A suspicion doubtless that regarded me, already armed against all pain.

Vincent was taken to the hospital, where, as soon as he arrived, his brain started again with the nonsense. All the rest is common knowledge, and there would be no reason to talk about it, but for the extreme pain of a man who, in an insane asylum, saw himself regain enough of his reason each month to know his own condition and then to paint, furiously, the wonderful paintings we know.

Gauguin, Paul, *Oviri, écrits d'un sauvage*
(Paris: Gallimard, 1974)

42. *Self-Portrait with a Bandaged Ear,*
Arles, January 1889, oil on canvas, 60 × 49 cm,
London, Courtauld Institute Galleries.

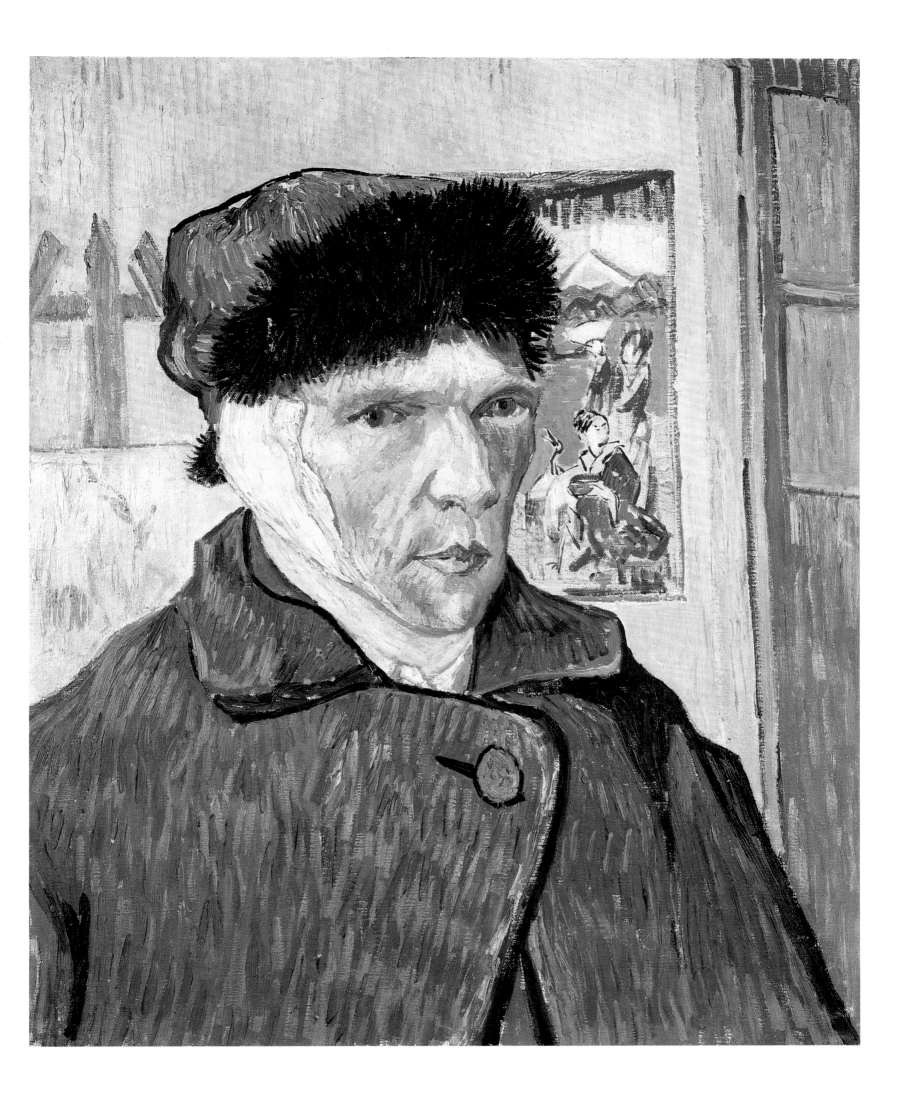

Let me go quietly on with my work; if it is that of a madman,
well, so much the worse. I can't help it.

Vincent to Théo, Arles,
28 January 1889, Letter 574 in French

So there is no worse harm done this time than a little more suffering and its attendant wretchedness. And I keep on hoping. But I feel weak and rather uneasy and frightened. That will pass, I hope, as I get back my strength.

Rey told me that being very impressionable was enough to account for the attack that I had, and that I was really only anemic, but that I really must feed myself up. But I took the liberty of saying to M. Rey that if the first thing for me was to get back my strength, and if by pure chance or misunderstanding it has just happened that I had had to keep a strict fast for a week—whether he had seen many madmen in similar circumstances fairly quiet and able to work; if not, would he then be good enough to remember occasionally that for the moment I am not yet mad.

Now considering that all the house was upset by this occurrence, and all the linen and my clothes soiled, is there anything improper or extravagant or exorbitant in these payments? If I paid what was *owing* to people almost as poor as myself as soon as I got back, did I do wrong, or could I have been more economical? Now today on the seventeenth I at last received 50 francs. Out of that I am paying first the 5 francs borrowed from the *patron* at the café and the ten meals taken on credit during the course of last week, which makes 7.5 frs.
I also have to pay for the linen brought back from the hospital and then
for this last week, and for shoe repairs and
a pair of trousers, certainly
altogether something like 5 frs.
Wood and coal owing for December and to
be bought again, not less than 4 frs.
Charwoman, 2nd fortnight in January 10 frs.

26.50 frs.

Net amount left me tomorrow morning after
settling this bill 23.50 frs.

It is now the seventeenth, there are still thirteen days to go.

Ask yourself how much I can spend in a day? I have to add that you sent 30 francs to Roulin, out of which he paid the 21.50 rent for December.

There, my dear boy, are the accounts for this present month. It is not over.

Now we come to the expenses caused you by Gauguin's telegram, which I have already expressly reproached him for sending.

Are the expenses thus mistakenly incurred less than 200 fr.? Does Gauguin himself claim that it was a brilliant step to take? Look here, I won't say more about the absurdity of this measure, suppose that I was as wild as anything, then why wasn't our illustrious partner more collected?

But I shan't press that point.

I cannot commend you enough for paying Gauguin in such a way that he can only congratulate himself on any dealings he has had with us. Unfortunately there again is another expenditure perhaps grater than it should have been, yet I catch a glimpse of hope in it. . . .

One good quality he has is the marvelous way he can apportion expenses from day to day.

While I am often absent-minded, preoccupied with aiming at *the goal*, he has far more money sense for each separate day than I have. But his weakness is that by a sudden freak or animal impulse he upsets everything he has arranged.

Now do you stay at your post once you have taken it, or do you desert it? I do not judge anyone in this, hoping not to be condemned myself in cases when my strength might fail me, but if Gauguin has so much real virtue, and such capacity for charity, how is he going to employ himself?

As for me, I have ceased to be able to follow his actions, and I give it up in silence, but with a questioning note all the same.

From time to time he and I have exchanged ideas about French art, and Impressionism. . . .

It seems to me impossible, or at least pretty improbable, that Impressionism will organize and steady itself now.

Why shouldn't what happened in England at the time of the Pre-Raphaelites happen here?

The union broke up.

Perhaps I take all these things too much to heart and perhaps they sadden me too much.

Vincent to Théo, Arles,
17 January 1889, Letter 571 in French

43. *Self-Portrait: Man with a Pipe,*
Arles, January 1889, oil on canvas, 51 × 45 cm,
London, private collection.

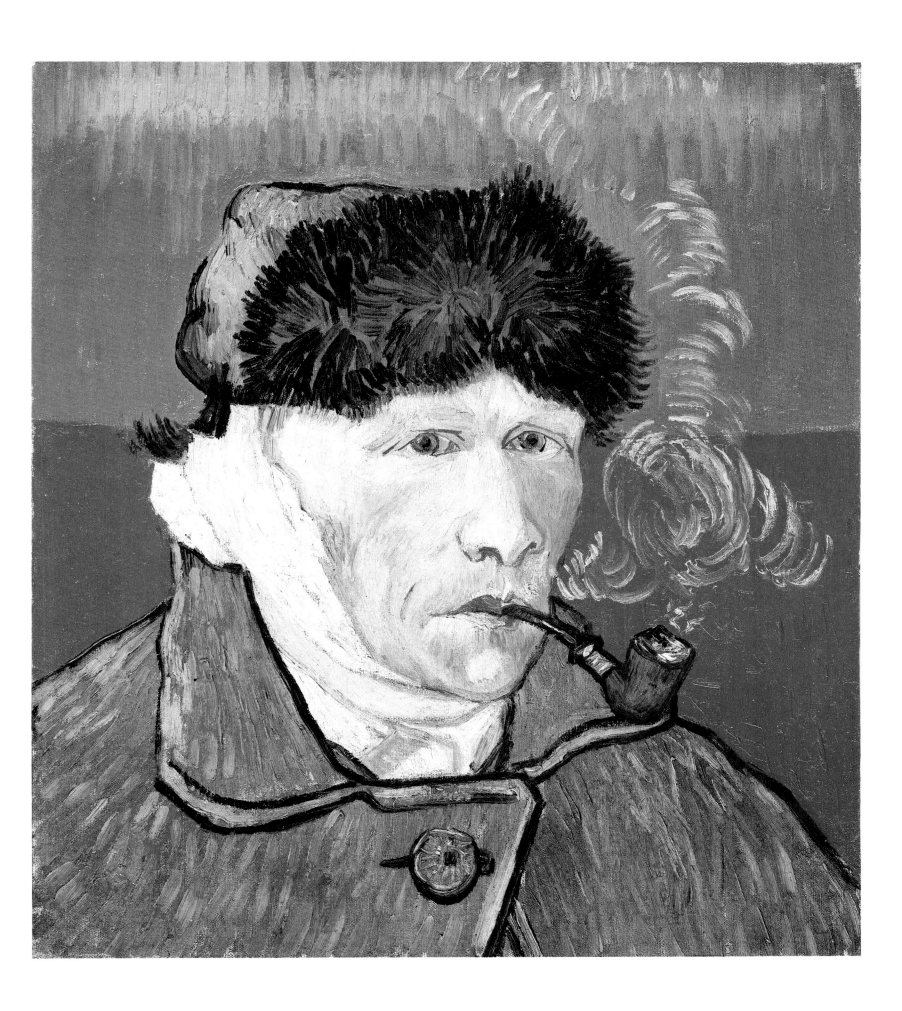

Japan

And you cannot study Japanese art, it seems to me, without becoming much gayer and happier. [542 F, September 1888]

The adjectives *gay* and *happy* become remarkable when one thinks of the self-portrait painted in Arles in January 1889 (Illustration 42). Van Gogh's bandaged profile is silhouetted against a Japanese print. What sort of gaiety has he found? What sort of happiness? Or has he resigned himself to turn his back on those things?

Beside the print is an open window. Van Gogh painted himself in the yellow house at 2 Lamartine Place in Arles. But the window opens on to Japan, not Provence. In June 1888, Van Gogh wrote to Théo: "About this staying on in the south, even if it is more expensive, consider: We like Japanese painting, we have felt its influence, all the Impressionists have that in common; then why not go to Japan, that is to say to the equivalent of Japan, the south? . . . I wish you could spend some time here; you would feel it after a while, one's sight changes: You see things with an eye more Japanese, you feel color differently. . . . I am convinced that I shall set my individuality free simply be staying on here." [500 F, June 1888] In September, writing to his sister, he said it again: "Théo wrote me that he had given you Japanese pictures. This is surely the practical way to arrive at an understanding of the direction which painting in bright clear colors has taken at present. For my part I don't need Japanese pictures here, for I am always telling myself that *here I am in Japan*." [Emphasis by van Gogh; W7 F, on or about 8 September 1888] When he left the hospital, van Gogh returned to Japan, to paint, behind his wounded head, an open window, an untouched canvas, and a Japanese print, affirming once again: "Japanese art is a thing like the Primitives, like the Greeks, like our old Dutchmen, Rembrandt, Potter, Hals, van der Meer, Ostade, Ruysdaël. *They never pass away.*" [Emphasis by van Gogh; 511 F, June–July 1888] His ear lobe severed, the ear bandaged, the crisis over and past, van Gogh painted his faith. It never passed away.

CHAPTER 30

Exile

If we nevertheless want to go on working, we have to resign ourselves to the obstinate callousness of the times and to our isolation, which is sometimes as hard to endure as living in exile. And so we have to expect, after the years that, relatively speaking, we lost, poverty, sickness, old age, madness, and always exile. [W13 F, July 1889]

Exile. Vincent van Gogh, born 30 March 1853, at Groot-Zundert in Brabant, was Dutch. But he left Holland at the age of twenty and returned to live there for less than five years altogether, from April 1881 to November 1885. And he painted less than one quarter of his paintings in Holland, including those painted at Etten and at Nuenen. It was in Paris, Arles, Saint-Rémy-de-Provence, and Auvers-sur-Oise that he existed as a painter, the perfect painter. But Holland haunted him—to the point where, following his stay at Saint-Rémy, he wrote on 10 September 1889: "When I realize that here the attacks tend to take an absurd religious turn, I should almost venture to think that this even *necessitates* a return to the North." [Emphasis by van Gogh; 605 F, 10 September 1889] And again in May 1890: "The brush strokes come like clockwork. So relying on that, I dare think that I shall find my balance in the North, once delivered from surroundings and circumstances which I do not understand or wish to understand." [630 F, May 1890]

North would be Auvers-sur-Oise. But it is not that North which for three years van Gogh has not ceased to dream of, and it is not that North which he "sees again" in Arles, Saintes-Maries-de-la-Mer, and Saint-Rémy. From Arles in June 1888: "If you saw the Camargue and many other places, you would be surprised, just as I was, to find that they are exactly in Ruysdaël's style." [496 F, June 1888] From Saintes-Maries-de-la-Mer on 16 June 1888: "The shore here is sandy, neither cliffs nor rocks—like Holland without the dunes, and bluer." [499 F, 16 June 1888] From Arles, in July 1888: "Involuntarily—is it the effect of this Ruysdael country?—I keep thinking of Holland, and across the twofold remoteness of distance and time gone by, these memories have a kind of heartbreak in them." [512 F, July 1888] From Saint-Rémy-de-Provence, on 23 January 1889: 'During my illness I saw again every room in the house at Zundert, every path, every plant in the garden, the views of the fields outside, the neighbors, the graveyard, the church, our kitchen garden at the back—down to a magpie's nest in a tall acacia in the graveyard. It's because I still have earlier recollections of those first days than any of the rest of you. There is no one left who remembers all this but Mother and me. I say no more about it, since I had better not try to go over all that passed through my head then." [573 F, 23 January 1889]

And on 9 June 1889: "In this country there are many things that often make you think of Ruysdael, but the figures of the laborers are absent." [594 F, 9 June 1889] In September 1889: "Then memories overwhelmed me like an avalanche, and I tried to reconstruct that whole school of modern Flemish artists, until I was as homesick as a lost dog. Which does no good, because our way lies forward, and retracing one's steps is forbidden and impossible. I mean, we can think about the past without letting ourselves be drowned in too sad a longing." [604 F, September 1889]

In January 1890: "I often think of Holland, of our youth in the past—for the very reason that I feel entirely in the country here. And yet I am aging, you know, and it seems to me that life is passing by more rapidly, and that the responsibilities are more serious, and that the question of how to make up for lost time is more critical, and that it is harder to do the day's work, and that the future is more mysterious and, dear me, a little more gloomy." [W19 F, January 1890] The time is a long way off when, only a year and a half earlier, after just three months in Arles, he wrote: "I don't yearn for the gray sea of the North." [B4 F, on or about 20 April 1888]

Van Gogh wanted to believe that the South would save him from everything. In June 1888, he wrote: "I keep on finding very beautiful and interesting subjects here, and in spite of the worry about the expense, I think that there is a better chance in the South than in the North." In September he affirmed to Théo: ". . . If Gauguin came and if it was fairly well known that we were staying here and helping artists live and work, I still do not see at all why the South should not become another native land to you as well as to me." [535 F, September 1888] Gauguin came. He stayed by van Gogh in the yellow house but two months. At the time Gauguin left him, van Gogh was not a man who would find another native land. His ear lobe severed, he was a lost, ravaged, exhausted soul they put away. Irremediably, he was once again, as always, excluded.

When he was lucid, van Gogh knew, as he'd always known, that misfortune would hound him wherever he went. At the end of November 1885, he arrived in Anvers: ". . . It will never hurt knowing Antwerp a bit; it will probably prove to be like everything everywhere, namely disillusioning."

For years van Gogh refused to leave for Paris despite the invitation from Théo: ". . . I need not tell you that here on this beautiful moor I haven't the slightest longing for Paris, and I wouldn't think about it at all if it hadn't been for your letter. . . . I repeat, I think that there are things for me to learn in Paris as well as here on the moor; in the city, I should have an opportunity to learn from other artists and to

see what they are doing, and that is worth something; but working here, I think I can make progress even without seeing other painters. And for my own pleasure I would much rather stay here." [335 D, October–November 1883] He knew what he would have to face there. ". . . *For* Paris I see everything *except* fatality!" And he left Paris in February 1888. "[Paris] seems as big as the sea. There one always leaves behind a considerable part of one's life." [W4 D, June or July 1888] On 24 March 1889, he drew a lesson from his stay in Arles: ". . . I have no better luck in the South than in the North. It's pretty much the same everywhere." [581 F, 24 March 1889] Everywhere. Always. Exile.

In the letter of December 1881, in which, after eight years of exile, he offered: "For, Théo, with painting my real career begins." He confessed as well that "Here in Holland I feel much more at home, yes, I think I shall again become a thorough Dutchman, and don't you think that's most reasonable, after all? I think I shall become quite a thorough Dutchman again, in character as well as in my drawing and painting style." [165 D, December 1881]

When writing to van Rappard, a painter, he defined himself as a "beginner draughtsman": "And as I see it, both you and I cannot do better than work after nature in Holland (figure and landscape). Then we are ourselves, then we feel at home, then we are in our element. The more we know of what is happening abroad, the better, but we must never forget that we have our roots in the Dutch soil." [R2 D, 15 October 1881] Four years later van Gogh was still in Holland, in Brabant: "And it doesn't seem at all improbable that I shall stay there for the rest of my days. In fact, I have no other wish than to live deep, deep in the heart of the country and to paint rural life. I feel that my work lies there, so I shall keep my hand to the plow and cut my furrow steadily." [398 D, April 1885] And he added, "I feel more at home in the country." [398 D, April 1885] But although he put down roots in Brabant, and although he both wanted and didn't want to be a Dutch painter as Rembrandt, Hals, or Ruysdaël had been, yet van Gogh knew that as a painter he was damned. ". . . A man has roots; transplantation is a hard thing, even if the terrain is more hospitable there were he is replanted. And is it better there??? What the puritans once were, painters are in today's society." Their integrity, rigor and intransigence render them intolerable; the painter's quest is rigorous also. And in the end the result is the same, exile. "Being a creature exiled, outcast from society, like you and me who are artists," he wrote to Émile Bernard. [B14 F, August 1888]

On 24 March 1889, van Gogh was committed. He admitted all, pleaded guilty: ". . . instead of eating enough and at regular times, I kept myself going on coffee and alcohol. I admit all that, but all the same it is true that to attain the high yellow note that I attained last

summer, I really had to be pretty well keyed up." [581 F, 24 March 1889] The uprooting killed van Gogh: "And that is what the first and last cause of my aberration was. Do you know those words of a Dutch poet's—*Ik ben aan d'aard gehecht met meer dan aardse banden'* ['I am attached to the earth by more than earthly ties']. That is what I have experienced in the midst of much suffering—above all in my so-called mental illness." [581 F, 24 March 1889] For three years van Gogh's exile was also one of language. Since reaching Paris he'd written to Théo in French. Starting with a note asking him to set a meeting in the Carré Salon of the Louvre, van Gogh had written more than 120 letters to Théo in French. But to state the cause of the illness that was destroying him, he quoted a Dutch poet in Dutch. When in his death throes, from his room in Auvers, it was in Dutch that van Gogh spoke to Théo.

Van Gogh's silent self-portraits were all painted in exile. There exist no self-portraits but those of an uprooted man. I ponder the metaphors he used. His self-portraits were those of a puritan, of a faith. The Scriptures "remain the light of the world." In Paris he proclaimed: "Let the Bible be enough for us," and explained: "I myself am always glad that I have read the Bible more thoroughly than many people nowadays, because it eases my mind somewhat to know that there were once such lofty ideas. But because of the very fact that I think the old things so beautiful, I must think the new things beautiful *à plus forte raison.*" [W1 D, summer or fall 1887] His painting represented the search for that new beauty which he wished to be worthy of the Scriptures.

While in Drenthe, van Gogh asserted that "if one is to grow, it must be by sinking roots into the earth," at a time when he was painting the earth flat, rich and upturned. The *Self-Portrait on the Road to Tarascon* (illustration 33) is a portrait of him as a rustic, and the blue smock he wore from portrait to portrait was an overall. He painted according to the rhythm of the hours, the day, and the seasons, and his canvases were weeded, harrowed, furrowed. ". . . I am working like one actually possessed, more than ever I am in a dumb fury of work. And I think that this will help cure me," he wrote in September 1889. [604 F, September 1889]

"We *must* work as much and with as few pretensions as a peasant if we want to last." [Emphasis by van Gogh; 615 F, November 1889] And his harvest was light.

Dedicated to the People

I feel that my work lies in the heart of the people, that I must keep close to the ground, that I must grasp life in its depths and make progress through many cares and troubles. I can't think of any other way. I do not ask to be free from trouble or care; I only hope the latter will not become unbearable. [197 D 11 May 1882]

Van Gogh wrote the words quoted above on 11 May 1882. Such a social aspiration was comparable to what he'd hoped for during his years as a pastor. To paint was to give of oneself, just as preaching was. Van Gogh never stopped being both missionary and painter; he was an apostle, which is to say, a witness. Painting was a kind of new New Testament. And van Gogh dreamed of a kind of church. On 1 November 1882, he wrote, "If the painters combined to see that their work (which in my opinion is, after all, made for the people—at least I think this is the highest, noblest calling for any artist to pursue) could indeed come into the public's hands and was brought within everybody's reach, it could produce the same results as those achieved during the *Graphic*'s first years." [240 D, 1 November 1882] A few weeks later, he describes his project in more preceise terms: "What I wanted to say is this. The idea of drawing types of workmen from the people for the people, distributing them in a popular edition, and taking the whole as a matter of duty and public service—that and nothing but that—look here, that idea is enough to convince me that even if it didn't succeed at once, one might suppose, 'The thing is as true today as it was yesterday, and it will be as true tomorrow.' And so it is a thing which one can begin and continue with serenity, a thing the good success of which one need not doubt or despair of—if only one doesn't relax or lose courage." [251 D, December 1882]

And in March 1883: "Every day here in The Hague I see, so to speak, a world which many people pass by, and which is quite different from what most of the painters make. And I shouldn't dare say so if I didn't know from experience that even figure painters really pass it by, and if I didn't remember that whenever some figure caught my eye while walking with them, I would repeatedly hear, 'Oh, those dirty people!' or 'That kind of person!' In short, expressions one would not expect from a painter. Yes, it often made me wonder. . . . It seems as if they purposely avoid the most serious, the most beautiful things—in short, as if they voluntarily muzzle themselves and clip their own wings." [276 D, March 1883] Van Gogh never derogated. In April 1889, he referred to the people of Arles: "It is probable that people here won't see very much in it, but nevertheless it has always been my great desire to paint for those who do not know the artistic

aspect of a picture." And again from the Saint-Rémy-de-Provence asylum: "And then it does one good to work for people who do not know what a picture is." [604 F, September 1889]

Facing van Gogh's canvases, there is no single way of looking that will break the silence of painting's mysteries. Each way of looking finds its proper response.

Van Gogh's Secret

Vincent has a secret that fears the light.

I read and reread the sentence quoted above, from a letter written out of spite and anger in May 1882. He was twenty-nine old when he wrote it; the letter describes the fatality that was painting. To paint the light was first of all the possibility of having to destroy the secret. And so to die. Van Gogh was this mystery. And thus his paintings did not have need of the image making of a faith. Painting itself was his faith. And van Gogh no longer saw the Scriptures, except in painting. If he painted a *Resurrection of Lazarus*, it was not the Gospel of John but Rembrandt that was his model; if he painted an *Angel*, it was after an engraving by Ch. Courtry, himself working from a painting attributed to Rembrandt; and when, in June of 1890, van Gogh painted a *Pietà*, his model was Delacroix, as it had been for *The Good Samaritan*. Van Gogh produced no paintings after the Bible, but a Bible was open on the table to the Book of Isaiah, one book among others—in front of the Bible, with a yellow cover, *La Joi de vivre*, by Zola. Four copies after Delacroix and Rembrandt represented the sum total of "religious" works by van Gogh. "The figure of Christ, as I feel it, has been painted only by Delacroix and Rembrandt . . . and later Millet painted . . . the doctrine of Christ." [B8 F, late June 1888] But the rest of his work was no less sacred—in terms of both what he painted and the sacrifice it required of him. Van Gogh copied Millet, known to him through wood cuts executed by Lavieille, as he copied Rembrandt and Delacroix; by the iconography, Millet's *Departure for Work* was a Flight from Egypt and *The Watch* a Nativity.

The faith of van Gogh was that of an apostle; faith was a witness and upon the privation was founded its truth. Van Gogh painted as he had preached. *The Potato Eaters* was a Last Supper as much as it was a genre painting. The humble subjects that van Gogh painted were the speech of the Gospel. "And now, as in other periods when civilization is in a decline, the corruption of society has turned all the relations of good and evil upside down, and one falls back logically upon the old saying 'The first shall be last, and the last shall be first.' " [326 D, September 1883] The paintings embody those words of Matthew and are modern as well. "To draw a peasant's figure in action, I repeat, that's what an essentially modern figure is, the very core of modern art, which neither the Greeks nor the Renaissance nor the old Dutch school have done. This is a question that occupies me every day." [418 D, July 1885]

It was not realism that van Gogh was pursuing, but spirituality. To paint was a quest. ". . . I am an artist—which I won't take back, because, of course, these words connote: always seeking without absolutely finding. It is just the opposite of saying, 'I know, I have found it,' " he wrote in May 1882. [192 D, May 1882] Was it for never having found the solution that, eight years later, van Gogh put a bullet in his chest? Was it because the light had given away his secret?

CHAPTER 33

Suicide

Dying is perhaps not so difficult as living. [358 D, February 1884]

Those words, written toward the end of February 1884, were not an indication of van Gogh's future suicide. Suicide was not one of the things that haunted him. Killing oneself remained an abstract notion to him, something that came to mind only in the third person. Such a death could not be his. On 6 July 1882: "I know that then I often, often thought of a manly saying of father Millet's: *'Il m'a toujours semblé que le suicide était une action de malhonnête homme'* [*'It has always seemed to me that suicide was the deed of a dishonest man'*]. The emptiness, the unutterable misery within me, made me think, Yes, I can understand people drowning themselves. But I was far from approving this. I found strength in the above-mentioned saying, and thought it much better to take heart and find a remedy in work." [Emphasis by van Gogh; 212 D, 6 July 1882] February 1884: "And—I firmly believe that there are things like that in the depths of our souls—and that they would cut us to the quick if we knew about them. At times we are quite disenchanted by mankind—our own selves included, of course— and yet—seeing that we are going to pop off soon enough after all—it would hardly be worthwhile to stick to our displeasure, even if it were well founded." [R41 D, February 1884] In September 1884, in Nuenen, a neighbor of the parsonnage, Margot Begemann, age thirty-nine, poisoned herself. "You will understand how everything, everything passed through my mind these last few days, and how absorbed I was in this sad story. Now that she has tried this and failed, I think it has given her such a fright that she will not readily try it a second time; the failure of a suicide is the best remedy against a future suicide. But if she gets brain fever or nervous fever, then . . ." [375 D, September 1884] In his eyes the essential cause of that suicide attempt was none of these possible illnesses, but something worse. "But for heaven's sake, what is the meaning of that standing and of that religion which the respectable people maintain? Oh, they are perfectly absurd, making society a kind of lunatic asylum, a perfectly topsy-turvy world—oh, that mysticism." [375 D, September 1884]

Why should he, who never played any kind of role, who never stopped working, who through work kept the demons at bay, one day come to dread suicide? The crises themselves, even in Arles, were not the danger. "I look upon the whole thing as a simple accident. There can be no doubt that much of this is my own fault, and at times I have attacks of melancholy and of atrocious remorse; but you know, the fact is, that when all this discourages me and gives me spleen, I am not exactly ashamed to tell myself that the remorse and all the other things that are wrong might possibly be caused by microbes too, like

170

love. Every day I take the remedy that the incomparable Dickens prescribes against suicide. It consists of a glass of wine, a piece of bread with cheese, and a pipe of tobacco. This is not complicated, you will tell me, and you will hardly be able to believe that this is the limit to which melancholy will take me; all the same, at some moments—oh, dear me. . . . Well, it is not always pleasant, but I do my best not to forget altogether how to make contemptuous fun of it. I try to avoid everything that has any connection with heroism or martyrdom; in short, I do my best not to take lugubrious things lugubriously." [W11 F, April 1889]

On 10 September 1889, while committed at Saint-Rémy, van Gogh wrote: "During the attacks I feel a coward before the pain and suffering— more of a coward than I ought to be—and it is perhaps this very moral cowardice that, whereas I had no desire to get better before, makes me eat like two now, work hard, limit my relations with the other patients for fear of a relapse—altogether I am now trying to recover like a man who meant to commit suicide and, finding the water too cold, tries to regain the bank." [605 F, 10 September 1889] As he'd lived by truth and by work, so might he continue to live by cowardice.

All that permitted one to continue painting was good. Once and once only, van Gogh mentioned suicide in the first person singular. On the 15th of October 1879, he wrote: "If I had to believe that I were troublesome to you or to the people at home, or were in your way, of no good to anyone, and if I should be obliged to feel like an intruder or an outcast, so that I were better off dead, and if I should have to try to keep out of your way more and more—if I thought this were really the case, a feeling of anguish would overwhelm me, and I should have to struggle against despair. This is a thought I can hardly bear, and still harder to bear is the thought that so much discord, misery, and trouble between us, and in our home, is caused by me. If it were indeed so, then I might wish that I had not much longer to live." [132 D, 15 October 1879] Van Gogh was twenty-six when he envisaged that hypothesis of being a surplus. Ten years later, on his way back from the Saint-Rémy-de-Provence asylum, he spent three days in Paris before going to Auvers-sur-Oise and Dr. Gachet. Théo picked up his brother on 17 May 1890, at the *Gare de Lyon* station. When they arrived at number 8, Pigalle flats, toward late morning, Théo led his brother to the room where his nephew and godson slept: Vincent Willem van Gogh, born 31 January of that same year, 1890. "In silence, with tears in their eyes, the brothers watched the sleeping child," recounted Johanna, Théo's wife. Almond branches in flower, after a canvas by the same name painted in February for the child, were the first of the few flowers to be placed on the flagstone in the Auvers cemetery on 30 July 1890. Van Gogh was born on 30 March 1853, one year to the

day after a Vincent Willem was stillborn. For thirty-seven years van Gogh had lived with the name of another, and then another began to carry the name with which he signed his paintings. . . . There was one Vincent Willem van Gogh too many.

In the field at Auvers-sur-Oise, where on 27 July 1890 he pressed the trigger of a revolver pointed at his chest, van Gogh may have recalled words written two years earlier: "Perhaps death is not the hardest thing in a painter's life. For my own part, I declare I know nothing whatever about it, but looking at the stars always makes me dream, as simply as I dream over the black dots representing towns and villages on a map. Why, I ask myself, shouldn't the shining dots of the sky be as accessible as the black dots on the map of France? Just as we take the train to get to Tarascon or Rouen, we take death to reach a star. One thing undoubtedly true in this reasoning is that we cannot get to a star while we are alive, any more than we can take the train when we are dead. So to me it seems possible that cholera, gravel, tuberculosis, and cancer are the celestial means of locomotion, just as steamboats, buses, and railways are the terrestrial means. To die quietly of old age would be to go there on foot." [506 F, June–July 1888] Which celestial means of locomotion is suicide? What star did van Gogh reach?

Upon his death in the garret of the Ravoux boardinghouse, an unfinished letter was found in van Gogh's coat pocket: "Well, my own work, I am risking my life for it, and my reason has half foundered because of it." [652 F, 29 July 1890]

CHAPTER 34

Van Gogh is . . .

Do you remember how many times . . . we talked about the same thing—
the necessity *of producing a lot?* [Emphasis by van Gogh; 626 F, 12 February
1890]

The body of work produced by van Gogh comprises nearly nine
hundred canvases and nearly seventeen hundred drawings. He painted
but eight and a half years—strenuous, persistent, backbreaking labor.
Van Gogh was summoned to work at that pace by a pressing lucidity
of mind. Van Gogh trapped, and perhaps serene—his canvases re-
main.

"I still can find no better definition of the word *art* than this, *'L'art*
c'est l'homme ajouté à la nature' [*'Art is man added to nature'*]—nature,
reality, truth, but with a significance, a conception, a character, which
the artist brings out in it, and to which he gives expression, *qu'il*
dégage, which he disentangles, sets free and interprets," he wrote in
June 1879. [Emphasis by van Gogh; 130 D, June 1879] Would he ever
know better? Did he ever cease wanting to bring more light? From 5
July 1876: "And yet I see a light in the distance so clearly; if that light
disappears now and then, it is generally my own fault." [70 D, 5 July
1876]

By 29 July 1890, the man who had been Vincent van Gogh and who
died in Auvers had embellished nature by many hundreds of flashes
of light.

Vincent is . . . was. . . . More than eight hundred canvases form
the response. And each one of them remains an enigma. Van Gogh
belonged only to a way of looking. And each look discovers and invents
him anew.

The case of van Gogh cannot be filed. One must always remember
the words: ". . . The reflection of reality in a mirror, if it could be
caught, color and all, would not be a picture at all, no more than a
photograph." [500 F, June–July 1888] Van Gogh's self-portraits are not
reflections in any mirror; they are hereafter and beyond.

*And if we feel, as it were, that there is an eye looking down upon
us, it would be well for us to lift up our eyes at times,
as if to see the invisible.*

Vincent to Théo, Amsterdam,
30 October 1877, Letter 112 in Dutch

Very good—and I, mostly because I am ill at present, I am trying to do something to console myself, for my own pleasure.

I let the black and white by Delacroix or Millet or something made after their work pose for me as a subject.

And then I improvise color on it, not, you understand, altogether myself, but searching for memories of *their* pictures—but the memory, "the vague consonance of colors which are at least right in feeling"—that is my own interpretation.

Many people do not copy, many others do—I started on it accidentally, and I find that it teaches me things, and above all it sometimes gives my consolation. And then my brush goes between my fingers as a bow would on the violin, and absolutely for my own pleasure. . . .

And now in the bad weather I am going to make a lot of copies, for really I must do more figures. It is the study of the figure that teaches you to seize the essential and to simplify.

When you say in your letter that I have always only been working, no—I cannot agree—I am myself very, very dissatisfied with my work, and the only thing that comforts me is that people of experience say you must paint ten years for nothing. But what I have done is only those ten years of unfortunate studies that didn't come off. Now a better period may come, but I shall have to get the figure stronger and I must refresh my memory by a very close study of Delacroix and Millet. Then I shall try to get my drawing clearer. Yes, misfortune is good for something, you gain time for study. . . .

When you think of Millet and Delacroix, what a contrast, Delacroix without a wife, Millet surrounded by a big family, more than anybody.

And yet what similarities there are in their work.

Do you know what I think of pretty often, what I already said to you some time ago—that even if I did not succeed, all the same I thought that what I have worked at will be carried on. Not directly, but one isn't alone in believing in things that are true. And what does it matter personally then! I feel so strongly that it is the same with people as it is with wheat, if you are not sown in the earth to germinate there, what does it matter?—in the end you are ground between the millstones to become bread.

The difference between happiness and unhappiness! Both are necessary and useful, as well as death or disappearance . . . it is so relative—and life is the same.

Even faced with an illness that breaks me up and frightens me, that belief is unshaken.

Vincent to Théo, Saint-Rémy,
19 September 1889, Letter 607 in French

I painted two pictures of myself lately, one of which has rather the true character, I think, although in Holland they would probably scoff at the ideas about portrait painting that are germinating here. Did you see the self-portrait by the painter Guillaumin at Théo's, and the portrait of a young woman by the same? They give an idea of what the painters are looking for. When Guillaumin exhibited his self-portrait, public and artists were greatly amused by it, and yet it is one those rare things capable of holding their own beside the old Dutch painters, even Rembrandt and Hals. I always think photographs abominable, and I don't like to have them around, particularly not those of persons I know and love.

Those photographic portraits wither much sooner than we ourselves do, whereas the painted portrait is a thing which is felt, done with love or respect for the human being that is portrayed. What is left of the old Dutchmen except their portraits?

Vincent to Wilhelmina, Saint-Rémy,
19 September 1889, Letter W14 in French

44. *Self-Portrait*,
Saint-Rémy, September 1889, oil on canvas, 57 × 43.5 cm,
New York, collection of Mrs. John Hay Whitney.

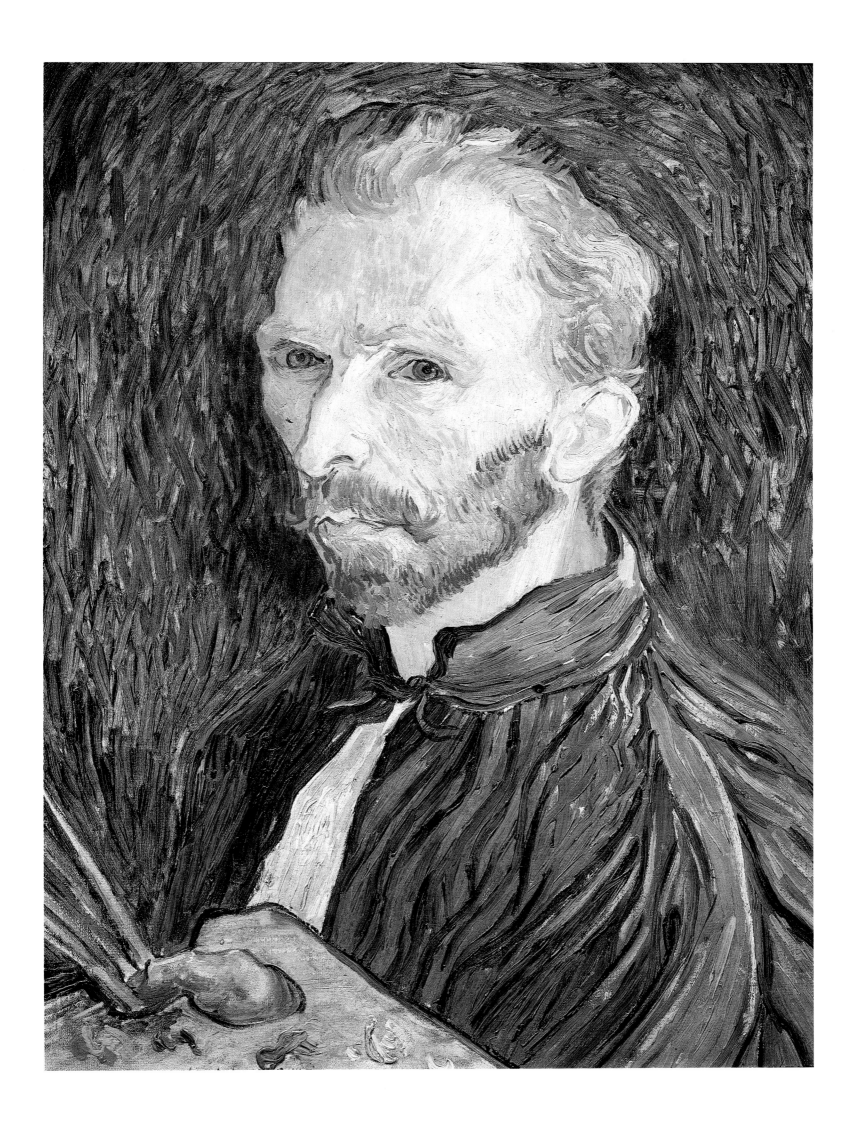

They say—and I am very willing to believe it—that it is difficult to know yourself—but it isn't easy to paint yourself either. I am working on two portraits of myself at this moment—for want of another model—because it is more than time I did a little figure work. One I began the day I got up; I was thin and pale as a ghost. It is dark violet-blue and the head whitish with yellow hair, so it has a color effect. But since then I have begun another one, three-quarter length on a light background. Then I am touching up the studies of this summer—altogether I am working from morning to night. . . .

And what's to be done? There is no cure, or if there is one, it is working zealously.

I dwell on this more than I should.

And altogether I would *rather* have a downright illness like this than be the way I was in Paris while this was brewing.

And you will see this when you put the portrait with the light background that I have just finished next to the self-portraits in Paris, and that I look saner *now* then I did then, even much more so.

I am even inclined to think that the portrait will tell you how I am better than my letter, and that it will reassure you—it cost me some trouble to do.

And then the *Reaper* is getting on, too, I think—it is very, very simple.

Vincent to Théo, Saint-Rémy,
10 September 1889, Letter 604 in French

I have done the portrait of the attendant, and I have a duplicate of it for you. This makes a rather curious contrast with the portrait I have done of myself, in which the look is vague and veiled, whereas he has something military in his small quick black eyes.

Vincent to Théo, Saint-Rémy,
10 September 1889, Letter 605 in French

I am working at his portrait, the head with a white cap, very fair, very light, the hands also a light flesh tint, a blue frock coat and a cobalt-blue background, leaning on a red table, on which are a yellow book and a foxglove plant with purple flowers. It was the same sentiment as the self-portrait I did when I left for this place.

M. Gachet is absolutely *fanatical* about this portrait and wants me to do one for him, if I can, exactly like it. I should like to myself.

Vincent to Théo, Auvers-sur-Oise,
4 June 1890, Letter 638 in French

My friend Dr. Gachet is *decidedly enthusiastic* about the latter portrait of the Arlésienne, which I have made a copy of for myself—and also about a self-portrait, which I am very glad of, seeing that he will urge me to paint figures, and I hope he is going to find some interesting models for me to paint.

What impassions me most—much, much more than all the rest of my métier—is the portrait, the modern portrait. I seek it in color, and surely I am not the only one to seek it in this direction. I *shall like*—mind you, far be it from me to say that I shall be able to do it, although this is what I am aiming at—I *should like* to paint portraits which would appear after a century to the people living then as apparitions. By which I mean that I do not endeavor to achieve this by a photographic resemblance, but by means of our impassioned expressions—that is to say, using our knowledge of and our modern taste for color as a means of arriving at the expression and the intensification of the character. So the portrait of Dr. Gachet shows you a face the color of an overheated brick, and scorched by the sun, with reddish hair and a white cap, surrounded by a rustic scenery with a background of blue hills; his clothes are ultramarine—this brings out the face and makes it paler, notwithstanding the fact that it is brick-colored. His hands, the hands of an obstetrician, are paler than the face. Before him, lying on a red garden table, are yellow novels and a foxglove flower of a somber purple hue.

My self-portrait is done in nearly the same way; the blue is the blue color of the sky in the late afternoon, and the clothes are a bright lilac. The portrait of the Arlésienne has a drab and lusterless flesh color, the eyes calm and very simple, a black dress, the background pink, and with her elbow she is leaning on a green table with green books.

Vincent to Wilhelmina, Auvers-sur-Oise,
June 1890, Letter W22 in French

45. *Self-Portrait*,
Saint-Rémy, September 1889, oil on canvas, 65 × 54 cm,
Paris, Musée d'Orsay.

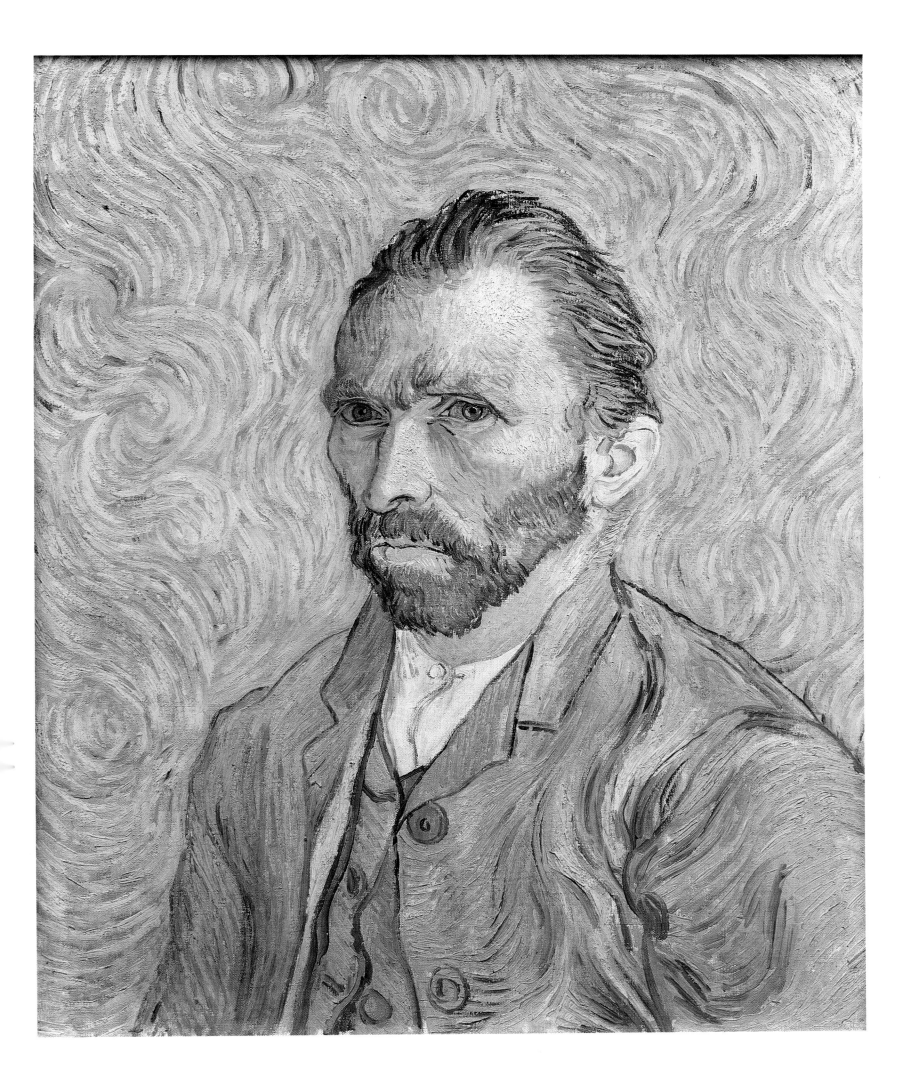

There are modern heads that people will go on looking at for a long time to come and that perhaps they will mourn over after a hundred years. Knowing what I know now, if I were ten years younger, with what ambition I should work at this!

Vincent to Wilhelmina, Auvers-sur-Oise,
June 1890, Letter W23 in Dutch

Soon I shall send you some smaller canvases with the four or five studies that I want to give Mother and our sister. These studies are drying now, they are size-10 and -12 canvases, small copies of the *Wheat Field* and the *Cypresses, Olives,* the *Reaper,* and the *Bedroom* and a little self-portrait.

Vincent to Théo, Saint-Rémy,
28 September 1889, Letter 608 in French

You will see from the self-portrait I add that though I saw Paris and other big cities for many years, I keep looking more or less like a peasant of Zundert, Toon, for instance, or Piet Prins, and sometimes I imagine I also feel and think like them, only the peasants are of more use in the world. Only when they have all the other things, they get a feeling, a desire for pictures, books, etc. In my estimation I consider myself certainly below the peasants.

Well, I am plowing on my canvases as they do on their fields.

It goes badly enough in our profession—in fact that has always been so, but at the moment it is very bad.

And yet never have such high prices been paid for pictures as these days.

What makes us work on is friendship for each other, and love nature, and finally, if one has taken all the pains to master the brush, *one cannot leave painting alone.* Compared with others, I still belong to the lucky ones, but think what it must be if one has entered the profession and has to leave it before one has done anything, and there are many like that. Given ten years as necessary to learn the profession and somebody who has struggled through six years and paid for them and then has to stop, just think how miserable that is, and how many there are like that!

And those high prices one hears about, paid for work of painters who are dead and who were never paid so much while they were alive, it is a kind of tulip trade, under which the living painters suffer rather than gain any benefit. And it will also disappear like the tulip trade.

But one may reason that, though the tulip trade has long been gone and is forgotten, the flower growers have remained and will remain. And thus I consider painting too, thinking that what abides is like a kind of flower growing. And as far as it concerns me, I reckon myself happy to be in it. But for the rest!

Vincent to his mother, Saint-Rémy,
late October 1889, Letter 612 in Dutch

46. *Self-Portrait,*
Saint-Rémy, September 1889, oil on canvas, 51 × 45 cm,
Oslo, Nasjonalgalleriet.

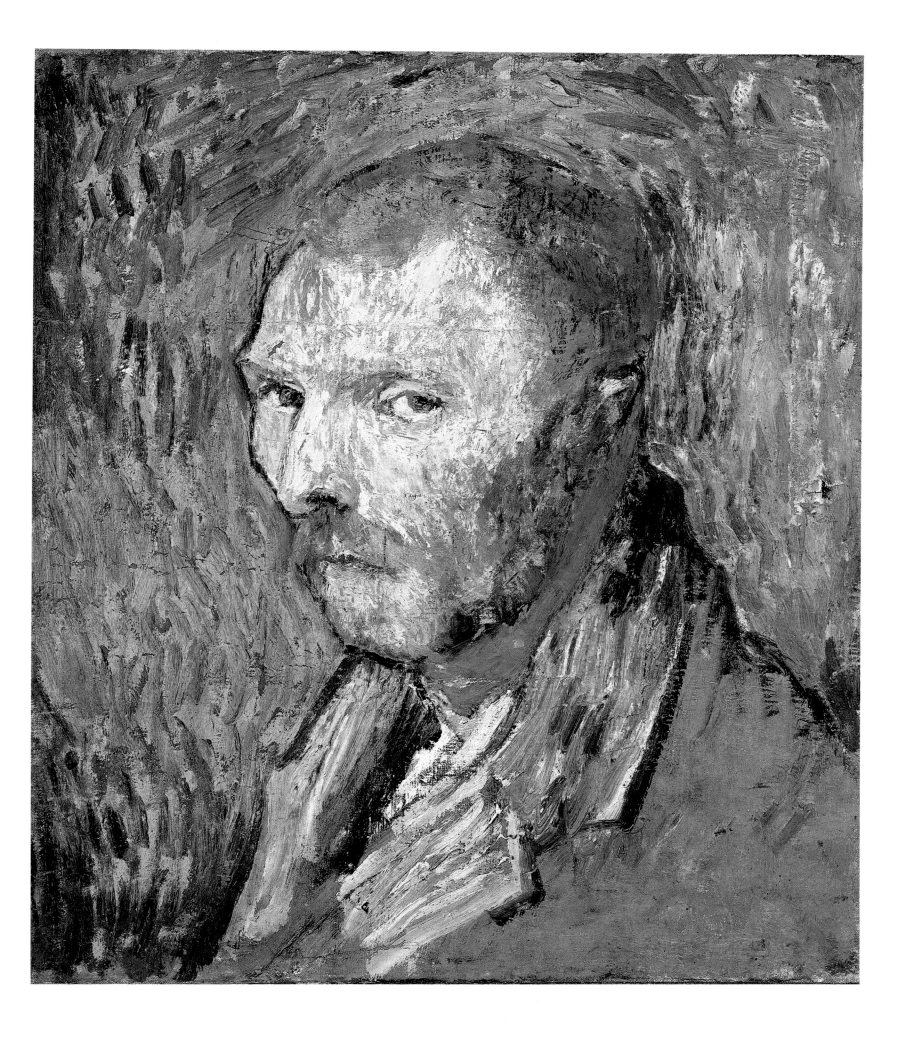

Ideas for my work are coming to me in swarms,
so that though I'm alone, I have no time to think or to feel,
I go on painting like a steam engine.

Vincent to Théo, Arles,
10 September 1888, Letter 535 in French

I am working in my room at full speed; it does me good and drives away, I think, these abnormal ideas.

So I have gone over the canvas of my bedroom. That study is certainly one of the best—sooner or later it must be *recanvased* good and solid. It was painted so quickly and has dried in such a way that the essence evaporated at once, and so the paint is not firmly stuck to the canvas at all. That will be the case with other studies of mine too, which were painted very quickly and very thickly. Besides, after some time this thin canvas decays and cannot bear a lot of impasto.

You have got some excellent stretchers. Damn, if I had some like them to work with here, it would be better than these laths you get here, which warp in the sun.

Vincent to Théo, Saint-Rémy,
4 or 5 September 1889, Letter 604 in French

47. *Van Gogh's Bedroom in Arles,*
Saint-Rémy, September 1889, oil on canvas, 56.5 × 74 cm,
Paris, Musée d'Orsay.

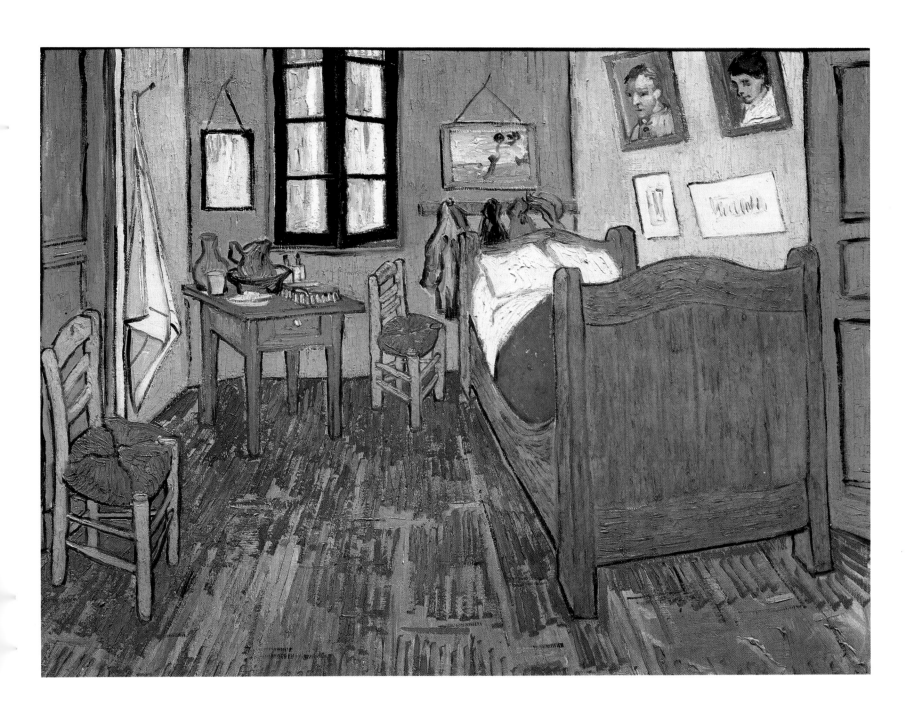

Within a very short time I shall send Théo the painted studies I promised you, and he will see to it that they are sent on to you at Leyden.

Here is what I have: an orchard of olive trees—a field of wheat with a reaper—a field of wheat with cypresses—an interior—a plowed field, early-morning effect—orchard in bloom—and a self-portrait.

Now suppose that I can send you as many during the next year, then they will make a little collection along with the two you have, and I should like you to keep them together if there is enough room, for I think that in Leyden you will meet artists from time to time, in which case other studies will join mine, I daresay. Don't be afraid to hang them in the passage, in the kitchen, on the staircase—above all, my paintings are meant to be seen against a simple background.

I do my best to paint in such a way that my work will show up to good advantage in a kitchen, and then I may happen to discover that it shows up well in a parlor too, but this is something I never bother my head about. Here in the South we have bare walls, white or yellow, or covered with wallpaper with large colored flowers. So it seems to me that it is a matter of using frank contrasts of colors. The same is true of the frames—the frames I use cost me five francs at the outside, whereas the gilt frames, which are less strong, would cost thirty or more. And if a picture shows to advantage in a simple frame, why put gilt around it?

Now listen—if I am going to continue sending studies to you and Mother with great pleasure, I also feel a desire, which is almost an irresistible urge, to do some more of them to be given to persons I often think of. So if, since you will be in Leyden, you should meet our cousins the ladies Mauve and Lecomte, please tell them that, in case they like my work, I shall be pleased, very pleased, to do things for them, but most of all I should like Margot Begemann to have a picture of mine. But letting her have it through your mediation would seem more discreet than sending it to her directly. So you will greatly oblige me my taking measures for the three persons I have just mentioned to get some work of mine. There isn't any reason for hurry, but I certainly have a right, yes, a *right*, to work from time to time for friends who are so far away that I shall probably never see them again.

The physician here has been to Paris, and went to see Théo; he told him that he *did not* consider me a lunatic, but that the crises I have are of an epileptic nature. Consequently alcohol is also not the cause, though it must be understood that it does me no good either. But it is difficult to return to one's ordinary way of life while one is too despondent over the uncertainty of misfortune. And one goes on clinging to the affection of the past.

So, as I told you, I feel a nearly irresistible urge to send something of my work to Holland, and if you should succeed in getting people to accept anything, it will be *my* duty to be grateful.

You will probably think the interior of the empty bedroom with a wooden bedstead and two chairs the must unbeautiful thing of all—and notwithstanding this I have painted it twice, on a large scale.

I wanted to achieve an effect of simplicity of the sort one finds described in *Felix Holt*. After being told this you may quickly understand this picture, but it will probably remain ridiculous in the eyes of others who have not been warned. Doing a simple thing with bright colors is not at all easy, and I for my part think it is perhaps useful to show that it is possible to be simple by using something other than gray, white, black or brown. Here you have the justification for this study's existence.

You will think my wheat fields too yellow, but in our native country one should not begin by saying it is too yellow, too blue or too green.

You will get the studies at Leyden—I don't know when. Théo will probably have one of them framed in Paris, so that you will be able to put them into a frame *if you should want to*, and then he will put them in a case to be sent to The Hague at the first opportunity. But what matters is that as far as my painting is concerned the work is finished, and I assure you that it is not the worst work I have done. I should also like you to have the red vine, which Théo has in Paris, and if I should ever go back to Paris I shall copy it for you.

Yes, I return once again to this interior. I certainly wish that other artists had a taste and a longing for simplicity as I do. But the ideal of simplicity renders life more difficult in modern society—and whoever has this ideal will not be able to do what he wants to in the end, as is the case with me. But so it is after all, yet this is what society should grant an artist in my opinion, whereas nowadays one is obliged to live in cafés and low inns.

The Japanese have always lived in very simple interiors, and what great artists have not lived in that country? If a painter is right in our society, then he has to live in a house which is like a curiosity shop, and this isn't very artistic either to my taste. As for me, I often suffered under the fact that I had to live in conditions in which order was impossible, with the result that I lost the notion of order and simplicity. . . .

I am now working on a ward in the hospital. In the foreground a big black stove surrounded by a number of gray and black figures of patients, behind this the very long room with a red tile floor, with two rows of white beds, the walls white, but a white which is lilac or green, and the windows with pink and green curtains, and in the background the figures of two sisters in black and white. The ceiling is violet with big beams.

I had read an article about Dostoevski, who wrote a book *Souvenirs de la maison des morts*, and this induced me to resume a large study I had begun in the fever ward at Arles. But it is annoying to paint figures without models.

The other day I read another of Carmen Sylva's "Thoughts," which is very true—when you suffer much, you see everybody at a great distance, and as at the far end of an immense arena—the very voices seem to come from afar. During the attacks I experience this to such a degree that all the persons I see then, *even if I recognize them*, which is not always the case, seem to come toward me out of a great distance, and to be *quite different* from what they are in reality, so much do I seem to see in them pleasant or unpleasant resemblances to persons I knew in the past and elsewhere.

Vincent to Wilhelmina, Saint-Rémy,
October 1889, Letter W15 in French

Why should I change myself? I used to be very passive and very soft-hearted and quiet; I'm not any more, but it's true, I am no longer a child now. . . . I have become more of what I truly am.

Vincent to Théo, Nuenen,
October 1884, Letter 378 in Dutch

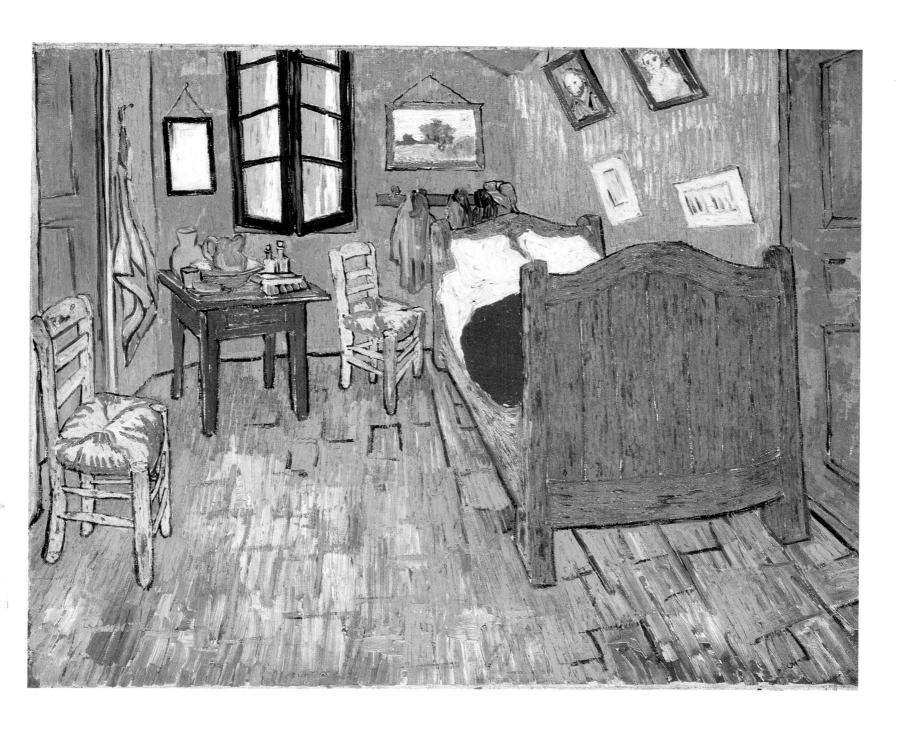

48. *Van Gogh's Bedroom in Arles,*
Saint-Rémy, September 1889, oil on canvas, 73 × 92 cm,
Chicago, Art Institute.

Chronology

1853
30 March. Birth of Vincent Willem van Gogh in the parish of Groot-Zundert (Brabant County). His father is a Calvinist pastor; three of his uncles, Hendrick, Vincent, and Cornelis, are art dealers. Anna Cornelia Carbentus, his mother, is the daughter of a bookbinder of the court of The Hague. Vincent is the oldest of six children.

1857
1 May. Birth of Théodorus Van Gogh, "Théo."

1864
1 October. At Zevenbergen, Vincent enters a boarding school under the direction of Provily.

1866
15 September. Vincent is enrolled at the Hannik Institute at 57 Korvel Street in Tilburg. He is a mediocre pupil.

1869
30 July. Vincent becomes a shop assistant at the branch office of the Goupil art gallery of Paris. He attends lectures and visits museums.

1872
August. Start of the correspondence between Vincent and Théo.

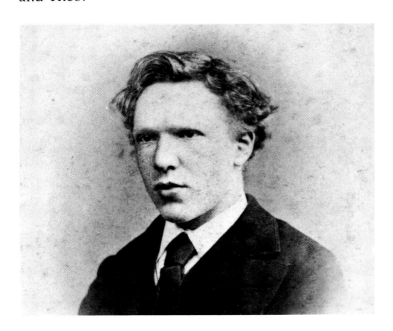

1873
May. After a brief trip to Paris, Vincent settles in London, where he works for the subsidiary of Goupil on Southampton Street.
August. He moves into the home of Madame Loyer.

1874
July. Ursula Loyer, the daughter of his landlady, rejects his advances. He moves in with his sister at Ivy Cottage, 395 Kensington New Road.
October–December. Works at the home office of Goupil in Paris. Returns to London.

1875
May. Works again for the Goupil gallery in Paris, on Chaptal Street. Intensive study of the Bible.
December. Spends Christmas in Etten, near Breda, where his father was appointed in October.

1876
1 April. Offers his resignation to Monsieur Boussod and leaves for Etten.
16 April. Takes room and board in a small school directed by a teacher named Stokes at Ramsgate, near London. Accompanies Stokes for the second semester to Isleworth, where he is adjunct preacher of the Methodist Pastor Jones.
4 November. Preaches his first sermon.
December. Returns to Etten for the New Year's festivities.

1877
21 January–30 April. Salesman at the Van Blussé et van Braam bookstore in Dordrecht. Rooms with a grain merchant, Rijken.
9 May. Moves in with his Uncle Johannes in Amsterdam to study for the entrance examination at the School of Theology.

1878
July. Abandons his studies in Amsterdam. His father and Pastor Jones present him at the Flemish School of Evangelism directed by Pastor Bokma in Brussels. He returns to Etten.
August–October. Novice at the Laeken school, near Brussels. At the end of the trimester, Vincent is determined to be unfit to hold the title of evangelist.
15 November. He moves to the Borinage, in Pâturages. Visits the sick, teaches the Bible.

1879

January. Named acting pastor of Wasmes in the mining region of Mons. Renounces the "comfort" of the baker Denis's home for the straw of a hovel.
July. He is dismissed.
August. Goes on foot to ask advice of Pastor Pietersen, in Brussels. Returns to Cuesmes (the Borinage). Reads, aids the poor. Misery.

1880

January. Goes on foot as far as Courrières (Pas-de-Calais) to see Jules Breton, the painter. Days of wandering under the open sky.
October. Takes a room at 72 Midi Boulevard in Brussels. Strikes up an acquaintance with G. A. van Rappard, a fellow Dutchman.

1881

12 April. Returns to Etten. Argues with his father about his choosing the career of an artist.
July–August. Falls in love with his cousin Kate, who rejects him. Numerous trips to The Hague. Visits there with Tersteeg and Anton Mauve. A month spent as a guest of the latter toward the end of the year. First paintings in oil.
December. Leaves Etten.

1882

January. Moves into 138 Schenkweg in The Hague, near Mauve, who advises him and assists him financially. At the end of the month, he strikes up with Clasina Maria Hoornk (Sien), a pregnant prostitute and alcoholic who has a small child.
March. Mauve breaks with him.
7 June. Admitted to a hospital for treatment of gonorrhea. Finds new lodgings for Sien and her two children.

1883

11 September. Moves into the home of Albertus Hartsuiker in Hoogeveen in Drenthe, after having abandoned Sien in The Hague. Leaves two weeks later for Nieuw-Amsterdam.
December. Returns to the parish of Nuenen, where his father had been appointed in August.

1884

May. Sets up his studio in the home of the Catholic sexton Schafrath.

August. Margot Begemann, with whom he is in contact, attempts suicide.

1885

26 March. His father dies of a stroke.
April–May. *The Potato Eaters.*
September. He is accused of getting Gordina de Groot, a young peasant woman, pregnant. The parish priest forbids parishioners from posing for him.
October. Three days in Amsterdam. Visits the Rijksmuseum.
23 November. Moves to Anvers, lives on the "Longue-rue-des-Images" [Long Street of Images]. Discovers Rubens.

1886

18 January. Enrolls at the School of Fine Arts. Attends the classes of C. Verlat, director of the school. Meets Horace Mann Levens, the painter.
February. Falls ill from exhaustion. Leaves at the end of the month to join Théo in Paris.
March. Stays with Théo on Laval Street (now Victor-Massé Street).
May. Joins the Cormon studio in Montmartre. Meets Toulouse-Lautrec and Émile Bernard there.
June. Moves with Théo to 54, Lepic Street. Associates with the Impressionists Pissarro, Degas, Renoir, Monet, Sisley, Seurat, and Signac.
November–December. Meets Gauguin, who is back from Pont-Aven.

1887

Frequent visits to the shop of the elder Tanguy. Enters into relations with Agostina Segatori, an Italian who manages Le Tambourin, a cabaret on the Clichy Boulevard. Exhibits there with Anquetin, Bernard, Gauguin, and Toulouse-Lautrec. They form the "little boulevard" group (as opposed to the "big boulevard" where Pissarro, Monet, Sisley, and Degas exhibited).

1888

20 February. Arrives in Arles and moves into the Carrel hotel-restaurant at 30 Cavalry Street.
May. Rents a house, the "yellow house," at 2 Lamartine Place, across from the Alcazar Café.
June. Spends several days at Saintes-Maries-de-la-Mer.

18 September. Moves into the "yellow house."

20 October. Joined there by Gauguin.

December. Vincent takes the severed lobe of his ear to a prostitute.

24 December. Gauguin leaves. Vincent in hospital.

1889

7 January. Returns to his home.

9 February. Has hallucinations. Hospitalized that night.

March. On the basis of a petition, the mayor decides to have Vincent committed once again.

April. He visits the "yellow house" on the arm of Signac.

8 May. He enters the insane asylum at Saint-Paul-de-Mausole in Saint-Rémy-de-Provence.

July. Violent crisis.

November. Sends six canvases to the eighth exhibit of The Twenty in Brussels.

December. Another crisis. Vincent attempts to swallow paint colors.

1890

January. The first article on his work, "Les Isolés," by Albert Aurier, appears in *Le Mercure de France*.

31 January. Birth of Vincent Willem van Gogh, his nephew, Théo's son, in Paris. Théo had married Johanna Bonger on 17 April 1889.

17 May. Arrives in Paris, where Théo is waiting at the station. Meets his sister-in-law and his nephew.

20 May. Moves to Auvers-sur-Oise, where Pissarro has advised Théo to entrust him to the care of Dr. Gachet. Lives at first in the Saint-Aubin Hotel, then moves to the Ravoux boardinghouse, opposite City Hall.

8 June. Théo and his family come to spend Sunday by Vincent's side.

6 July. Vincent visits Théo at home in Paris, where he meets Toulouse-Lautrec and Albert Aurier.

27 July. In the afternoon, Vincent shoots himself in the chest with a revolver. The Ravoux discover him bleeding in his room. Dr. Gachet treats him and contacts Théo.

29 July. Vincent dies during the night, at approximately 1:00 A.M.

30 July. He is buried, accompanied to the Auvers cemetery by Dr. Gachet, Lucien Pissarro (the son of Camille Pissarro), Dries Bonger, Émile Bernard, and the elder Tanguy.

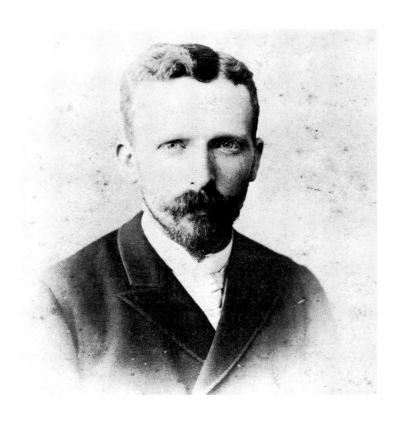

1891

25 January. Théo dies in a private hospital in Utrecht. (In 1914 his body is exhumed and buried beside that of Vincent in Auvers.)

Bibliography

In 1942, C. M. Brooks published a bibliography of Vincent van Gogh in New York (*Vincent van Gogh: A Bibliography*); in it he counted 777 published studies between 1890 and 1940. In the forty-nine intervening years the flow of writing on van Gogh has not ceased. The following list is thus necessarily selective and may seem arbitrary. Its aim is to indicate works that might "complete" the present book, a portrait of Van Gogh by van Gogh that is neither a catalogue nor a biography.

Essential References

The Complete Letters of Vincent van Gogh. Boston: New York Graphic Society, 1981. (All the letter citations of the present volume refer to this edition.)

J. B. de la Faille, *Catalogue de l'oeuvre de Vincent van Gogh.* Paris/Brussels, 1928.

J. B. de la Faille, *The Works of Vincent Van Gogh: His Paintings and Drawings.* Introduction by A. M. Hammacher. Amsterdam: Meulenhoff International, 1970.

Other Titles of Interest

J. Meier-Graffe, *Vincent van Gogh, A Biographical Study.* New York, 1922.

G. Coguiot, *Vincent Van Gogh.* Paris, 1923.

L. Pierard, *La Vie tragique de Vincent van Gogh.* Paris, 1939.

V. Doiteau, E. Leroy, *La Folie de Vincent van Gogh.* Paris, 1928.

F. Fels, *Vincent van Gogh.* Paris, 1928.

Ch. Terrasse, *Van Gogh, Peintre.* Paris, 1935.

W. Pach, *Vincent van Gogh: A Study of the Artist and His Work in Relation to His Times.* New York, 1936.

M. Florisoone, *Van Gogh.* Paris, 1937.

L. Hautecoeur, *Van Gogh.* Munich/Paris, 1946.

E. A. Jewell, *Vincent van Gogh.* New York, 1946.

A. Artaud. *Van Gogh le suicidé de la société.* Paris, 1947.

P. Courthion, *Van Gogh Raconté par lui-même, ses amis, ses contemporains, sa postérité.* Geneva, 1947.

G. Duthuit, *Van Gogh.* Lausanne, 1948.

A. Parronchi, *Van Gogh.* Florence, 1949.

J. Leymarie, *Van Gogh.* Paris, 1951.

C. Mauron, *Notes sur la structure de l'inconscient chez van Gogh.* Paris, 1953.

H. Perruchot, *La Vie de Vincent van Gogh.* Paris, 1955.

P. Marois, *Le Secret de van Gogh.* Paris, 1957.

R. Huyghe, *Vincent van Gogh.* Paris, 1958.

R. Gogniat, *Van Gogh.* Paris, 1959.

A. M. Hammacher, *Vincent van Gogh, Selbstbildnisse.* Stuttgart, 1960.

J. Rewald, *Le Post-Impressionisme: De van Gogh à Gauguin.* Paris, 1961.

P. Cabanne, *Van Gogh, l'homme et son oeuvre.* Paris, 1961.

F. Erpel, *Die Van Gogh Selbstbildnisse.* Berlin, 1963.

H. R. Graetz, *The Symbolic Language of Vincent van Gogh.* New York/Toronto/London, 1963.

J. Leymarie, *Qui Était Van Gogh?* Geneva, 1968.

M. E. Trabaut, *Vincent van Gogh le mal aimé.* Lausanne, 1969.

R. Wallace, *The Word of van Gogh.* New York, 1969.

V. Forrester, *Van Gogh ou l'enterrement dals les blés.* Paris, 1983.

R. Pickvance, *Van Gogh in Arles.* Geneva, 1985.

Table of Illustrations

39. *Self-Portrait*, Arles, November–December 1888, oil on canvas, dedicated and signed in the lower right, "To friend Laval, Vincent," 46 × 38 cm, New York, private collection.

40. *Self-Portrait*, Arles, September 1888, oil on canvas, 40 × 31 cm, Switzerland, private collection.

41. *Van Gogh's Bedroom in Arles*, Arles, October 1888, oil on canvas, 72 × 90 cm, Amsterdam, Rijksmuseum Vincent van Gogh.

42. *Self-Portrait with a Bandaged Ear*, Arles, January 1889, oil on canvas, 60 × 49 cm, London, Courtauld Institute Galleries.

43. *Self-Portrait: Man with a Pipe*, Arles, January 1889, oil on canvas, 51 × 45 cm, London, private collection.

44. *Self-Portrait*, Saint-Rémy, September 1889, oil on canvas, 57 × 43.5 cm, New York, collection of Mrs. John Hay Whitney.

45. *Self-Portrait*, Saint-Rémy, September 1889, oil on canvas, 65 × 54 cm, Paris, Musée d'Orsay.

46. *Self-Portrait*, Saint-Rémy, September 1889, oil on canvas, 51 × 45 cm, Oslo, Nasjonalgalleriet.

47. *Van Gogh's Bedroom in Arles*, Saint-Rémy, September 1889, oil on canvas, 56.5 × 74 cm, Paris, Musée d'Orsay.

48. *Van Gogh's Bedroom in Arles*, Saint-Rémy, September 1889, oil on canvas, 73 × 92 cm, Chicago, Art Institute.